Deleuze Studies
Volume 5 Number 2 2011

Edinburgh University Press

Subscription rates for 2011

Three issues plus one supplementary issue per year, published in March, July and November

		UK	Rest of World	N. America
Institutions	Print	£95.00	£105.00	$190.00
	Online	£85.00	£85.00	$154.00
	Print and online	£118.00	£131.00	$238.00
	Back issues/ single copies	£33.00	£37.00	$68.00
Individuals	Print	£40.00	£45.00	$81.00
	Online	£40.00	£40.00	$73.00
	Print and online	£50.00	£57.00	$104.00
	Back issues/ single copies	£15.00	£17.00	$31.00

How to order

Subscriptions can be accepted for complete volumes only. Print prices include packing and airmail for subscribers in North America and surface postage for subscribers in the Rest of the World. Volumes back to the year 2000 (where applicable) are included in online prices. Print back volumes will be charged at the current volume subscription rate.

All orders must be accompanied by the correct payment. You can pay by cheque in Pound Sterling or US Dollars, bank transfer, Direct Debit or Credit/Debit Card. The individual rate applies only when a subscription is paid for with a personal cheque, credit card or bank transfer.

To order using the online subscription form, please visit www.eupjournals.com/page/dls/subscribe

Alternatively you may place your order by telephone on +44 (0)131 650 6207, fax on +44 (0)131 662 3286 or email to journals@eup.ed.ac.uk using your Visa or Mastercard credit card. Don't forget to include the expiry date of your card, the security number (three digits on the reverse of the card) and the address that the card is registered to.

Please make your cheque payable to Edinburgh University Press Ltd. Sterling cheques must be drawn on a UK bank account.

If you would like to pay by bank transfer or Direct Debit, contact us at journals@eup.ed.ac.uk and we will provide instructions.

Advertising

Advertisements are welcomed and rates are available on request, or by consulting our website at www.eupjournals.com. Advertisers should send their enquiries to the Journals Marketing Manager at the address above.

Transferred to digital print 2013

Contents

Signatures of the Invisible: On Schizoanalysis and Visual Culture

Phillip Roberts Cardiff University

This collection marks a critical juncture somewhere between Deleuze's studies of cinema (2005a; 2005b) and his schizoanalytic work with Félix Guattari (2004a; 2004b). Each essay in this collection positions itself in the field of discourse mapped out between each of Deleuze's projects; each acts as a little machine, redirecting the systems of discourse that pass between the constellations of Deleuze's thought so that they might break away onto new trajectories. Each of the essays here, in its own way, attempts to utilise a schizoanalytic conception of visual culture *in order to do something.* The task of this introduction is firstly, to sketch out the discursive field in which they are working – to determine where in the territory between Deleuze's two projects their little machines are set to work – and secondly, to consider what it is that these machines are doing. We are engaged here in the task of drawing up an inventory of these critical connections.

In two essays on schizoanalysis and cinema (2008; 2010), Ian Buchanan has already started to question what forms this connection might take, suggesting that although Deleuze himself was seemingly reluctant to construct his cinematic studies with the same systems of concepts that would inform schizoanalysis, there is nothing to stop us from putting these projects into communication ourselves. Deleuze's own silence on the connections between the two projects does not make such connections impossible or unnecessary, and 'doesn't mean', Buchanan says, 'we have to follow Deleuze in ignoring the questions he left unasked and unanswered' (2008: 2). This is the form that any successful intersection between schizoanalysis and cinema must take. In order to adequately determine what the field of discourse between the projects might look like, we must identify the spaces that Deleuze's own

Deleuze Studies 5.2 (2011): 151–162
DOI: 10.3366/dls.2011.0015
© Edinburgh University Press
www.eupjournals.com/dls

lines of enquiry had failed to explore; find those questions that Deleuze's work left unasked and unanswered and to set our little machines to work. What this means is that rather than framing this collection as an attempt to *add* a schizoanalysis to Deleuze's work on cinema, we take this as an exercise of a different sort, that is, as a search for what is *missing* from this work that might be introduced through forcing Deleuze's cinematic toolbox into communication with the conceptual schema set forth by schizoanalysis.

Buchanan's work is useful in this respect, providing us with a provisional list of areas that the cinema books had failed to explore, lines of enquiry that Deleuze had not developed fully, and questions that were *beyond the scope of the strictly philosophical framework he set for himself* (2008: 2). Deleuze's analysis of cinema, Buchanan notes, is unconcerned with, and perhaps even unsuited to answering, questions of material film production: 'the interrelated questions of why we watch certain films and just as significantly why we pay money to do so' (2008: 2). He has seemingly little interest in film's effect on audiences or in its status as an industrial art, or in any form of cinema that might exist outside of those precious few examples that would demonstrate the potential of cinema as art. He does not at any point, Buchanan says, 'write about *Hell Behind Bars*, *Shaft*, *Night of the Living Dead*, *The Birds 2*, or even *Star Wars*' (2008: 11). In short: 'Deleuze refuses to draw any conclusions from his analysis of the sense of cinema about issues that do not pertain directly to cinema as a specific form of art' (2008: 3).

Buchanan is very clear on the spaces that he feels a schizoanalytic approach to cinema will help to fill, identifying questions relating to cinema as a mass culture object and setting his machines to work. But we can go even further than this, opening Deleuze's taxonomy of images to systems of art and advertising, fashion, photography, political reporting, professional athletics, media branding, pop music, celebrity magazines and association football. If, in *Cinema 1*, Deleuze would say that an atom is an image, or an eye or a brain or a body (2005a: 59), if he would frame *the universe as cinema in itself* (2005a: 60), then why stop at *Star Wars*? Why not open the image onto the world? Why not, as Guy Debord's theorisation of the image as spectacle would attest, conceive of 'a social relation between people that is mediated by images' (2009: 24) and develop the connections across Deleuze's work that would help us analyse this? This is precisely the reason why we have written *visual culture* rather than cinema on the front of this volume. Analysing the *social relations between people* is something that the schizoanalysis

books had already been doing, and as any communication between the two projects will demand that cinema opens itself to a bit of *relation to the outside* (as schizoanalysis asks), then any coupling of schizoanalysis *and* cinema must always be more than cinema – *Schizoanalysis and Visual Culture*.

So then, if we are to open Deleuze's studies of cinema onto the larger field of visual culture, then what spaces do we find in the discursive field between visual culture and schizoanalysis? What is missing and *why* is it imperative that we should bring this to light? By developing connections between the work in this way we can begin to ask those questions that Buchanan has already been driving towards and which in different ways had concerned much of the critical work on cinema prior to the writing of Deleuze's cinema books – questions of audience reception, of the cinematic apparatus, of ideology and, above all, of power. Paradoxically, Deleuze himself was to point out this absence in *Cinema 2*, dedicating a short section towards the end of the book to the functioning of a political cinema and to his admission that 'the people no longer exist, or not yet ... *the people are missing*' (2005b: 208). This is perhaps as true of Deleuze's own work on cinema as it is of the films that he is analysing, as despite the richness of the few pages in which he explores the development of a third-world cinema, neither book is able to expand this political theorisation of the image in any significance. This is perhaps surprising given the concerns that these pages share with the schizoanalysis books, with Deleuze and Guattari's work on Kafka (1986), or even his book on Foucault (2006), published shortly after *Cinema 2* and directly concerned with the questions of power and visibility that could so easily have informed the preceding works.

We should perhaps be most surprised that even within his brief writings on third-world cinema, Deleuze would neglect to draw on the extensive work in this field that film criticism had produced in the years leading up to his cinema project. As such we find no mention of Third Cinema as a concept, of Solanas and Getino, or of Peter Wollen and Counter Cinema, both of which were relevant to Deleuze's position and available (and hugely influential) when he was writing his cinema books.[1] This not to say that Deleuze is blind to the existence of a wider cinema criticism; he is a great admirer of André Bazin, often refers to Christian Metz and marks Jean-Louis Comolli's political cinema as exemplary (although he refers to him only once and then only in his capacity as a film-maker). However, Deleuze's use of the great cinema theorists is restricted to the extent to which each coincides with his own

study of cinema as a philosophical exercise. He is seemingly unwilling to insert his work into a wider theoretical discourse on cinema, to see where a Bergson-inspired reading of cinema might sit along side the psychoanalytic, semiological and ideological studies that were prevalent at the time, to engage his toolbox of concepts in the problems that would inform each approach.

Given the scope and complexity of his cinema studies, we should perhaps not hold Deleuze to account for this too strongly, but rather set ourselves to the task of perverting his work so that it might be able to answer these very questions. If we are to apply Deleuze's thinking in this other work to *Cinema 2*'s few pages on political cinema, we should see how in constructing a people that do not yet exist, these films are engaged in the process of *making visible* a people that had been hidden. So when Rocha films his Brazil he isolates a lived experience beneath the myth of Brazilian cinema, making visible a new Brazil; when Sembene films his talking-cinema, he makes visible the African as story-teller, and contrasts this with the myth of the African as dancer (2005b: 214), thus constructing a reality that had not been made visible and providing an actually existing people with the tools to speak about their own political reality for the first time.

Buchanan is correct to highlight that Deleuze's conception of the cinematic image is already schizoanalytic (2010: 136); our questions of visibilities and discourse already direct us towards the formalism of *A Thousand Plateaus*. There is a conceptual equivalence, Buchanan says, in which the body without organs, the abstract machine and the assemblage, already inform the basic matrix of Deleuze's account of the cinematic image (ibid.). Schizoanalysis is already present within the cinema project, obscured in the spaces between the lines of Deleuze's strictly philosophical and aesthetic discussion of cinema. It is the task of our own critical machines, of each of the essays in the present collection, to discover it and reorder the points of intersection between the two projects so that we might begin to traverse the many important territories that Deleuze's work has not yet fully explored. We might direct our lines of enquiries towards questions of power in visual culture, towards mass culture or the material production of film, spectatorship, or innumerable other points in our field of critical discourse, and find that despite his apparent silence on any number of such issues, these systems of enquiry are already at work within Deleuze's cinema project – what we require of schizoanalysis is that it make these systems visible.

Tom Conley's contribution, which opens this collection, is engaged in this very act, developing Buchanan's suggestion that specific words and images function *in the manner of little machines* in order to explore an important (but surprisingly infrequent) dialogue between the works of Deleuze and Maurice Blanchot. Conley takes as his starting point an encounter between the two thinkers that an essay by Marie-Claire Ropars-Wuilleumier had already staged (2010), arguing that Ropars-Wuilleumier's reading of Blanchot's interventions into Deleuze's thought in *Cinema 2* alters and occasionally subverts his taxonomical and philosophical project. By this he means that Blanchot's formulation of the *outside,* a space that is irreducible to language, that resides between what is said and what is not said, confronts Deleuze's cinema of thought with an outside – an unthought. This outside is the spaces of discourse and visibility that have not yet come into emergence. It confronts Deleuze's cinema of thought with the spaces of what is not thought, the peoples that are yet to come, the systems of knowledge that are yet to be made visible, and should inform our reading of visual culture as not simply an ordering of what is seen and said but as a marker of what we do not yet have the tools to express. That is, as a confirmation of what is missing from the regimes of the visible.

Conley utilises his little machines as conceptual *diagrams,* recurring formulas of concepts that operate, he says, as machinic systems that we can set to work within Deleuze's thinking. A diagram is a map of forces; there is a diagram for every historical formation – a Napoleonic diagram or a Fordist diagram – one for every system of discourse or visibility. It is an abstract machine, Deleuze says, that 'communicates with the stratified formation, stabilizing or fixing it, but following another axis it also communicates with the other diagram, the other unstable diagrammatic states, through which forces pursue their mutant emergence' (2006: 71). Diagrams are tools that can help us to make visible the spaces within Deleuze's work – to bring it into contact with the *outside* of his thought.

Hanjo Berressem's incisive reading of a schizoanalytic Hitchcock will develop this idea further by addressing the use of montage in *Psycho* and *The Birds*. Schizoanalysis, we are reminded, presupposes that the machinic assemblages, the architectures of forms within which our diagrams will operate, are *systems of interruptions or breaks*. It is the cut that breaks the continuous material flow and at the same time produces a new one. It is this premise upon which the actual concrete machines and the virtual abstract machines, the formations of

matter and thought, are assembled. For Berressem this is quite literally montage – an arrangement of flows and cuts that mark the relation between the actual and the virtual. Here Berressem has drawn from what Tom Conley, in another article, would call *the mental map of classical cinema* (2009), framing the fields of forms and forces that Conley would discuss as actual forms and virtual forces – marking the actual/virtual cut as reminiscent of the thought/unthought diagram that would emerge from Deleuze's encounter with Blanchot. Here it is the virtual – the field of intensive events, of duration and memory, the breaks in the actual material and perceptual matter of film – that forms the basis of Hitchcock's cinematic arrangements; it is the spaces between the actual arrangements of form that are to reform the whole. We can certainly read the essay itself in similar terms, observing how Berressem's approach, in challenging the logic of what he feels is a critical fixation on an Oedipalised Hitchcock, seeks out the virtual fissures within the Oedipal interpretations of Hitchcock's films in order to reform the whole into a schizoanalytic Hitchcock of *pure optical and sound images*. This will make psychoanalysis into the actual matter into which the sensory shock of Hitchcock's cinematic form can cut. It will, Berressem says, make the material and contextual form of the films into optically and auditively assembled blocs of affect; the narrative continuity of *Psycho*, all its Oedipalised formations, even Marion Crane's early embezzlement narrative, all MacGuffins before Hitchcock's delivery of the film's ultimate visceral thrills in the motel shower scene.

Similarly, Nadine Boljkovac's fine essay engages in an analysis of the actual and virtual elements of Chris Marker's *Sans Soleil*, scouring the film for the forces and sensations that exist beneath the discursive systems and visibilities of the film itself. Boljkovac explores the regions of what is left unsaid, in order to make visible the relations between Deleuze's thought and the cinema of Chris Marker. Boljkovac again looks to explore the *outside* of thought that *Sans Soleil* draws out of its images – the virtual connections that occur between the actual forms of our world. Boljkovac approaches Marker's film as an exercise in virtual mapping – an ordering of forces that occur between the actual forms of the film. The material images of the film are assembled with the same virtual cut that Berressem will seek to draw out of Hitchcock's work. *Sans Soleil* foregrounds the cuts between its images. They are, Boljkovac suggests, fissures or cracks, dissociative forces or holes in appearances; they are the breaks within the visible substance of the film itself or between the concrete structures of the everyday world – the forces of time or memory or belief that intersect banality. This is a cartography

of cinema as diagrams of forces and sensations; little machines hidden in the spaces between forms that Marker can set to work, *making the territorial assemblage open onto something else*; making the concrete organisations of banality, both familiar and indecipherable, open onto the spiritual and cosmic worlds within our own.

This contrast between virtual worlds and actual forms is further interrogated by Richard Rushton, who attempts to re-insert the concerns of cinema theory into Deleuze's discourse on film, relating his actual/virtual conceptual framework to the concepts of the real and imaginary developed by the Lacanian and Althusserian film theorists of the seventies and eighties. Here Rushton questions the position of the imaginary in Deleuze's cinema works, suggesting that, perhaps contrary to our expectations, the imaginary is far from an absent concept. The imaginary is utilised by Deleuze, particularly in *Cinema 2*, but is eclipsed by his focus on the actual/virtual schema that informs his reading of movement and time. But what does this semi-neglected imaginary *do* in Deleuze's work, Rushton asks? What is its relationship to the Lacanian-Althusserian film theory that was prevalent at the time of Deleuze's project? And how might we utilise Deleuze to conceive of a different kind of imaginary, one that is not to be formulated as pure negativity or ideological fantasy? Rushton is thus engaged in a twofold project – to re-trace the position of the imaginary in Deleuze's writings and also to challenge the dominant reading of the imaginary in Baudry or Heath or Narboni and Comolli as negative fiction, a *false consciousness* that can be contrasted to a cinema of the real.[2]

What is at stake here are the same questions of power that would shape the theoretical discourses of certain kinds of film criticism. David Rodowick would choose to frame this as a film criticism of *political modernism*, 'the expression of a desire to combine semiotic and ideological analysis with the development of an avant-garde aesthetic dedicated to the production of radical social effects' (1994: 1). The *Cahiers du Cinéma* of Jean-Louis Comolli and Jean Narboni is particularly instructive in this respect, as they highlight in their famous editorial the political function of a cinema criticism that much of the world of film theory was to follow. This form of cinema criticism exists to root out the ideologies and ideological functions of the cinematic machine, say Narboni and Comolli, to challenge 'the necessity of reproducing things not as they really are but as they appear when refracted through ideology' (1976: 25). From the perspective of Deleuze's actual/virtual analysis the juxtaposition of an imaginary (ideological) representation to a real representation is problematic, and

exploring this difficulty is clearly Rushton's point. However, we can see how this very form of critical discourse – concerning the power relations through which the cinematic apparatus might address its viewer, the construction of discursive systems, the utilisation of visual media to produce and circulate ideological positions – is not at all alien to our concerns, despite Deleuze's own reluctance to draw from it in any significant detail. We have already addressed the productions of visibilities that our schizoanalysis/visual culture diagram might seek to produce. The cinematographic machine is engaged in the act of *producing* those images that make a people or a world or a system of discourse visible; it serves to actualise what is virtual, to make the possible into something that *is*. This political modernism of cinema criticism that Rushton takes as his starting point had discovered that cinema was producing something of these spaces between the actual forms of the material world, but had drawn from this only an *imagined* real that should be unfavourably contrasted with an actual concrete real. If, following Deleuze, we can show how these imagined forms are no less real than their actualised counterparts, then we can re-order the spaces within this political modernist criticism in order to find that there is something of value in these spaces, that what is not actual must not necessarily be aligned with what is ideological mystification; and this is surely the value of Rushton's work.

The final two essays in this collection, by Patricia Pisters, and William Brown and David Fleming, are more directly concerned with the interrelation of schizoanalysis and visual culture, and return us to the concerns expressed in Buchanan's work and, in particular, to the question of delirium. Buchanan had suggested that delirium should be taken as the basis of a schizoanalytic understanding of visual culture. He utilises Deleuze and Guattari in order to argue that cinema is suited to capturing the movement of madness, and that a schizoanalysis of cinema must seek to explain why this is so (2010: 136–46). If every delirium, as Deleuze and Guattari say, is the investment of a field that is social, economic, political, cultural, racist, pedagogical and religious, then how might we make an analysis of what is delirious about cinema in order to connect Deleuze's cinematic studies to the spaces in which these discourses circulate? If, as Buchanan would suggest, 'Deleuze and Guattari's reconceptualization of delirium as a *regime of signs* can be used to inaugurate a new kind of semiology of the cinema' (2010: 153), then how might we begin to make visible the systems of signs that connect the image to the world itself (and what problems might this help us to solve)?

Patricia Pisters suggests that we can read the contemporary state of cinema and visual culture as modelled by the schizophrenic brain. Clinical schizophrenia, she says, is the degree zero of schizoanalysis, and serves as the basis for a new conceptualisation of cinema that centres on what she calls the *Neuro-Image*, that is, a third image (following on from Deleuze's movement and time images) in which visual culture is determined by Deleuze's third synthesis of time and opens to the future – the spaces of what is possible but is not yet. Contemporary visual culture is a complex system of connections, of electronic signals and binary information, like the schizophrenic 'too much of everything' that Pisters would identify in another essay, the 'fundamental characteristic of the contemporary saturated world where there is always too much (or too little) of everything' (2008: 111). Indeed, Deleuze himself would highlight at the beginning of *Cinema 1* how cinema is ordered in this way, arguing that the visual apparatus of cinema acts like consciousness; that 'the whole cinematic consciousness is not us, the spectator, nor the hero; it is the camera – sometimes human, sometimes inhuman, sometimes superhuman' (2005a: 21). In this way we can begin to analyse how the marks of light that make up our perceptions of cinema and visual culture are organised as a system of thought; how does the visual form a system of discourse? How does it construct and disseminate a field of knowledge? A schizoanalysis of visual culture can help us to see how our own brains might open onto these systems; establishing a connection with those spaces of discourse that are outside of our own synaptic circuits – connecting us to the thought of the outside. 'What is on the screen is delirium in person', says Buchanan, 'what we see is always in somebody's head, and for that reason, it looks and feels real, even when it is not' (2010: 140). The cinematic delirium is not, as the film theorists of political modernism had objected, a falsified or imagined depiction of a real world, it is a fully real part of this world – it is real without being actual. We have seen the emergence of these virtual forms through Berressem and Boljkovac's work and can now draw our lines between Deleuze's projects with more certainty. We can find within the visual 'the feeling of having sensed something that does not belong to this world [...] something that can only be sensed, that cannot be put into words' (Buchanan 2010: 137). This is why Pisters had chosen to invert Comolli's statement that cinema is a machine of the visible; the cinematic apparatus and the systems of visual culture are, rather, *machines of the invisible* (2008: 113). They are systems that serve to make visible the virtual relations that lie beneath the surface of the actual forms of visual culture.

Brown and Fleming, in an insightful reading of *Fight Club*, attempt to trace the emergence of these virtualities even within a mainstream Hollywood blockbuster. What potentials for deterritorialisation might occur even in contemporary cinema of this sort, they ask? And furthermore, could it be argued that Deleuze himself has underestimated such potential in modern Hollywood? Or could we alternatively (or concurrently) suggest that schizoanalysis itself, to the extent that we can now find it in 'mainstream' cinematic forms, might have reterritorialised onto the imagined spaces of those same ideological discourses? We might also ask Brown and Fleming whether the same deterritorialisations, these same departures from the actual textures of light that make up our perceptions of cinema into the forces of the virtual, can be found in Coca-Cola commercials or in video games or what we might consider the everyday manifestations of visual culture. We might question whether these forms of images might construct, as Brown and Fleming suggest (following a 2009 article by Rushton), an image-viewer assemblage in which the spectator might connect with the systems of thought that visual culture composes, in order to constitute a new form of consciousness. If the systems of visual culture that we are attempting to open Deleuze's thinking towards might form a *contagious set of ideas*, then we shall need to consider how the formation and circulation of these ideas might be articulated by a schizoanalysis of visual culture. There is clearly much work to be done in this respect, but what I would like to suggest is that these final two essays might in some way help us to further illuminate this connection (between the image and the world; between cinema and delirium; between Deleuze's two projects) and in doing so, help us draw out these same connections in each of the other essays in this collection.

My own necessarily idiosyncratic readings should, I hope, help to sketch out a preliminary sense of how each of these essays relates to the development of a schizoanalysis of visual culture and how each of them might help us to sketch out some of the spaces that were left blank in the systems that make up Deleuze's own work. Doubtless there are other spaces within this volume that we have not explored; forces within each system of thought that we have not yet made visible. A schizoanalysis of visual culture is surely more complex and more open than we could have possibly done justice to here, and I have no doubt that the following essays will only serve to demonstrate this; to show what is not yet visible, but nonetheless present in Deleuze's thought; to find new spaces within this thought and set their little machines to work.

Notes

1. See Solanas and Getino's 1971 article 'Towards a Third Cinema' and Peter Wollen's 'Godard and Counter Cinema: *Vent d'Est*' from 1972, both of which can be found in Bill Nichols's extremely useful *Movies and Methods* collection.
2. See Baudry's 'Ideological Effects of the Basic Cinematographic Apparatus' from 1970 and Comolli and Narboni's 1971 'Cinema/Ideology/Criticism', both available in *Movies and Methods*, and also Stephen Heath's *Questions of Cinema* from 1981.

References

Baudry, Jean-Louis (1985) 'Ideological Effects of the Basic Cinematographic Apparatus', trans. Alan Williams, in Bill Nichols (ed.), *Movies and Methods Volume II: An Anthology*, Berkeley, Los Angeles and London: University of California Press, pp. 531–42.

Buchanan, Ian (2008) 'Five Theses of Actually Existing Schizoanalysis of Cinema', in Ian Buchanan and Patricia MacCormack (eds), *Deleuze and the Schizoanalysis of Cinema*, London and New York: Continuum, pp. 1–14.

Buchanan, Ian (2010) 'Is a Schizoanalysis of Cinema Possible?', in D. N. Rodowick (ed.), *Afterimages of Gilles Deleuze's Film Philosophy*, Minneapolis and London: University of Minnesota Press, pp. 135–56.

Comolli, Jean-Louis and Jean Narboni (1976) 'Cinema/Ideology/Criticism', trans. Susan Bennett, in Bill Nichols (ed.), *Movies and Methods Volume I: An Anthology*, Berkeley, Los Angeles and London: University of California Press, pp. 22–30.

Conley, Tom (2009) '*The 39 Steps* and the Mental Map of Classical Cinema', in Martin Dodge, Rob Kitchin and Chris Perkins (eds), *Rethinking Maps: New Frontiers in Cartographic Theory*, New York: Routledge, pp. 131–48.

Debord, Guy (2009) *Society of the Spectacle*, trans. Ken Knabb, Eastbourne: Soul Bay Press.

Deleuze, Gilles (2005a) *Cinema 1: The Movement Image*, trans. Hugh Tomlinson and Barbara Habberjam, New York and London: Continuum.

Deleuze, Gilles (2005b) *Cinema 2: The Time Image*, trans. Hugh Tomlinson and Robert Galeta, New York and London: Continuum.

Deleuze, G (2006) *Foucault*, trans. Seán Hand, New York and London: Continuum.

Deleuze, Gilles and Félix Guattari (1986) *Kafka: Towards a Minor Literature*, trans. Dana Polan, Minneapolis and London: University of Minnesota Press.

Deleuze, Gilles and Félix Guattari (2004a) *Anti-Oedipus: Capitalism and Schizophrenia*, trans. Robert Hurley, Mark Seem and Helen R. Lane, New York and London: Continuum.

Deleuze, Gilles and Félix Guattari (2004b) *A Thousand Plateaus: Capitalism and Schizophrenia*, trans. Brian Massumi, New York and London: Continuum.

Heath, Stephen (1981) *Questions of Cinema*, London: Macmillan.

Pisters, Patricia (2008) 'Delirium Cinema or Machines of the Invisible?', in Ian Buchanan and Patricia MacCormack (eds), *Deleuze and the Schizoanalysis of Cinema*, London and New York: Continuum, pp. 102–15.

Rodowick, D. N. (1994) *The Crisis of Political Modernism: Criticism and Ideology in Contemporary Film Theory*, Berkeley, Los Angeles and London: University of California Press.

Ropars-Wuilleumier, Marie-Claire (2010) 'Image or Time? The Thought of the Outside in *The Time-Image* (Deleuze and Blanchot)', trans. Mathew Lazen and D. N. Rodowick, in D. N. Rodowick (ed.), *Afterimages of Gilles Deleuze's Film Philosophy*, Minneapolis and London: University of Minnesota Press, pp. 15–30.

Rushton, Richard (2009) 'Deleuzian Spectatorship', *Screen*, 50:1, pp. 45–53.

Solanas, Fernando and Octavio Getino (1976) 'Towards a Third Cinema', in Bill Nichols (ed.), *Movies and Methods Volume I: An Anthology*, Berkeley, Los Angeles and London: University of California Press, pp. 44–64.

Wollen, Peter (1985) 'Godard and Counter Cinema: *Vent d'Est*', in Bill Nichols (ed.), *Movies and Methods Volume II: An Anthology*, Berkeley, Los Angeles and London: University of California Press, pp. 500–9.

Deleuze and the Filmic Diagram

Tom Conley Harvard University

Abstract

This article aims to consider how the 'diagram' or 'little machine' is integral to the dissociative, at once polyvocal and polymorphous *writing* that marks the work of Blanchot and that, in turn, informs the disjunctive – hence critical and productive – operation within the register of Deleuze's writings on cinema. I shall consider a number of Deleuze's 'keywords' or recurring formulas *as* diagrams, that is, as intermediate configurations at once visual and lexical, in order to show how, like rebuses or ideograms, they form collisions and ruptures of voice and graphic form, in order to bring forward the 'outside' of thought – what cannot be put into language yet is conveyed in language.

Keywords: Blanchot, diagram, schizoanalysis, cartography, cinema

'Is a Schizoanalysis of Cinema Possible?' In the response to the question he poses in the title of his probing essay on Deleuze and film, Ian Buchanan argues that over the course of the author's work 'specific words and images' or 'diagrams' function 'in the manner of little machines' according to the context in which they are deployed (Deleuze 2010: 136).[1] Pertinent to one situation, then to another, and then to another yet again, diagrams migrate back and forth across the writing. They find optimum effect, he adds, in the reading of films, an operative process that applies to these various contexts. Buchanan suggests that what Deleuze *does with* film figures in a broadly based and highly effective political aesthetics. Neither holistic, reductive nor of thematic orientation, his reflections work towards a tactics of 'reading' cinema that draws on Deleuze's repeated insistence that film is a medium of simultaneously visual and lexical virtue. It is one that needs to be seen

Deleuze Studies 5.2 (2011): 163–176
DOI: 10.3366/dls.2011.0016
© Edinburgh University Press
www.eupjournals.com/dls

and read in the same cognitive gesture. Right from the outset of *L'Image-mouvement*, writing of the rarefaction or saturation of the cinematic surface within the borders of the frame, Deleuze remarks that 'l'image ne se donne pas seulement à voir. Elle est lisible autant que visible' (the image is given not solely to be seen. It is as much legible as it is visible) (Deleuze 1983: 24).[2] And at the end of *L'Image-temps* he underscores how much 'la division du visuel et du sonore' (the division of sight and sound) helps us to see where the aesthetics and politics of film are interwoven (Deleuze 1985: 352). The diagram becomes ubiquitous. Modern cinema, he notes elsewhere, having killed the flashback, imposes a dissociation of sound images from visual images (364).

We begin to see how the identity, difference and repetition of the reciprocal identity of seeing and reading ramifies throughout the oeuvre. Such may be the cinematic diagram to which Buchanan refers. It is studied on similar grounds but from a different angle in 'Image or Time? The Thought of the Outside in *The Time-Image* (Deleuze and Blanchot)', Marie-Claire Ropars-Wuilleumier's epochal reading of the ways that Blanchot intervenes, alters and occasionally subverts what, at their outset, Deleuze had called the taxonomical and philosophical project of the two volumes.[3] Blanchot's reflections on the *dehors* or the 'outside' – a space beyond meaning or that cannot be put in words or that resists all ideation, she argued, bear directly on Deleuze's appreciation of cinema that confronts an 'outside' and an 'inside' independently of any spatial and temporal distance or interval. Thanks to Blanchot, his is a concept of cinema where 'thinking outside of itself' broaches the *impensée* or 'unthought' within *la pensée* or 'thought' itself. By way of Blanchot the project aimed at offering a 'tableau' or gridded picture, quite possibly a large-scale diagram of cinema is thrown awry. Thanks to the author of *L'Entretien infini* (The Infinite Conversation), cinema reflects on the limits of thinking wherever there is 'the absolute contact of an outside and inside that are infinite [*non-totalisables*], asymmetrical [*asymétriques*]', or the presence of what Deleuze calls an 'autonomous outside that is necessarily given as an inside' (1985: 363). As Ropars-Wuilleumier puts it succinctly, 'Suddenly appearing in an analytical detour, Blanchot's [force of] attraction quickens the strangeness of a Deleuzian text that does not follow its own declared program – thought-cinema – in taking the risk of letting thought escape the conceptual frame to which it attends' (2010: 28; translation slightly modified).

The paragraphs that follow seek to discern some of the affinities of Buchanan's and Ropars-Wuilleumier's readings in order to consider how the 'diagram' or 'little machine' is integral to the dissociative,

at once polyvocal and polymorphous *writing* that marks the work of Blanchot and that, in turn, informs the disjunctive – hence critical and productive – operation within the register of Deleuze's reflections on cinema. A working hypothesis is that recurring words, stylistic turns and the contours of various formulas pose creative obstacles to the formulation of concepts. As a corollary, they become quasi-cinematic 'icons' or filmic shapes where writing and cinema are of the same meddle. These icons bring together, in an oft-repeated *rupture de contact* – the formula is Blanchot's – philosophy, cinema and poetry. When they are embroiled in what Buchanan calls Deleuze's political aesthetics, they become especially operative.

For that end I shall consider a number of Deleuze's 'keywords' or recurring formulas *as* diagrams, that is, as intermediate configurations at once visual and lexical; that to a degree are what elsewhere, in his study of Francis Bacon, he calls 'an operative set of asignifying and nonrepresentative lines and zones', for what concerns painting, 'traits and color patches' that 'unlock areas of sensation'. The diagram is abstract in nature, and it is even a ordering of chaos, 'a catastrophe', but also the germ of rhythm, a violent disorder in respect to figuration (Deleuze 2003: 83). The diagram also belongs to a deeply embedded poetic tradition in which, like rebuses or ideograms, collisions and rupture of voice and graphic form, it brings forward the 'outside' of thought – that is, what cannot be put into language yet is conveyed in language.[4]

Ropars-Wuilleumier had shown that Blanchot offers a model for a cinematic writing of the 'limit' or 'outside', suggesting also that his 'Parler, ce n'est pas voir' may be the one essay in *L'Entretien infini* best informing the film theory. To see how it will suffice, first, we need to examine how it figures in Ropars-Wuilleumier's reading before, second, it can be studied in its own placement or *disposition* (in the loose but carefully designed order of Blanchot's work). For this purpose it is useful to determine how 'Parler, ce n'est pas voir' inflects the composition of *L'Entretien infini* from its own intermediate stage, in proof-form, to its final published version in 1969.[5] Keynote is to see how it 'works' as a 'zone' in a set of essays that owe their force more, as Blanchot elsewhere in the volume remarks of the poetry of René Char, to juxtaposition than to composition: therein are perhaps some of the elements of Deleuze's own film-writing.

At the end of *Cinéma 2* Deleuze asserts how a 'new time-image' locates visibility between the visual and the auditory' (360–4 and *passim*). He discerns a visibility of the invisible that is countenanced

in the texture of 'Parler, ce n'est pas voir', the essay that, according to Ropars-Wuilleumier, Deleuze radically 'inverts into a "to not speak (or a speaking at the limits of sound)" ' (2010: 18). Deleuze negates Blanchot's critique of vision that inheres in speech while calling 'into question the possibility of seeing the visible' (ibid.). The force of attraction of what Blanchot calls the 'outside' *dislocates* or estranges speakers or viewers from stable points of reference in their milieus. In her words, 'the outside obstructs the interiority of the inside and removes all spatial anchoring from exteriority itself' (19). In Blanchot's essay 'presence', what would be part and parcel of the 'present' of time and space assumed to be here and now, is shown to be outside or exterior to itself. Ropars-Wuilleumier, in establishing a threshold for her reading, further specifies the nature of Deleuze's understanding of Blanchot that emerges from his *Foucault* (1986). Quite possibly 'Deleuze has barely read Blanchot because he distorts his terms, does not retain what concerns time, and rejects the radical logic that places ontology into question' (ibid.): because in the *Foucault* that immediately follows *L'Image-temps* in 1986, Deleuze deploys the distinction of discursive and visible formations to sustain the hypothesis, gained from cinema, that the visible is irreducible to language (21). The dialogue with Foucault further allows him to develop fresh speculation about the nature of a 'diagram'. Via Foucault, Blanchot's outside is marshalled to show how an open-ended play of *force* emerges from the circumscriptions of *form*. 'L'histoire des formes, archive, est doublée d'un devenir des forces, diagramme' (the history of forms, the archive, is doubled by a becoming of forces, a diagram) (Deleuze 1986: 51, cited by Ropars-Wuilleumier 2010: 21).[6] History, taken to be an archive, is a recognisable architecture (*form*) whereas the diagram that both duplicates and exceeds the latter is an open and not entirely predictable 'becoming' (*force*).[7] It also draws the 'outside' into a welter of maps and issues of mapping. A diagram is at once a map and layering of maps superimposed upon one another from which an implied 'stratigraphy' is availed to the reader or archaeologist whose eyes move across them, one stratum over another, in order to discern where forces might be vectored from given coordinates in the archive or geology of 'forms' in which they seem to be concealed. From diagrams a regime of creativity, mutation and resistance becomes possible. Deleuze's recrafting of Blanchot through Foucault allows him to turn cinema into a map of becoming, or at least a medium endowed with potential of the kind suggested in the infinite substantive that is *le devenir*.[8] Telescoping Ropars-Wuilleumier's argument, we might say that a cautiously open-ended 'becoming' is identified with cinema, and

as a result the medium can be thought of in the manner of the 'new cartography' that Foucault is shown fashioning in the pragmatics of theory undergirding his archaeology and history.

The theoretical potential of the seventh art – the infinite possibility of its substance – is obtained circuitously. By diverse means coming to a same end, 'Parler, ce n'est voir' allows Deleuze to have the medium reach the limits of what can be seen and what can be heard. The outside is affiliated with off-screen space and voice-*off*, which can suggest disembodiment, and at the same time it can be suggestive of things whole or total. Using Bresson as Blanchot's double, Deleuze cites the filmmaker's *Notes sur le cinématographe* to affirm how a principle of non-coincidence or difference operates in cinema. 'Lorsqu'un son peut supprimer une image, supprimer l'image ou la neutraliser' (when a sound can suppress an image, suppress the image or neutralise it), it happens that 'le sonore sous toutes ses formes vient peupler le hors-champ de l'image visuelle, et s'accomplit d'autant plus en ce sens comme composante de cette image' (sound in all of its forms begins to populate the off-screen space of the visual image, and it is realised all the more in this way as a component of this image) (cited in Deleuze 1985: 306). Taking Ropars-Wuilleumier's reading along a different path, we might say that the essay becomes a 'passe-partout' or skeleton key that opens the door to the 'outside' and that remains a map for cinematic itineraries by which the viewer gains access to its threshold.

It suffices to discern the way that 'Parler, ce n'est pas voir' *becomes* what it is in the 'superimposition of maps' visible in the production of *L'Entretien infini* – specifically, in the relation of the page proofs of the book to its final printed form. By and large changes to this essay are minimal. Some of the spaces between the words are tightened or opened, and at others a comma and a colon are either inserted or removed. The shift of the force of the text in the whole or *tout* of the volume is found elsewhere, notably at the edge between the 'inside' and 'outside' of the book itself, in the paratextual matter of the cover, the initial page of five epigraphs (v). In addition, a prefatory note (vi–viii) serves as an introduction to the open-ended aspect of forty chapters, parsed into three sections ('La Parole plurielle', subtitled [between parentheses] 'parole d'écriture' (1–118); 'L'Expérience-limite' (119–420); 'L'Absence de livre', also bearing a subtitle title in parenthesis '(le neutre le fragmentaire)' (421–636). A short postface (637) that initially is a typescript insert in the proofs indicates that the author would like the 'moving, articulated-inarticulated' relation of the book to its play of form (what Blanchot admires in René Char) bear witness to items,

written from 1953 to 1965, that are more operative when remaining undated in the gist of the book itself. The absence of chronological markers seems to explain that the author holds 'them to be already posthumous' and shows why he is led 'to look at them as almost anonymous' (637). As the writings become more remote their author slowly disappears into the collective murmur of the language that conveys them. The writings

> [t]hus belong to everyone [*tous*], and [are] even written and always written, not by one alone, but by several, by all those for whom it is incumbent to maintain [*maintenir*] and to prolong the exigency to which I believe that these texts, with an obstinacy that today astonishes me, have ceaselessly sought to respond, up to the *absence of the book* that they designate in vain. (Ibid.)

These final words appear to confirm the reason why the author takes care to remove from the title page a parenthetical subtitle, '(recherches)' (searchings) set below *L'Entretien infini*, the title printed in appreciably higher case. What began in the name of 'recherches' in the proofs is now bereft of direction or of a projective geography of investigation. Or perhaps, faithful to the destiny of chance, any association with the famous epigraph that André Malraux once used for his psychological history of art might be avoided: Picasso's dictum (that Lacan elsewhere cited), 'je trouve mais je ne cherche pas' (I find but I do not seek). It can be inferred that research or repeated action of inquiry, what 'Parler, ce n'est pas voir' so stridently calls a *crisis*, need not be signalled from the title page but, rather, merely lost and 'found' (*trouvé*) when the reader proceeds by chance or ... happens to discover in stumbling upon the chapter. Thus the incipit of the essay-dialogue responds to what has been erased:

<div align="center">III</div>

Parler, ce n'est pas voir
« Je voudrais savoir ce que vous cherchez.

- Je voudrais le savoir aussi. Cette ignorance n'est-elle pas désinvolte?
- Je crains qu'elle ne soit présomptueuse. Nous sommes toujours prêts à nous croire destinés à ce que nous cherchons, par un rapport plus intime, plus important que le savoir. Le savoir efface celui qui sait. La passion désintéressée, la modestie, l'invisibilité, voilà ce que nous risquons de perdre en ne sachant pas seulement. » (35)

(I want to know what you're searching for.

- I would also like to know. Isn't this unawareness slightly offhand?

– I fear that it might be presumptuous. We're always ready to believe ourselves destined to find what we're seeking, through a more intimate relation, more important than knowledge. Knowledge effaces he or she who knows. Disinterested passion, modesty, invisibility; that's what we risk losing solely in not knowing.')

In the imaginary filigree drawn between the title and the text, *pas voir*, not to see, gives the reader to see – to see the visual echo of *savoir* as both verb and infinitive substantive. The two corresponding voices are *seen voice-off* or disembodied in the dialogical form in which they are cast. What one of the voices notes as our believing in being destined to find what we seek through a 'relation more important than knowledge' may be what the erasure of the subtitle to the book makes clear. When '(recherches)' vanishes in the transformation from proof to book the reader beholds an evanescing voice from which any sign of a search for certitude fades away. Or: *Voir, ce n'est pas sa...voir?* Perhaps in the way that the text makes *voir* and *savoir* become echoes of each other encodes Freud's *ça* and Mallarmé's *là,* the unknowable force and place (or musical note) of what cannot be named, and at the same time, *sa,* the acronym of the terror of absolute knowledge, of what the next shard of dialogue calls 'la terrible flamme du savoir absolu' (the terrible flame of absolute knowledge) (34).

Reflection on searching turns to its contrary in finding, and therein the dialogue accrues even greater potential force. The second (or another) voice notes that '[il] y a ceux qui cherchent en vue de trouver, même sachant qu'ils trouveront presque nécessairement autre chose que ce qu'ils cherchent' (there are those who seek in view of finding, even knowing that they will almost by force find something other than what they seek) (ibid.). The remark prompts the interlocutor to reflect on the etymology of *trouver* without (or before) considering the form of the verb in its visual aspect:

– Je me rappelle que le mot trouver ne signifie d'abord nullement trouver, au sens du résultat pratique ou scientifique. Trouver, c'est tourner, faire le tour, aller autour. Trouver un chant, c'est tourner le mouvement mélodique, le faire tourner. Ici nulle idée de but, encore moins d'arrêt. Trouver est presque exactement le même mot que chercher, lequel dit: 'faire le tour de'. (35–6)

(I recall that the word to find doesn't first of all mean to find, in the sense of a practical or scientific result. To find is to turn about, go around, do a tourney. Here no idea of a goal, even less of arrest. To find is almost exactly the same word as to search, which means: to go around.)

The reader cannot fail to see the transcribed words of the speaking voice veering towards a musical appreciation of *trouver* and towards, too, the sense of an eternal repetition and return. Yet the remark leads to further reflection on the cinegraphic disposition of the verb. The voice utters, 'Trouver, c'est chercher par le rapport au centre qui est proprement introuvable' (To find is to search by way of the relation to the centre that cannot be found) (36). Seasoned readers of Blanchot recall that the epigraph to *L'Espace littéraire* (1955) asserted that no matter how fragmentary its composition may be, a book will betray a movement to and away from an imaginary centre, and that here too a geography of centre and circumference may be defining the space of the work before the reader's eyes.[9] But it also draws attention, in the gloss of the words when they are seen and heard in their montage, in accord with the sound- and image-tracks of writing, to *force* emanating from verbal *form*. In *trouver* the visual axis is the vowel *ou*, the homonym of *où*, or (*ou*) the 'where' about which *trouver* is said to turn. Or is the unconscious or unknown the *trou*, the hole or abyss written into the word? Can it be said that the troping, the *ver(s) où* that caps the word is also what opens it, leaves it *ouver(t)*, at the edge of a space 'outside' or beyond the bounds of meaning? Like what is seen in the erasure of *recherche* from the title page, the play about and around *trouver* indicates that the word is a diagram, a 'little machine', indeed a miniature map of forces that come forwards from the aural and visual matter embedded in its form.

The end of the essay may be a return to its beginning. But for a first and only time in the reflection does the abstraction of the movement find in the words what might be called a totemic echo:

« – Voilà donc à nouveau la bizarrerie de ce tour vers … qu'est le détour. Qui veut avancer, doit se détourner, cela fait une curieuse marche d'écrevisse. Ce serait aussi le mouvement de la recherche?
– Toute recherche est une crise. Ce qui est cherché n'est rien que le tour de la recherche qui donne lieu à la crise: le tour critique.
– Cela est désespérément abstrait.
– Pourquoi? Je dirais même que toute oeuvre littéraire importante l'est d'autant plus qu'elle met en oeuvre plus directement et plus purement le sens de ce tournant, lequel, au moment où elle va émerger, la fait étrangement basculer, oeuvre où se retient, comme son centre toujours décentré, le désoeuvrement: l'absence de l'oeuvre.
– L'absence d'oeuvre est l'autre nom de la folie.
– L'absence d'oeuvre où cesse le discours pour que vienne, hors parole, hors langage, le mouvement d'écrire sous l'attrait du dehors. » (45)

(Thus once again the strangeness of this turn towards ... which is the detour. Whoever wants to advance has to turn away, and that makes for the curious movement of a crayfish. Wouldn't that also be the movement of research?
– All research is a crisis. What is sought is nothing other than the turning of research that gives way to the crisis: the critical turn.
– That's terribly abstract.
– Why? I'd even say that every important literary work is all the more so when it engages more directly and with greater purity the sense of this turning which, at the moment the work is about to emerge, uncannily causes it to teeter-totter, a work in which is held, like its ever off-centred centre, an idleness: the absence of the work.
– Absence of the work is another name for madness.
– Absence of the work in which discourse ceases so that there may come, outside of speech, outside of language, the movement of writing under the attraction of the outside.)

Whoever 'searches' only 'finds' when going about and around, or else backwards, in tracing an itinerary marking the path of a 'crisis' drawn about or from an unknown point of a moving axis. When one of the voices remarks that the movement goes 'like a crayfish', the image of the crustacean comes forwards in order no sooner to disappear. Its very name, *écrevisse*, anticipates the event of a *crise* that inheres in the intransitively critical and poetic operation of writing, as it is being suggested here, which is part and parcel of the seeing, reading and hearing that comprise the labour of cinema. Given that Blanchot writes within a tradition that reaches back to the Troubadours and the Trouvères, if it is licit to recall a *rondeau* by past master Clément Marot, the crayfish can be taken as a totem of the outside, of the occupant of a space at the edge of the world in so far as its etymon and its aspect recall the *crevice* or 'edge' or gap in the world.[10] For the poet and for Blanchot, *écrevisse* belongs to the complex tracking of *écriture*, of writing. Here the image of a fresh-water crustacean skipping along the bottom of a riverbed might be related to *ciné-écriture*. The crayfish is at once a *festina lente*, the subject of a latent blazon or emblem-poem, but crucially it is also a homonym of the imperfect subjunctive of *écrire*. The pun allows the crayfish to be assimilated into what *might have been written* ... completely backwards.

By now it is clear that the gist of Blanchot's reflection 'turns' on seeing and reading at once at the edge or in the crevice of a divide between speaking and seeing. Writing, which in Deleuze's reading of Blanchot is tantamount to cinema itself, becomes what the first section

of *L'Entretien infini* calls 'La Parole plurielle', a plural and complex force of image and language perceived in the drift of sight and sound.

Thus it may be that the 'diagram' which describes cinema in much of *L'Image-temps* is found in the poetic register of the essay to which Deleuze turns and returns in his reflections on the 'components' (*composantes*) of the cinematic image at the end of *L'Image-temps*. To thematise or to make abstraction of Deleuze's film-writing might betray the force of the 'mapping' or of the *diagram* that inheres in its form. The writing bodies forth what might be called *la pensée de l'image* – the thought in and of the image – insofar as the moments where the writing turns about or 'seeks' itself in its own image is seen and heard *moving* and *becoming*, by virtue of the essay to which he so often refers, a writing imbued with cinema.[11]

By way of afterthought it is productive to return to the moment in *Cinéma 2* where Deleuze anticipates what he will note in *Foucault* about a diagram being a map of 'becoming' that doubles the archive from which it emerges and never entirely gets detached. Deleuze observes that Alain Resnais exhibits in his preparatory sketches for his features a taste for a 'detailed cartography of the places' that his characters frequent and the itineraries they take. His is 'un *établissement de véritables diagrammes*' (an *establishment of veritable diagrams*) (158; stress added) in which the sight and sound of 'establishment' are reminiscent of a Baroque *table* of figures on a landscape or in a garden like that of *Last Year at Marienbad*.[12] The diagram is 'l'ensemble des transformations d'un continuum, l'empilement des strates ou la superposition des nappes coexistantes. Les cartes et les diagrammes subsistent donc comme parties intégrantes du film' (the total array of the transformation of a continuum, the piling of strata or the superimposition of coexisting sheets [of time]. Maps and diagrams thus subsist as the integrating parts of the film) (ibid.). There results a mental or cerebral cartography where a given sheet (*nappe*) of the past causes a distinction of functions to correspond and an arrangement of objects: it is in this play of surfaces where *writing*, the writing of the kind affiliated with Blanchot and Deleuze's preferred poets (Mallarmé, Melville, Michaux and perhaps Marot) takes place through its identification with cinema.

Deleuze underscores the point in a sudden reflection where reading and seeing, *lire* and *voir*, bear for an instant on the *very creation of the film book before our eyes*:

Il se peut que, quand nous *lisons* un livre, *regardons* un spectacle ou un tableau, et *à plus forte raison quand nous sommes nous-mêmes auteur* [...]:

nous constituons une nappe de transformation qui invente une sorte de continuité ou de communication transversales entre plusieurs nappes, et tisse entre elles un ensemble de relations non-localisables. (161–2; stress added)

(It may be that when we read a book, look at a spectacle or a painting, and even more strongly when we are ourselves [its] author [...]: we constitute a sheet of transformation that invents a kind of transversal continuity or connection among several sheets, and weaves among them an array of relations that cannot be located.)

The invocation of the 'we' – Deleuze *with* his interlocutors – as plural *author* spins off the art of seeing and reading. When we study cinema we produce and lose ourselves creatively in our relation with the medium and our memories of it, surely and clearly, but we also find ourselves by dint of gaining our bearings, by turning about and around in the midst of the multifarious signs, crevices, corners, edges and transformative sites of our own writing. The cinematic diagram would be the 'little machine' that plots and enables critical transformation. When Deleuze notes that we are their 'author' he joins the parade of *auteurs*, the great filmmakers, who think by writing with images. Can we assume that through his manner of thinking and writing he counts, as he notes in the last sentences of *Cinéma 2*, among 'les grands auteurs de cinéma [qui] sont comme les grands peintres ou les grands musiciens: c'est eux qui parlent le mieux de ce qu'ils font' (the great cinema auteurs [who] are like great painters or great musicians: it is they who best speak about their work) (366). Close reading tells us that the answer is affirmative.

Notes

1. 'Doing with' is indeed one of these 'specific words and images' or diagrams that would align Buchanan's Deleuze with his readings of the cultural criticism of Michel de Certeau, an author for whom what a reader 'does with' an issue belongs to a tactical operation. See Certeau 1975.
2. Here and elsewhere all translations from the French are mine.
3. 'Cette étude n'est pas une histoire du cinéma. C'est une taxinomie, un essai de classification des images et des signes' (This study is not a history of cinema. It is a taxonomy, an essay on the classification of images and of signs) (Deleuze 1983: 7).
4. In *The Culture of Diagram*, John Bender and Michael Marrinan provide a theoretical history of the first magnitude. For them the parabola of the diagram, 'a working object' (197) begins from the relation of image and text on the white surface of the pages of Diderot and D'Alembert's *Encyclopédie*. The space of the page becomes the ground of the correlation of words and images. The authors show how the visual and aural dimension of the philosophers' diagram and its claim to embracing an opened-ended totality give way to mathematical configurations that lead it to quasi-pure abstraction, far from visible forms, that

we now find in digital media. Although cinema remains outside of its bounds, their work on the 'diagram' serves as a backdrop for what follows.

5. The proof copy of *L'Entretien infini* is now in the Harvard Houghton Library (ms. Fr 794). Most of the major emendations – mostly additions – are found in typescript pages folded and placed between the folios where they are inserted. Now and again manuscript annotations are in the margins of the proofs themselves.

6. In English translation: 'forces are in a perpetual state of becoming [*devenir*], there is a becoming [*devenir*] of forces that doubles history.' For this reader, the translation loses sight of the points of reference and contention in the essay from which the words are taken.

7. By way of Foucault Deleuze rehearses the play of form and force that Derrida had set forward in 'Force et signification', the inaugural essay of *L'Ecriture et la différence* (1967). Originally published as a book review of Jean Rousset's *Forme et signification* (Paris: José Corti, circa 1962), the substitution of one letter in place of the other becomes a play of sight and sound (*c* in lieu of *m*) indicating a proclivity for 'play' or 'becoming' that opens the closed confines of a structure. The resemblance of *force* (that Derrida later turns towards *fors* and its cognate meanings) to *forme* varies on the famous relation he establishes between *différance* and *différence*.

8. In the French poetic tradition the infinite substantive is often deployed to call attention to the potential force that can be released or detonated when *res* becomes *verba*, that is, when it is conjugated into action or when the entity is 'cracked open'. The past master of the infinite substantive is Maurice Scève, in his *Délie* (Lyons, 1544). One of the most celebrated *dizains* of the work (the 77th of an arcane sum of 449) associates the poet with Prometheus. The incipit reads, '*Au Caucasus de mon souffrir lyé*' (On the Caucasus of my suffering [I am] bound), in which *souffrir*, an element of the author's own device (*souffrir non souffrir*) suggests infinite suffering in place of the name of the Titan god, chained to the rocky summit of Mount Caucasus, whose liver a vulture forever consumes. Gisèle Mathieu-Castellani studies the force of the formula in her contribution to Nash (ed.), *A Scève Celebration: 'Délie' 1544–1994* (1994).

9. 'Un livre, même fragmentaire, a un centre qui l'attire: centre non pas fixe, mais qui se déplace par la pression du livre et les circonstances de sa composition. [...] Celui qui écrit le livre l'écrit par désir, par ignorance de ce centre' (A book, even fragmentary, has a centre to which it is attracted: not a fixed centre, but that moves according to the pressure of the book and the circumstances of its composition) (5). Blanchot notes that the centre of *L'Espace littéraire* would be the essay on 'The Gaze of Orpheus', in other words, a musical body shown seeing what blinds it.

10. Blanchot treats it moreover in the way that a great former poet, Clément Marot, had done in the fitting form of a *rondeau*, a diminutive, machine-like poem that turns about in order to retrieve and lose itself in its form:

> Tout au rebours (dont convient que languisse)
> Vient mon vouloir, car de bon cueur vous veisse
> Et je ne puis par devers vous aller.
> Chante qui veult, balle qui veult baller,
> Ce seul plaisir seullement je voulsisse,
> Et s'on me dit qu'il faut que je choisisse
> De par deça dame qui m'esiouysse,
> Je ne sçauroys me tenir de parler,
> Tout au rebours.

Si responds franc, J'ay dame sans nulle vice
Aultre en aura en amours mon service
Je la desire & souhaitte voller
Pour l'aller veoir, & pour nous consoler
Mais mes souhaictz vont comme l'escreuice,
 Tout au rebours.

(Always backwards (and it is fitting that I languish)
Comes my desire, for had I seen you with a keen heart
I could never dare to go before you.
Sing who may sing, dance who may dance,
I would wish solely for this pleasure,/And if they
 say that I must choose,
Here or about a lady who affords me bliss,/I could
 do no more than speak
 Always backwards.
Were I to respond frankly, I have
 a lady without any vice
Another will have in love my service,
I desire her and dream of flying
Off to see her, and to console ourselves,
But my dreams go like the crayfish,
 Always backwards.)

in Clément Marot, *Oeuvres complètes 1*, ed. François
Rigolot (Paris: Garnier/Flammarion, 2007) 134.

Following Guy de Terverant, Rigolot notes that the crayfish had symbolised 'contrary fortune'. Noteworthy is that *languisse* (languish) belongs to the same register because of the pun on *langue isse* (language seen issuing forth).

11. *La pensée de l'image* is also, pertinently, the title of a collection of essays (edited by Mathieu-Castellani) in which conflations of the written image and the thoughts it provokes are taken up in essays on Claudel, Deleuze, Melville and a host of others.

12. In the first paragraph of the third chapter of *Le Pli: Leibniz et le baroque* (1988), Deleuze takes care to note that the baroque is characterised by a flat surface on which tables and figures, indeed mathematical formulas, are written. In contrast to the idea of a painting that is a window on the world he proposes the 'table' to which, here, *établissement* seems related.

References

Bender, John and Michael Marrinan (2010) *The Culture of Diagram*, Stanford, CA: Stanford University Press.

Blanchot, Maurice (1955) *L'Espace littéraire*, Paris: Gallimard.

Certeau, Michel de (1975) 'Ce que Freud fait de l'histoire' (What Freud does with history), chapter 9 of *L'Ecriture de l'histoire*, Paris: Gallimard; in English (1992) as *The Writing of History*, New York: Columbia University Press.

Deleuze, Gilles (1983) *Cinéma 1: L'Image-mouvement*, Paris: Éditions de Minuit.

Deleuze, Gilles (1985) *Cinéma 2: L'Image-temps*, Paris: Éditions de Minuit.

Deleuze, Gilles (1986) *Foucault*, Paris: Éditions de Minuit.

Deleuze, Gilles (1988) *Le Pli: Leibniz et le baroque*, Paris: Éditions de Minuit.

Deleuze, Gilles (2003) *Francis Bacon: The Logic of Sensation*, Minneapolis: University of Minnesota Press.

Deleuze, Gilles (2010) 'Is a Schizoanalysis of Cinema Possible?', in D. N. Rodowick (ed.), *Afterimages of Gilles Deleuze's Film Philosophy*, Minneapolis: University of Minnesota Press.

Derrida, Jacques (1967) 'Force et signification', in *L'Ecriture et la différence*, Paris: Editions du Seuil.

Mathieu-Castellani, Gisèle (1994) in Jerry C. Nash (ed.), *A Scève Celebration: 'Délie' 1544–1994*. Stanford French and Italian Studies 77. Stanford, CA: Anma Libri.

Mathieu-Castellani Gisèle (ed.), (1993) *La pensée de l'image*, Paris: Editions de l'Université de Paris-VIII/Vincennes à Saint-Denis.

Ropars-Wuilleumier, Marie-Claire (2010) 'Image or Time? The Thought of the Outside in *The Time-Image* (Deleuze and Blanchot)', in David Rodowick (ed.), *Aftereffects: Gilles Deleuze and the Philosophy of Cinema*, Minneapolis: University of Minnesota Press, 2010.

Actual Image | Virtual Cut: Schizoanalysis and Montage

Hanjo Berressem

Abstract

If a machine is something that cuts into a continuous flow, schizoanalysis can be read, quite literally, as an analysis of cuts. In cinematic registers, it is an analysis of montage. Looking closely at a number of modes and moments of montage in the work of Alfred Hitchcock, this paper shows how his strategies of 'reciprocally presupposing' actual image and virtual montage relate to a Deleuzian poetics and politics of the cinema.

Keywords: psychoanalysis, schizoanalysis, Hitchcock, *The Birds*, *Psycho*

> He tried to consider the complexities of editing.
> Don DeLillo, *Point Omega*

> The average public do not, or are not, aware of 'cutting' as we know it,
> and yet that is the pure orchestration of the motion-picture form.
> Alfred Hitchcock

> [It] is all in the style of cutting, never obvious, always tremendously
> effective and completely unique.
> François Truffaut

I. Propositions and Givens

A Deleuzian poetics and politics of the cinema may be developed from the way Deleuze's philosophy brings about an anoedipal 'attribution' – or, as Deleuze calls it in *Cinema 2: The Time-Image*, 'reciprocal presupposition' (Deleuze 1989: 69) – of the actual and the virtual. In developing this argument, I take 'the Oedipal' to not only refer

Deleuze Studies 5.2 (2011): 177–208
DOI: 10.3366/dls.2011.0017
© Edinburgh University Press
www.eupjournals.com/dls

to the triangulation of desire that defines the logic of psychoanalysis. Especially in *Anti-Oedipus*, it is a code word for the general capture of desire within a network of interlocking psychoanalytic force fields and concepts, and thus for the general capture of the subject by the psychoanalytic machine. Against the psychoanalytic poetics and politics inherent in this capture, Deleuze and Guattari set a schizoanalytic poetics and politics.

Why choose Hitchcock, whose work has been relentlessly psychoanalysed, to talk about Deleuze and schizoanalysis, one might ask? Why return to psychoanalysis to talk about schizoanalysis? One reason is that Deleuze uses Hitchcock's work in reference to his concept of the crystal-image, which lies at the centre of the relation of the actual and the virtual. A second reason is that to develop an anoedipal Hitchcock from within and against a heavily psychoanalysed film studies is a bit like, for Deleuze and Guattari, to develop schizoanalysis from within and against psychoanalysis. In both cases, it is a question of deprogramming and of deterritorialising. If a clinical schizoanalysis implies to deprogram and to deterritorialise the 'subject of psychoanalysis', a critical schizoanalysis implies to similarly deprogram and to deterritorialise Hitchcock, whose movies film studies have often read as representations of highly Oedipalised family affairs.[1]

Before I get to Hitchcock, however, let me lay out the conceptual givens that form the parameters of my argument. I take the actual to denote the field of material, extensive matters-of-fact, of substances-as-being and of pulses of perception. Cinematographically, the actual is related to chronic time, to the sensory-motor arc and the movement-image. The virtual I take to denote the field of immaterial, intensive events, of relations-as-becoming and of lines of duration. Cinematographically, the virtual is related to aionic time, to memory and the time-image.[2]

The cinematographic attribution of the actual and the virtual – the somewhat paradoxical fact that they are each other's attribute – is not only a topic within *Cinema 1* and *Cinema 2*, it is directly embodied by their both conceptual and material complementarity. Although both books deal with the actual *and* the virtual, the focus of *Cinema 1* is the actual and processes of actualisation: the actualisation of perceptual systems, the actuality of corporeal movement and the actuality of physical change. The conceptual registers in *Cinema 1* are the trajectory of the sensory-motor arc and actual movement in space. Virtual time enters the equation only as an attribute of movement. The focus of *Cinema 2* is the virtual and processes of virtualisation: the virtualisations

of memory, the virtuality of acorporeal duration and the virtuality of psychic change. The conceptual registers in *Cinema 2* are the trajectory of memory and virtual movement in time. Actual movement enters the equation only as an attribute of time.

In the single volumes, therefore, the attribution of the terms – of the virtual to the actual and of the actual to the virtual – is asymmetrical. In fact, as single volumes the books literally do not make sense, and to say that one likes one of the volumes more than the other is like saying that in Deleuze's philosophy one likes the actual more than the virtual, or the other way around. It is only as a complementary couple that the two volumes come to form the full figure of Deleuzian philosophy. This pertains to their conceptual, virtual and thus intensive difference as well as to their material, actual and thus extensive difference; to their conceptual and to their material separation as single, separated volumes. In fact, the paradox of their reciprocal presupposition can only unfold properly when they are distributed on the surface of the 'projective plane' that defines Deleuzian thought. On the one-sided surface of this projective plane, *Cinema 1* forms the actual side, while *Cinema 2* forms the virtual side.

II. In Lieu of an Introduction: Motel Architecture 1

Living in complete, self-imposed isolation, Pangborn, the protagonist of J. G. Ballard's short story 'Motel Architecture' (1978), has been spending virtually every second of the last twelve years of his life analysing 'the shower sequence from *Psycho*' (Ballard 1982: 179), because the 'extraordinary relationship between the geometry of the shower stall and the anatomy of the murdered woman's body seemed to hold the clue to the real meaning of everything in [his] world, to the unstated connections between his own musculature and the immaculate glass and chromium universe' (179) of his apartment. 'The immaculate and soundless junction of the film actress's skin and the white bathroom tiles', he feels, 'contained the secret formulas that somewhere united his own body to the white fabric and soft chrome of his contour couch' (188). The only person allowed to disturb the world he has 'formed entirely from the materials of his own consciousness' (184) is the young cleaning-woman, Vera Tilley. The mosaic of TV screens Pangborn has assembled in his apartment, each of which shows a different fragment of the sequence, in fact redoubles Hitchcock's montage on a second-order plateau of relations, 'montagesquared': 'He had played the sequence to himself hundreds of times, frozen every frame and explored it in

close-up, separately recorded sections of the action and displayed them on the dozen smaller screens around the master display' (179).

Ballard relates Hitchcock and Freud by way of a pun that he does not need to actualise *in* the story because it is actualised *by* the story, which is about Pangborn performing, quite literally, a *psycho*lanalysis. In trying to make sense of the Hitchcock Motel through the montage of filmic cuts, however, Pangborn also performs, again quite literally, a *schizo*lanalysis in the sense that Deleuze and Guattari talk of 'schizzes' (Deleuze and Guattari 1983: 39) in their *Capitalism and Schizophrenia* project, a term that refers back to the Greek *skhizein*, which means 'to split' or 'to cut'. In this context, a detail about *Psycho* mentioned by Stephen Rebello takes on an almost emblematic status: 'Following the release of *Psycho*, the Hitchcock office and Paramount lodged a complaint with the Motion Picture Association of America about the registration of the title *Schizo* by none other than Hitchcock's old boss, producer David O. Selznick' (Rebello 1990: 53), who subsequently withdrew his claim to the title. Although he could have done it, however, Hitchcock, for better or worse, never got around to making a movie called *Schizo*.

III. Hitchcock: From *Psycho*lanalysis to *Schizo*lanalysis

In both *Psycho* (1960) and *The Birds* (1963), which will form the centre of my analysis, psychoanalytic readings have organised the filmic narrative around 'mother's voice' as an evil quasi-*acousmêtre* that can be heard through its demented ventriloquisations: in *Psycho*, when Norman Bates's voice modulates into a high-pitched whine. In *The Birds*, mother's shrill resentment of her son's desire can be heard in the angry twittering of the birds, although in this case 'mother' is still alive and indeed speaks for herself.

Despite this difference, in both cases the traumatic stain around which the narrative revolves concerns 'mother' or, more precisely, what Slavoj Žižek, whom I will use as a metonymical stand-in for a psychoanalytically informed film studies, has identified as the 'raw incestuous energy' (Žižek 2006) of the 'ferocious' (Žižek 1992a: 99), 'cruel and obscene' (18) maternal superego. In this reading, Žižek could rely on earlier work driven by psychoanalysis, such as Ian Cameron and Richard Jeffery's 'The Universal Hitchcock' (1986) or Margaret M. Horwitz's essay '*The Birds*: A Mother's Love', in which she notes that 'the wild birds function as a malevolent female superego' (Horwitz 1986: 281).

On this background, my argument is quite simple and straight-forward. While psychoanalytic readings, which tend nowadays to be filtered through the work of Jacques Lacan, are conceptually organised around an Oedipal architecture of cuts that are centred around the traumatic stain of the Real, schizoanalytic readings are conceptually organised around a multiplicity of machines that, by cutting through both virtual and actual *phyla*, assemble heterogeneous elements into fragile assemblages that are not pre-formed or organised into sets of psychoanalytically and thus Oedipally overcoded structures. Against the psychoanalytical reading of movies as both thematic representations and formal figures of Oedipal machines, schizoanalysis sets the reading of movies as optical expressions and affective montages of relational changes between heterogeneous machinic systems; as optical and acoustic planes of consistency. While psychoanalysis looks for Oedipus under the optics, schizoanalysis looks for the optics under Oedipus.

A first relation between schizoanalysis and the cinema is that it is based on the general notion that all machinic assemblages are nothing but 'system[s] of interruptions or breaks'. A machine 'cuts into' (Deleuze and Guattari 1983: 36) a 'continual material flow (*hylè*)' (36); a 'phylum' (Deleuze and Guattari 1987: 406) that it 'cuts up into distinct, differentiated lineages, at the same time as the machinic phylum cuts across them all' (ibid.). As each flow is cut by machines and, at the same time, each of these cuts produces new flows, the diagram of the world consists of 'the thousand breaks-flows of desiring-machines' (Deleuze and Guattari 1983: 61).

It is on the background of the notion that both actual, and thus concrete, machines as well as virtual, and thus abstract, machines are infinitely assembled, that Deleuze and Guattari can talk of 'molecular biology' as being itself 'schizophrenic' (289). In Deleuze and Guattari, in fact, the terms 'schizophrenic' and 'schizophrenia' no longer refer narrowly to a psychoanalytically defined pathology; they designate any form of heterogeneous assemblage, whether that is the psychic assemblage of a phantasm or the physical assemblage of a molecular machine.

Schizoanalysis, therefore, concerns a much larger field than just the human or, even more restrictedly, the psychic one. To maintain that molecular biology is schizophrenic means that schizoanalysis concerns the logic of the 'assembly of life' – both human and non-human – in general. On the most general level, schizoanalysis concerns the analysis of the assemblage of self-organising machines. In the words of Deleuze and Guattari, it concerns 'chronogeneous machines engaged in their own

assembly (*montage*)' (266). Schizoanalysis, then, may be defined as an analysis of the ensembles and the dynamics of anoedipal machinic cuts and of the arrangements they produce. Complementarily, schizopolitics, which includes a critique of psychoanalysis as a political dispositif, may be defined as the practice of unfreezing Oedipal organisations and power-relations. When schizoanalysis addresses the human unconscious, it is not as something that is structured like a language but as a machinic system whose 'true activities' are 'causing to flow and breaking flows' (325).

One of the ways in which schizoanalysis is related to the cinema is that the assemblage of movie images is, like that of 'chronogeneous machines', quite literally a montage. Deleuze stresses this relation between chronogeneous and cinematographic machines when he states, in reference to the cinematographic ontology he develops in the cinema books, that 'the universe [is] cinema in itself, a metacinema' (Deleuze 1986: 59). On both cinematic and metacinematic levels, the analysis of flows|cuts concerns the relation between actual image and virtual cut: *schizo*analysis.

IV. Deleuze's Hitchcock

Symptomatically, when Deleuze talks about Hitchcock, he immediately brushes away any Oedipal reference. He is not interested in *psycho*grams but in 'the autonomous life of [. . .] relation[s]' (Deleuze 1986: 203) that are 'external to their terms' (x). There is no need to make Hitchcock 'a psychologist of the depth' (202), Deleuze notes in *Cinema 1*. Rather, Hitchcock is important as the inventor of 'the image of mental relations' (x). His movies consist of sets of images that are 'purely thought' (203). As Hitchcock himself said about the relation of thought and montage, 'a cut is nothing. One cut of film is like a piece of mosaic. To me, pure film, pure cinema is pieces of film assembled. Any individual piece is nothing. But a combination of them creates an idea' (Hitchcock 1995c: 288). Through their montage, the single actual images come to be woven into a virtual narrative that, as Deleuze states, 'changes in the evolution of the relations from a disequilibrium that they introduce between the characters to the terrible equilibrium that they attain in themselves' (Deleuze 1986: 203). In other words, Hitchcock's movies are about sets of weird circumstances and the erratic, devious developments these initiate. At some point – 'at an uncertain time and in an uncertain place', one might say – something unexpected, and potentially shocking, happens. Invariably, there is a first-minute deviation from the *habitual*

order of things.[3] Both the plot of *Psycho* and that of *The Birds* are set in motion by such an initial Lucretian 'clinamen'. In the novel *Psycho*, Marion Crane takes 'the wrong turn' (Bloch 1959: 15) on her way to the psychoanalytically overcoded village of Fairvale; in the movie, it is a sudden rainstorm that prompts her to stop at the Bates Motel. In *The Birds*, a single gull inclines from its horizontal flight, making two series or flows converge: the turbulent line created in the water by the boat's outboard motor, and the seagull's equally turbulent line of flight.

> Take, for example, the movement of water, that of a bird in the distance, and that of a person on a boat: they are blended into a single perception, a peaceful whole of harmonized Nature. But then the bird, an ordinary seagull, swoops down and wounds the person: the three fluxes are divided and become external to each other. The whole will be reformed, but it will have changed: it will have become the single consciousness or the perception of a whole of birds, testifying to an entirely bird-centred Nature, turned against Man *in infinite anticipation*. It will be redivided again when the birds attack, depending on the modes, places and victims of their attack. It will be reformed again to being about a truce, when the human and the inhuman enter into an uncertain relationship. (Deleuze 1986: 20; emphasis added)

Hitchcock's carefully premeditated arrangement of storyboard stills lays out, in advance, the complex dynamics of relational changes that develop from each specific inclination|clinamen within an equally specific cinematographic phase-space. It charts the diagram of the evolutions that are triggered by these unexpected machinic mutations. More importantly even, it lays out the optical, cinematographic organisation of these evolutions; their optical expressions. In these arrangements, two modes of relational change are superimposed: internal relations change through *actual* movements within single shots, such as the movement of the camera and of the actors, while 'the whole' changes through the *virtual* movement of the montage, which defines the movement of the cinematographic composition. These two movements invariably operate simultaneously:

> The frame is like the posts which hold the warp threads, whilst the action constitutes merely the mobile shuttle which passes above and below. We can thus understand that Hitchcock usually works with short shots, as many shots as there are frames, each shot showing a relation or a variation of the relation. (Deleuze 1986: 200)

The only exception to this logic is *Rope (1948)*, which has, at least ideally, no cuts at all, and in which Hitchcock remains *within* the level of internal relations, creating a kind a fluid montage within the shot.

Deleuze talks about the moments of initial deviation or inclination in terms of marks, which denote 'natural' relations, and demarks, which denote 'abstract' relations that are fundamentally enigmatic because they are new and unexpected. In order to avoid any misunderstanding, let me stress that by calling relations 'natural', Deleuze does not endorse an essentialist agenda. In fact, Deleuze considers nature in itself not as natural in the common sense, but as inherently machinic.[4] What Deleuze means, quite simply, is that natural relations are habitual, while abstract relations define the movement of elements that have detached themselves from the chain of habitual terms by violence – in the sense that it always takes a certain amount of violence to change a habitual setup – in order to link up with another series. The first gull that swoops down and 'strikes the heroine', for instance, 'is a demark, since it violently leaves the customary series, which unites it to its species, to man and to Nature' (Deleuze 1986: 204). It is unnatural for a gull to attack humans only in the sense that according to the 'natural order', it is not a general habit of gulls to attack humans. Similarly, it is not habitual for a crop-dusting plane to attack a human being, as it does in *North by Northwest* (1959).

Because of Hitchcock's investment in changes of relations, Deleuze positions him at the end of *Cinema 1*, 'at the juncture of two cinemas' (Deleuze 1986: x) and thus at the juncture of two regimes of the image: at the moment when the actual movement-image turns into the virtual time-image, the moment when every material action is immediately 'surrounded by a set' or swarm of virtual 'relations' (Deleuze 1986: 200). In terms of the topology of the cinema books, Deleuze positions Hitchcock's work at the crystal moment where the actual almost meets the virtual and vice versa. The only reason Hitchcock does not fully belong in *Cinema 2* is because of the logic of suspense, which relentlessly propels his plots forward and thus subjects time-in-general to movement-in-general. Invariably, however, these movements have already lost their internal coherence. The narrative goes off at tangents and follows minute inclinations as in *Psycho*, it goes into prolonged temporal cycles as in *The Trouble with Harry* (1955), or it is curiously randomised as in *The Man Who Knew Too Much* (1956).

It is in relation and in attribution to these brittle, demarked narratives that Hitchcock's relational and affective surfaces establish themselves. Affects, in fact, are themselves crystal in that they are corporeal, actual and extensive as well as ideal, virtual and intensive. As in a crystal-image, there is no continuous passage between the two 'affective' series. As Spinoza notes, '*the body cannot determine mind to think, nor can the mind determine body to motion or rest*' (Spinoza 2006: 63). Despite

this radical separation of the series, however, Spinoza maintains that affects and ideas of affects need to be adequate. It is in this context that Deleuze considered Hitchcock a master of relation. If the actual images and the virtual cuts need to be 'adequate', my question in the following is, whether Hitchcock's fragile optical and sound surfaces are 'contained' within a *psycho*analytic logic. Is psychoanalysis 'adequate'?

V. The Shower

Both murders in *Psycho* can only too easily be read as the lethal, backlighted impersonation of mother killing the object of her son's desire. Why 'only too easily'? To explain what I mean by this, I will first look at the production process of the movie. In the case of *Psycho*, this process assembles a complicated media ecology that reaches back to the real-life serial-killer Ed Gein, who used, on occasion, to wear a 'woman suit' made from human skin so he could impersonate the dominating puritan mother he had murdered. Robert Bloch relates Gein directly to Norman Bates in his 1959 novel *Psycho*, in which the narrator notes that '[s]ome of the write-ups compared' the killings 'to the Gein affair up north' (Bloch 1959: 149).[5] Bloch, in fact, lived only thirty-five miles away from Gein when he wrote the novel, which contains a veritable overkill of psychoanalytic references. Bates is a 'multiple personality with at least three facets' (154), *Norman, Norma* and *Normal*. He is a 'transvestite' (151), who is allegedly 'guilty of cannibalism, Satanism, incest, and necrophilia' (150). In his more lucid moments, he conveniently diagnoses himself as 'the victim of a mild form of schizophrenia, most likely some form of borderline neurosis' (84) and in one 'conversation' with mother, he in actual fact notes that their relation is 'what they call the Oedipus situation, and I thought if both of us could look at the problem reasonably and try to understand it, maybe things would change for the better' (12). Dr Nicholas Steiner, who examines Bates after his arrest, has no difficulty in tracing his pathology back to a primal scene; a moment when Norman 'walked in on his mother and [her lover] together in the upstairs bedroom' (153). Shortly after this traumatic encounter, Bates poisoned both his mother and her lover, but then he had felt guilty, 'dug her up' (154) and preserved her taxidermically in order to 'keep her alive'. In fact, Bates has made himself believe that she is not dead at all, but in a state of 'suspended animation' (136).

This psychoanalytically oversaturated and overdetermined story was subsequently rewritten for mainstream Hollywood cinema by Joseph

Stefano, who was responsible for the element of 'motivation', something Hitchcock, at least according to Stefano, was not really interested in, although he knew very well that motivation was a 'given' if you wanted to make a Hollywood movie, which meant a movie geared towards a mass-market that was raised on psychoanalytic clichés and that expected Hollywood movies to adhere to these clichés.[6] From the countless melodramas of the forties and fifties onwards, in fact, psychoanalysis had been relentlessly cinemascoped and sensurrounded. In fact, it had become a cinematographic cliché. Hitchcock, who hated clichés but loved to play with the audience's cliché expectations, was very aware of the power of psychoanalysis as a conceptual matrix for motivation, but he also had a highly ironic relation to it. In fact, he considered the story of *Psycho* somewhat of a joke. '*Psycho* is a film that was made with quite some sense of amusement on my part', he noted, 'to me, it's a fun picture' (Rebello 1990: 168).

If Hitchcock was not interested in catering to clichés, he was similarly uninterested in providing psychoanalytic verisimilitude. 'After all, it stands to reason that if one were seriously doing the *Psycho* story it would be a case history' (Thomson 2009: 144), he maintained. What Hitchcock was interested in was to create 'pure cinema'.[7] In this context, his somewhat apocryphal statement that he considered dialogue to be just another part of the soundtrack is more than just another witticism. Like his many comments about his uses and abuses of actors, it shows the degree to which he considered motivation to be subservient to the affects produced by pure cinema. As he noted, famously, '[w]hen an actor comes to me and wants to discuss his character, I say, "It's in the script." If he says, "But what's my motivation," I say, "Your salary"'.[8]

After Bloch, then, Stefano was responsible for 'psychoanalysis'. As Bloch had already put so many psychoanalytical references in place, however, Stefano only needed to streamline the story for Hollywood consumption. Ironically, this streamlining involved not so much adding psychoanalysis to the script, which would have led to a complete conceptual overkill, but subtracting some of the psychoanalytic references. To oversaturate the movie with psychoanalytic references would have taken away from the suspense Hitchcock was out to create on two counts. First, too much overt psychoanalysis would have made the movie too cerebral. Second, it would have made it inadvertently humorous. If the novel attempted to create a frightening verisimilitude by way of the accumulation of pathological details, the movie was to create suspense and shock-effects by means of 'pure optical and sound images' (Deleuze 1989: 15). Hitchcock's 'optical and sound images',

however, differ in one important aspect from the ones Deleuze describes in *Cinema 2*. While these designate optical and acoustic milieus that are suffused with virtual memory and in whose often 'uncut' atmosphere actual movement is curiously suspended, passive and without direction, Hitchcock's images are highly montaged, actively shocking and highly affective. Despite this difference, however, both versions decompose narrative movement into crystal blocs of suspended time.

The pervasive presence of psychoanalysis in the movie, then, is to a large degree owed to the distributed production processes that define the cinema – even *auteur* cinema – in general. These processes are generally not acknowledged by psychoanalytically informed readings, not even by Cohen, who reads Hitchcock's movies as disseminative 'signature machines' (Cohen 2005a: 8). While Deleuze's analyses of the cinema also remain centred around specific directors and their personal styles, a schizoanalysis of the cinema might well profit from an approach that embeds the 'director machine' into an ecology of other machines: other flows|cuts.

In the light of these distributed processes, psychoanalytical readings are defined by a curious chronological loop: 'The Trouble with *Psycho*'. If by the sixties both pulp fiction and Hollywood were fully suffused with psychoanalysis, it was strictly a pop version of psychoanalysis. Bloch and Stefano brought precisely this pop version of psychoanalysis to *Psycho*, which makes it somewhat ironic to observe Žižek retrieve 'deep Freud' from the most obvious of Hollywood treatments and appropriations. Not only does psychoanalysis find itself, as Jacques Derrida would say, it actually proves itself by way of its own pop-versions.

In fact, *Psycho* is a good example to show that the artistic attitude towards Freud tended to be quite debonair. Psychoanalysis had its uses, especially in a mass-market economy. Bloch, for instance, noted about his novel that

> in the late fifties, Freudian theories were very popular and [...] I decided to develop the story along Freudian lines. The big Freudian concept was the Oedipus fixation, so I thought, 'Let's say he had a thing about his mother.' (Rebello 1990: 9)

A similar, probably even more cavalier relation to psychoanalysis can be felt in the way the illustrator who designed the film's poster talks about his artistic rationale: 'The guy [in the novel] was quite cracked up, so, in the graphic, I cracked up the lettering to reinforce the title' (11). What these remarks show is that psychoanalytic readings of Hollywood often make a mistake when they take the presence of

psychoanalysis too seriously. In other words, psychoanalysis should take the modes of its own presence in Hollywood into account. In fact, a somewhat disturbing result of psychoanalysis finding itself in its Hollywood treatments is that it subscribes to its own popularisation, which means that it subscribes to its own cliché. Even Žižek, whose work is famously filled with jokes, does not show such conceptual self-irony. This is why he ultimately fails both as a cinematographic critic and as a psychoanalyst. From Hitchcock he retrieves only 'deep psychoanalysis', which is not fair to Hitchcock as a cinematographer; from Gein's deeply enigmatic and disturbing pathology he retains only Hollywood's sanitised, pop-cultured treatment, which is not fair to Gein as a case history.

In psychoanalysis's finding of itself, Žižek is the last in a long line of critics that goes from Raymond Bellour to Lee Edelman's psychoanalytic deconstructions.[9] Already in Bellour, the seriousness of the critical endeavour creates curiously blind spots. On the background of Hollywood's uses of psychoanalysis, it is in fact somewhat ironic that Bellour, in order to introduce scopic desire as the most appropriate and obvious cinematographic pathology into his analysis of Hitchcock's movies, refers to precisely one of the results of the hypervisibility of Freud in Hollywood cinema: the fact that the voyeuristic Norman is 'concealed, significantly, by a painting which prefigures the effect he is to produce: *Susannah and the Elders*' (Bellour 1986: 321). While Bellour sees the presence of the painting as a significant clue for the implementation and presence of the scopic regime in the movie, it might also be read as a witty, highly tongue-in-cheek detail of the movie's set design. How much more obvious, in fact, could one get? To let a voyeur look through a representation of voyeurism shows to what extent psychoanalytic concepts could be consciously used, as much for 'effect' as for 'irony'.

Something similar happens in Horwitz. Even though *The Birds* itself pre-empts a psychoanalytic reading in which the birds function as the projection of a maternal superego gone berserk when it has Annie, who seems, even within the movie's diegetic reality, to realise how easily people fall into the psychoanalytic trap, tell Melanie that Lydia is not possessive 'with all due respect to Oedipus' (Horwitz 1986: 282), Horwitz still reads the movie into a psychoanalytic register. Rather than reading this remark as another tongue-in-cheek play about the hypervisibility of Freud and the facility of Freudian readings, she chooses to read it as a denial, claiming that 'the text denies (repressed) contradictions to which it cannot admit on a conscious level' (282).

In fact, at this point, she reads the film as if it were a patient: Freud famously explained, in a beautifully laconic manner, the logic of denial by describing a hypothetical patient, who tells the psychoanalyst that he did not know the identity of a specific person in one of his dreams but that he was sure that it was not the mother: ' "You ask who this person in the dream can be. It's *not* my mother" ' (Freud 1925: 235). To which Freud, somewhat deviously, adds: 'We emend this to: "So it *is* his mother" ' (ibid.).

Similarly, when *The Birds* notes that it does not know what it is structured around, but that it is *not* the maternal superego, Horwitz emends this to: 'So it *is* the super-ego', thus turning a very conscious, tongue-in-cheek remark into a symptom of the return of the repressed. As if the film were saying: 'Do not read me psychoanalytically!' but in actual fact meant: 'Read me psychoanalytically!' As if the statement 'the key is not psychoanalysis' meant, in actual fact, 'the key is psychoanalysis'.

I have already noted that while Hitchcock was not really interested in personal motivation, he was obsessively interested in affect and in how to produce 'pure optical and sound affects' by way of cinematic means; in how to produce suspense and shock. Against this background, the story is a mere vehicle to lead up to the truly important moments, such as the two murders and the final discovery of 'mother'. What Deleuze notes in reference to Francis Bacon's work applies equally to Hitchcock's. In Bacon, all relations lead to, and are in the service of, sensations. While a predominantly narrative and conceptual art – the painterly equivalents being figurative and abstract painting – addresses the mind, a 'sensational' art like that of Bacon or Hitchcock addresses predominantly and directly the nervous system:

> As Valéry put it, sensation is that which is transmitted directly, and avoids the detour and boredom of conveying a story. [...] [T]he same criticism can be made against both figurative painting and abstract painting: they pass through the brain, they do not act directly upon the nervous system, they do not attain the sensation. (Deleuze and Guattari 1994: 33)

In Hitchcock's words, 'the impact of the image is directly on emotions' (Hitchcock 1995b: 216). As Hitchcock noted about *Psycho*, '[i]t's a pretty good film. But, more important, it's the first shocker I've ever made. This one *literally* shocks you' (Rebello 1990: 194). It is because he wanted to literally shock that Hitchcock spent one week and seventy camera positions in assembling a forty-five-second montage; one-eighth of the movie's overall shooting time on the visualisation of three

sentences, which, by the way, come much earlier in the novel than in the movie: 'Mary started to scream, and then the curtains parted further and a hand appeared, holding a butcher knife. It was the knife that, a moment later, cut off her scream. And her head' (Bloch 1959: 33).

Within the representation of the familiar psychoanalytic narrative, Hitchcock assembles with the shower sequence an extremely expressive, affective bloc of cinematographic space-time by way of an affective architecture of images and cuts. The aim of the montage was to create the highest 'dramatic impact' (Truffaut 1968: 334), and the proof that it worked was that the spectators were affected by the scene on a directly nervous level. As Truffaut adds, they were, on a directly 'physical' (350) level, 'aroused by pure film' (349).

Like cinema in general, the shower scene is mainly about the optical attribution of material matters-of-fact and immaterial events; actual images and virtual relations. The resulting affect concerns not so much the theatrical level addressed by psychoanalysis as it does the level of production addressed by schizoanalysis. Within the obvious frame of the representation of mother's derailed violence, Hitchcock orchestrates a meeting *with* and a direct expression *of* violent affect. If Hitchcock told Stefano that he was happy to leave motivation to him, Hitchcock was fully responsible for the scene's optical and acoustic arrangement, something that becomes very obvious in the heated controversy between Hitchcock and Saul Bass about 'who actually did what' during the filming of the scene.

In Hitchcock's murderous montage, the optical and acoustic affects are more important than the plot that frames and carries them. Both the narrative setup and the actors' incomputable movements and automatic spasms are, through the practices of the cinema, optically and auditively assembled into a series of blocs of affect. This process comprises both the virtual, narrative surprise of killing off the person who appears to be the heroine – a surprise that is even heightened because she is played by the 'star of the film' (Truffaut 1968: 340) whom the audience would never expect to die so early on – and the actual movements and bodies that form the given diagrams from within which the cinematographic machine of shock and suspense is created. In this dramatisation, the art lies in playing 'odd and even' with the audience, a game in which Hitchcock excelled because the public is 'represented by the camera' (328) and is thus at the mercy of the director's optical manipulations.

It is in this context that one should read the urban myth that seems not to have been true, but that is so convincing in its logic that it should have been true. Allegedly, Hitchcock turned, suddenly and unexpectedly

for Janet Leigh, the luxuriously hot shower to cold during the filming of the scene so that, like Marion Crane's body is attacked by a knife, Janet Leigh's body is attacked by the cold. Leigh's body becomes the site on which a double violence is performed: the virtual violence of Bates's attack, which is related to the field of expressive acting, and the actual violence of the energetic 'freeze frame', which is related to the field of impressive feeling. What better way to extract an 'adequate' response from Janet Leigh?

Even though the story about this physical version of method acting is really too good to be true, it may stand metonymically for the fact that beyond the all-too-expected psychoanalytic theatre of the Hitchcockian plot there lies a much more disruptive production and expression of pure affects which can be called the Hitchcockian *figure*; precisely the figure Pangborn is so obsessed with. The psychoanalytic narrative that psychoanalytic theory retrieves from Hitchcock's montage is merely the thematic carrier of a cinematographic architecture of affective expression. Arguably, in the shower scene this might have worked even better *without* the soundtrack, which was what Hitchcock had originally planned. The sounds – the water, the shrieks, the slashes – are probably the most adequate and affective soundtrack. The shrieks of the violins take away from the intensity of this soundspace because one can hear in them too easily Norman's mother's agitated, demented breathing.

VI. The Telephone Booth

Daphne du Maurier's story 'The Birds', unlike Bloch's *Psycho*, has nothing directly Oedipal about it. In England, a farmer and his family fight against birds that, for some enigmatic reason, have begun to attack humans. Both Deleuze's reading of the first gull as a demark and Hitchcock's 'real' interest in the story are actually very close to du Maurier, who poses the question not so much of *why* but of *how* the birds attack. 'Why do the birds attack?', on the contrary, is precisely the psychoanalytic question Žižek asks himself (Žižek 1992a: 97); as do the characters in the story and the movie. Once more, Žižek answers the question in terms of the movie's internal distribution of desire and its objects. At the end of his reading, it is clear why the birds attack: 'the terrifying figure of the birds is actually the embodiment in the real of a discord, an unresolved tension in intersubjective relation [...] the incarnation of a fundamental disorder in family relationships' (99). For Deleuze and Guattari, however, the question posed by desire is not so much about meaning and representation as it is about production and

assembly, and as such much more in tune with du Maurier and with Hitchcock: 'the question posed by desire is not What does it mean? but rather *How does it work*?' (Deleuze and Guattari 1983: 109).

It is very difficult, in fact, to find out *why* unexpected things happen. They happen all the time, whenever a habitual pattern is broken and a new machinic assemblage is created. Because of some built-in force – call it appetitus, conatus, libido or *élan vital* – living machines do not stop assembling and entering into complex arrangements and dynamics. Deleuze and Guattari call this force desire, which is why every living machine is a desiring-machine. If one remembers that evolution drifts and that living machines are self-organised rather than created 'in the image of someone or something', this force of desire does not represent something outside of itself. In causing processes of self-organisation, it is productive and directly involved in how living machines come about and how they work: 'The desiring-machines [...] represent nothing, signify nothing, mean nothing, and are exactly what one makes of them, what is made with them, what they make in themselves' (288).

On this background, Deleuze and Guattari develop their notion of the unconscious as productive rather than representative; as a factory rather than a theatre. It 'does not symbolize any more than it imagines or represents; it engineers, it is machinic' (53). When Deleuze and Guattari note that 'the whole task of schizoanalysis' is to 'overturn the theatre of representation into the order of desiring-production' (271), this is precisely to say that questions need to be shifted from *why* to *how*. In fact, Deleuze and Guattari 'reproach psychoanalysis for having stifled this order of production, for having shunted it into *representation*' (296). Quite programmatically, '[s]chizoanalysis forgoes all interpretation because it foregoes discovering an unconscious material: the unconscious does not mean anything' (180). Unfortunately, such statements have often led to the idea that Deleuze and Guattari are not interested in meaning at all. Nothing, of course, could be less true. The question is rather that of how meaning – or better, how sense – is assembled from and within a field of production, how it can remain attributed to that productive ground and how it is related to sensation.

As in Hitchcock's movie, in du Maurier's story the reason for the attacks is never given. The question is not one of a clear causation, but rather of 'How do the birds form a deviant assemblage?' In her detailed and loving description of this process, du Maurier contours a compelling image of swarm intelligence. The first phases of the process are assemblage and agitation. The birds are attracted to each other as

if they were following some gravitational pull. Their normal, habitual desires are redistributed within a communal desire for change. 'The birds are restless':

> Great flocks of them came to the peninsula, restless, uneasy, spending themselves in motion; now wheeling, circling in the sky, now settling to feed on the rich new-turned soil, but even when they fed it was as though they did so without hunger, without desire. Restlessness drove them to the skies again. (du Maurier 1952: 85)

The next phase is defined by the assembly of a new collectivity that comes to overrule and transgress former barriers between territories and populations. Birds that normally would not form alliances begin to assemble cross-population machines. Very carefully, du Maurier refrains from giving a reason for this behaviour. The birds act as if they were compelled to do so:

> Black and white, jackdaw and gull, mingled in strange partnership, seeking some sort of liberation, never satisfied, never still. Flocks of starlings, rustling like silk, flew to fresh pasture, driven by the same necessity for movement, and the smaller birds, the finches and the larks, scattered from tree to hedge as if compelled. (85–6)

In a third phase, the restless swarm turns into an army. Its self-organising movements are now directed towards an enemy: 'There were robins, finches, sparrows, blue tits, larks and bramblings, birds that by nature's law kept to their own flock and their own territory, and now, joining one with another in their urge for battle' (89). At some point, an enigmatic decision has been taken: 'Nor did they fly so high. It was as though they waited upon some signal. As though some decision had yet to be given. The order was not clear' (102).

The story will remain silent about where the order comes from. Certainly, it is not given by some individual 'birdleader' who controls the movement. Rather, it is a distributed order that spreads out within the multiplicity of birds. Towards the end of the story, the farmer – who had first thought that the birds were remote-controlled by some human agency such as the Russians – begins to suspect that the attacks have to do with a deeply enigmatic evolutionary, and thus also genetic, drift. '[H]ow many millions of years of memory were stored in those little brains, behind the stabbing beaks, the piercing eyes, now giving them this instinct to destroy mankind with all the deft precision of machines' (123), he wonders.

If one reads du Maurier's 'million years of memory' as another name for 'unconscious machine', the story describes how the birds assemble what Deleuze and Guattari call a war machine. In this context it is significant that du Maurier had extrapolated the attacks from real-life, actual attacks by aviatory versions of Ed Gein, and that Hitchcock had been, in turn, 'reminded of the story in the early sixties by reports – from California – of unusual bird behaviour and what might be interpreted as attacks' (Thomson 2009: 104).

For Hollywood consumption, du Maurier's story is treated by the American crime writer Ed McBain, writing as Evan Hunter. There might have been a certain surreal beauty in an American crime writer re-writing an English writer of romances, but in actual fact McBain did not so much rewrite the story, as change just about everything except the basic idea. The only two details Hunter takes over is the eye-pecking and the birds' mode of entry. 'Then they'll try the windows, the chimneys', du Maurier's farmer notes (105).[10]

McBain frames the story about evolutionary drift by a psychoanalytically informed narrative. Once more, a mother is trying to 'save' her son from his object of desire. One inhabitant of Bodega Bay, the village Mitch Brenner lives in and to which Melanie Daniels had come by boat, in fact accuses Melanie openly – though wrongly, as Robin Wood stresses – of being the direct cause of the attacks, because she and the birds have arrived at the same time; a synchronicity that is another internal psychoanalytic 'spoiler alert' because it links Melanie, Mitch and his mother to the attacks of the birds.

Žižek – as have many other commentators – immediately zooms in to the family clues that lie scattered amidst the bird attacks. Again he argues that the plot about the birds is only a means to distract the audience from the psychoanalytic truth of the story. As Žižek argues, the manifest narrative about the eruption of the birds' violence functions, somewhat like a screen memory, as a diversion from the narrative about the violent eruption of mother's anger. Thus Žižek's conceit of '*The Birds* without Birds' (Žižek 1992a: 104–6). The birdplot 'makes sense' precisely when it is discovered as a condensed and displaced representation of a both familial and familiar psychoanalytic narrative.

My argument is once more that the obvious family romance is merely the carrier for complicated meetings of the actual and the virtual and for the production of landscapes of violent, shocking affect. Is it not, in fact, that Hitchcock once more turns psychoanalysis upside down? Hitchcock's aim is to assemble a montage that approaches the actual affectively and architecturally. One of the strategies to do so has to

do with projective planes and optical superimpositions. In the famous 'Pearl Harbour scene', during which the birds attack first Bodega Bay's gas station and then Melanie, who has fled into a telephone booth, Hitchcock, in fact, creates a direct formal and thematic inversion of the shower sequence, with the birds taking on the function of the knife. Only this time, there is a translucent protective plane into which the birds crash before they can hurt Melanie.[11]

Although Žižek is always extremely aware of the formal aspect of Hitchcock's work, in his overall argument, he relates the 'projection' of the birds onto Bodega Bay – the fact that Hitchcock inserted the images of the birds into the scene during post-production – to a thematic, psychoanalytic layering of the birds' and mother's destructive energy. The formal layering, however, can also be read as an affective rather than a representative projection. In fact, the relation of the sequence in the telephone booth to the shower scene sequence is not only formal. Another way in which they are related is that, as Hitchcock noted in 'It's a Bird, It's a Plane, It's ... *The Birds*', it took 'three months' (Hitchcock 1995a: 317) to assemble the extended scene, of which the sequence in the telephone booth is a part.

The most interesting and at the same time the most disconcerting optical characteristic of the scene is related to the fact that most of the images of the birds were added only during post-production. In terms of the filming of the scene and of acting in it, this meant that in a first temporal series, the actors had to run from and protect themselves from purely imaginary birds, as if the birdplot was indeed a communal phantasm. In their flight from the attack of invisible birds, the actors had to counter-actualise the complete affective bloc envisioned by Hitchcock, even though the birds, which made up the most important material objects in that bloc, were added to the image only at a later point. The actors, therefore, had to act into the future, as it were, and at the same time as if the birds were already there. They had to mime a presence yet to come, which made their task a subjunctive counter-actualisation reminiscent, although in a completely different context, of Žižek's conceit of *The Birds* without birds. Similarly, Hitchcock's camera had to continually anticipate the birds.

The optical result of this 'special effect' is a curious incongruity, to which the fact that the birds are *in front of* the actors, which are, optically, the back-projection, adds an extra layer. If one thinks of the usual back-projections in Hitchcock, such as those that define train or bus rides, in *The Birds*, the *Verfremdungseffekt* is even stronger because

the habitual figure–ground relationship is reversed. The lesson of this formal reversal is that the reality of Bodega Bay forms the ground to the figure of the reality of the birds, whose perspective the spectator is asked to take. Quite literally, the images are given from a 'bird's-eye' view.

In its weird optical alignments and de Chirico perspectives, the completed scene's optical architecture shows quite directly that there will always be an infinitesimal distance between the world of the birds and the world of the humans, even when they are projected onto the same movie screen.[12] This infinitesimal distance is embodied by the technological gap between the two plateaus of superimposed images. The world of the birds and the world of the humans are visually attributed in such a way that they are 'almost' on the same plane. Their eerie optical oscillation in fact recapitulates formally the incongruities of what happens in the movie. This, of course, is not to say that Hitchcock used the mode of projection as an intended strategy – we can assume he was after the most appropriately affective images within the set of given technical constraints – but to highlight the specific optical organisation of the film's images, which is seminal in producing their singular affective impact.

In a larger context, the optical layering of the scene is one of Hitchcock's cinematographic strategies to create crystal-images, which designate, within the internal architecture of the two cinema books, the 'smallest internal circuit' (Deleuze 1989: 70) between the actual and the virtual. They are images of the infinitesimal meeting of the actual and the virtual at the impossible, infinitely receding 'point at infinity' where the actual and the virtual become identical; the impossible moment when the two volumes of *Cinema 1* and *Cinema 2* would become one volume. When the distance between them would be reduced to zero.

It is only at this ideal point that the plane of the anonymous, actual movement of movement-images folds over onto the plane of the anonymous, virtual movement of time-images, where pure actual perception turns into pure virtual imagination. Where the sensory-motor arc turns into memory. As figures of the point-at-infinity on a projective plane, crystal-images measure out 'a place and its obverse which are totally reversible' (69). In the crystal of the image, one invariably sees 'the indiscernibility of the actual and the virtual' (87). Deleuze's philosophy develops within the conceptual space 'given' by the projective plane. Cinematographically, this projective plane is embodied by the movie screen, which is quite literally 'projective'.

In the scene that I have described above, Hitchcock superimposes two actual worlds. A similar superimposition on the virtual level, however,

plays itself out in the gap between the respective relational sets of the birds and of the humans. Unlike psychoanalytic readings, Hitchcock does *not* provide a link between the series of the actual attacks and the virtual series of the explanations of the attacks. Both formally and in terms of narrative, Hitchcock leaves the actual series and the virtual series disjunct but reciprocally attributed in terms of optical and sound situations: crystal cinema. What he provides are highly affective montages of the collision of the both actual and virtual worlds of the birds and of the humans.

Another eerie superimpositional attribution of the actual and the virtual defines Madeleine|Judy in *Vertigo* (1958), who oscillates between actual person and virtual projection. Ironically, in *Vertigo*, the cinematic assemblage terminates precisely at the point of their hallucinatory identification. This is even clearer in the novel than in the movie, in which Hitchcock sacrifices psychological for optical symmetry. Because the director does not move the action forward 'with psychoanalysis' but 'with a camera – whether that action is set on a prairie or confined to a telephone booth' (Hitchcock 1995b: 215), Hitchcock trades the ending of Pierre Boileau and Thomas Narcejac's novel *D'Entre les morts* (1954), on which the movie is based, for an ending that is optically and cinematographically more convincing, although it is both psychologically and narratologically much less so. In this ending, rather than having Flavières kill Renée, John 'Scottie' Ferguson returns once more to the vertiginous bell-tower, where Judy is killed purely by accident.

VII. The Politics of Birds

What one can say about the birds in *The Birds* is that they seem to follow at least three scripts: an evolutionary script, in which they embody an enigmatic eruption of a violent, instinctual aggression (du Maurier), an optical, cinematographic script, in which they are bodies related in an affective bloc created by vision and sound (Hitchcock), and an Oedipal script that functions as the narrative carrier and that provides motive (Hollywood).

But what about desire and its distribution? Up until now, I have neglected the level of the narration in favour of moments of the production of affect, and the level of politics in favour of the level of a poetics. Affect, however, is not only a product *of* the movies, it is also a topic *in* their narratives. To look at the distribution of desire in the movies addresses the difference between the Oedipal and

the anoedipal from a slightly different perspective. Quite obviously, both *Psycho* and *The Birds* are libidinally highly charged. While psychoanalysis reads their plots in the context of human sexuality, however, a schizoanalytic reading stresses how they assemble site-specific sexual landscapes according to 'the truth' that 'sexuality is everywhere' (Deleuze and Guattari 1983: 293), which means: in the non-human arena as well.

Although in both movies the deviant desiring-machines are assembled from under the shadow of Oedipus, there is an important difference between *Psycho* and *The Birds*. Norman's desiring-machine remains framed by a human perspective, while the birds widen the field of desire to the level of the non-human. More directly than Norman does, they show that, as Michel Serres states in *Genesis*, 'the cosmos is not a structure, it is a pure multiplicity of ordered multiplicities and pure multiplicities' (Serres 1995: 111). As such, they are more directly images of anoedipal schizo-machines.

Both in the story and the movie, the individual birds become first a swarm and then a bird collective: 'a war machine: a physics of packs, turbulences, "catastrophes," and epidemics' (Deleuze and Guattari 1987: 490). More than in du Maurier's story, however, in the movie this war machine is assembled against the background of the 'habitual' capture of birds by humans. Hitchcock plays with this not only in the movie's opening scene, which is set in a pet store amidst countless caged birds, but also in a trailer he made for the movie, which shows him narrating, with his usual ironic detachment, how utterly horribly humans have, throughout history, treated the species of birds.[13] A similar reason 'why the birds attack' is provided when Hitchcock notes that the film is about the 'reversal of the age-old conflict between men and birds' (Truffaut 1968: 360). Again, however, these explanations do not seem to be central to the movie. They are conceptual MacGuffins provided outside of the frame of the actual movie, which never directly addresses this aspect. In fact, in a scene that was later deleted, Melanie and Mitch were actually supposed to make fun of 'why' the birds attack: 'They joked about the fact that the birds have a leader, that he's a sparrow perched on a platform addressing all the birds and saying to them, "Birds of the world, unite. You've nothing to lose but your feathers"' (364).

On another level, however, the change of the habitual relationship of birds and humans is addressed throughout the movie, especially in the way it charts the gradual production of the birds' war machine. Already in its opening scene in the pet store, the flirtatious conversation

between the 'lovebirds' Mitch and Melanie is drowned out by the nervous twittering of the caged birds that washes acoustically over the voices. In their acoustic insistence, the birds in the store have begun to no longer fit the image of the romantic lovebirds Melanie wants to buy. Already, they have become terrifying twittermachines whose decibel level quite materially disturbs the spectators in their attempt to make sense of the dialogue. Later, the motif of the cage is taken up by the caged bird Melanie carries on the boat, and by the way Hitchcock sets up the scene in the telephone booth. As Hitchcock notes, 'Melanie Daniels takes refuge in a glass telephone booth and I show her as a bird in a cage' (Truffaut 1968: 360).

After the first gull's aggressive inclination, the birds, as if they had collectively read Althusser, assemble around the school, as one of the most effective institutions of Oedipalisation, where they congregate, in an inexorably slow fashion, on the telephone wires, in a scene that, quite ironically, superimposes two modes of information transfer: one human, the other aviatory. Rather than being a figure of human desire, is the movie not, therefore, much more the figure of a fight between caged desire and free desire? A fight between the two equally real series of birds and humans? A reversal of series: the birds are free, the humans are caged.

In the movie's tracing of the birds' assembly of a war machine, their attacks become figures of a desiring-machine that is fuelled by a pure, anoedipal and thus unrestrained energy; an energy that defines the movie's central affective spaces, from the first inclination to the various endings, in one of which the final image should have been of the birds 'covering' the Golden Gate Bridge.

The birds' desiring-machine, therefore, is not, as in Žižek, a stain that embodies an impossible, real sexuality that is excluded from the subject's psychic reality and thus from the space and interest of psychoanalysis except in its very negativity *as* excluded. Rather, it sets up, on a machinic level below any Oedipal organisation, a complex energetic force field that might be said to embody what Deleuze calls, in *Difference and Repetition*, the field of 'passive syntheses' (Deleuze 1994: 74). As a war machine, the birds re-distribute their relation to the overall environment on a level of a material anoedipal production on an 'unconscious' level below and beyond the level of the human. As Deleuze and Guattari state in *Anti-Oedipus*, 'we do not deny that there is an Oedipal sexuality, an Oedipal heterosexuality and homosexuality, an Oedipal castration, as well as complete objects, global images, and specific egos' (Deleuze and Guattari 1983: 74). But then, they make a crucial distinction, declaring

that '[w]e deny that these are the production of the unconscious' (74). The productions of the unconscious are quite literally swarms of desiring-machines.

Once more, Hitchcock is not really interested in the birds' ultimate motivation or in the birds as figurations of Oedipal violence. Rather, he is interested in the gradual optical superimposition of the birdmachine onto the Oedipal machines that define Bodega Bay, and in the ways it brings about their violent deterritorialisation. The smooth sky, waves of birds, in revolt against the striated bay. As such, the birds' war machine resonates with the war-machine aspect of schizoanalysis, which is directed against the Bodega Bay of psychoanalysis. As Deleuze and Guattari note, 'schizoanalysis must be violent, brutal: defamiliarizing, de-oedipalizing, decastrating; undoing theater, dream, and fantasy; decoding, deterritorializing' (381).

Importantly, the birdmachine is not a natural machine, because, as I noted before, nature itself is not natural. It is always 'machinic' and thus 'montaged', which brings me back to du Maurier's notion that the birds follow an evolutionary instinct. Deleuze and Guattari emend this to the more radical idea that 'desire is never an undifferentiated instinctual energy', but 'a highly developed, engineered setup rich in interactions' (Deleuze and Guattari 1987: 215). The real desire is to build machines: 'Assemblages are passional, they are compositions of desire. Desire has nothing to do with a natural or spontaneous determination; there is no desire but assembling, assembled desire' (399). The birds assemble a molecular, non-human *schizo*machine – as Deleuze and Guattari note, '[t]he desiring micromultiplicities are no less collective than the large social aggregates' (Deleuze and Guattari 1983: 340) – and as such they come to embody the positive productions of a material unconscious; a field in which

> [s]exuality is no longer regarded as a specific energy that unites persons derived from the large aggregates, but as the molecular energy that places molecules-partial objects (libido) in connection, that organizes inclusive disjunctions on the giant molecule of the body without organs [...] and that distributes states of being and becoming according to domains of presence or zones of intensity [...] For desiring-machines are precisely that: the microphysics of the unconscious. (183)

The birds' mycrophysical dynamics actualise the tensors of an enigmatic evolutionary drift that goes far beyond the 'ecological' (Žižek 1992a: 97) narrative mentioned by Žižek. The birds become a thousand tiny

sexes, uncontrollable emanations of a deterritorialising energy field that unleashes itself over the Oedipal bay:

> for the two sexes imply a multiplicity of molecular combinations bringing into play not only the man in the woman and the woman in the man, but the relation of each to the animal, the plant, etc. a thousand tiny sexes. (Deleuze and Guattari 1987: 213)

In this context, the difference between swarms and families can be read as that between anoedipal war machines and war machines that are operationalised and Oedipalised by the state, such as the Oedipal war machine that defines the symbolic order of Bodega Bay.

While Norman is unable to untangle his sexual war machine from his highly Oedipalised environment, the birds' war machine succeeds in completely destabilising the overall Oedipal machine: the thousands of birds assemble a desiring-machine that 'is the production of a thousand sexes, which are so many uncontrollable becomings' (278–9). It is much easier, therefore, to be on the side of the birds than to be on the side of Norman. They do not discriminate. They are not after anybody specific. They simply show that, according to a schizoanalytic logic, every Oedipalised family romance can be deterritorialised into a more comprehensive, more complex and more anonymous chemical romance; into the field of libidinal micro-machines that an Oedipal sexuality has repressed and organised in order to come into being. Below Oedipal sexuality, $n - 1$ sexes, below stable structures, $n - 1$ sets of unstable, dynamic relations: 'Go, Birdies, go!' or, in the rhetoric of Deleuze and Guattari: 'Destroy, destroy. The task of schizoanalysis goes by way of destruction [...] Destroy Oedipus' (Deleuze and Guattari 1983: 311). In Žižek, the birds are the hallucinations of a real sexuality that enters human sexuality only as a traumatic stain. In Deleuze, the birds are part of the non-human world's sexual diagram that engages with the human world's sexual diagram in a fully machinic, deterritorialising manner.

Symptomatically, the soundtrack of *The Birds* is literally synthesised from the acoustic reservoir of actual twitterings and wing-flaps: from the actual twittermachine. As Hitchcock notes, it is a true *sound*-track: 'We used only sounds for the whole of the picture. There was no music' (Truffaut 1968: 369). The acoustic effect Hitchcock aimed for was 'a menacing wave of vibration' (371); a purely affective, non-musical landscape of birdsound.[14]

Let us come back to the question of the 'meaning' of it all. From a psychoanalytic angle, the birds' attacks are projections or embodiments

of the protagonists' psychic attitudes, which is why the question about the reasons for the attacks can be answered from within the conceptual architecture of psychoanalysis. Quite literally, the birds attack because 'mother is afraid of being left alone' and *only* because mother is afraid of being left alone. The agency, therefore, lies with mother. Her maternal superego quite literally wills the birds into being.

If psychoanalysis can resolve the problem 'without a rest', Wood maintains that the question cannot be answered at all, stating that '[t]he question we are left with, "What do you suppose made it (the seagull) do that?" is not meant to have an answer' (Wood 1989: 159). For Wood, the meaning of the birds lies precisely in their meaninglessness: 'The film derives its disturbing power from the absolute meaninglessness and unpredictability of the attacks' (162).[15] Here, the agency lies solely with the birds. Both of these approaches miss the middle ground on which the bird series intersects with the human series. Both fail to address the diagram of the complex relations that pertain between the two fields and thus the poetics and the politics of their interaction. Already in *Anti-Oedipus*, Deleuze and Guattari had stated that the cinema 'is not analytical and regressive, but explores a global field of coexistence' (Deleuze and Guattari 1983: 274).

VIII. In Lieu of a Conclusion: Motel Architecture 2

In Ballard's 'Motel Architecture', Pangborn begins, at some point, to feel that he is being haunted by a stranger who first stabs Vera Tilley to death in the shower and then attempts to kill Pangborn. In the end, in fact, the stranger indeed does succeed in killing Pangborn, but then the stranger is of course Pangborn himself. Ballard's narrative twist defines the final act of murder as a schizo-suicide. The final image is of Pangborn 'rais[ing] the knife to his happy heart' (Ballard 1982: 194). As on a projective plane, on the narrative surface of 'Motel Architecture' actual musculature and virtual consciousness enter into a complex arrangement that remains as enigmatic as Gein's personal killing machine or as real-life death by bird.

The only truth of Ballard's story, as well as of Hitchcock's movies, is that of the dramatisation of the adequate optical attribution of matters-of-fact and relational architectures; the enigmatic, affective truth of Ballard's and Hitchcock's motel architectures: their schizoanalyses. In fact, Ballard is extremely Deleuzian in his reading of a schizoanalytic Hitchcock, and thus of a poetics and politics of the cinema in which the movie screen becomes a projective plane on which the actual and

the virtual converge by way of crystal-images: a screen on which virtual surface and actual points, bodily affect and the idea of the affect meet at infinity.

A more recent literary variation on the *Psycho* theme, Don DeLillo's *Point Omega* (2010), stresses, like 'Motel Architecture', the affective power of the movie and the crystal relation between the actual and the virtual series. The text consists of a narrative that is framed by two scenes, called 'Anonymity' and 'Anonymity 2', that describe a nameless male person watching – as obsessively as Pangborn watches *Psycho* – Douglas Gordon's real-life installation *24 Hour Psycho*, which decelerates the movie from its original 109 minutes to a running time of 24 hours. The narrator describes this installation as something akin to a weightless sculpture made purely from light. 'The screen was free-standing, about ten by fourteen feet, not elevated, placed in the middle of the room. It was a translucent screen' (DeLillo 2010: 3).

The man is especially obsessed with the affects the slowed-down images extract from the narrative. As the third-person narrator notes, '[t]his was the point. To see what's here, finally to look and to know you're looking, to feel time passing, to be alive to what is happening in the smallest registers of motion' (6). In the slow-motion projection, which shifts the focus quite literally from the movement-image to the time-image, narrative and meaning dissolve into floating moments of memory and affect, isolating details such as the 'flurries of trembling light' (ibid.) or the 'four rings spinning slowly over the fallen figure of Janet Leigh, a stray poem above the hellish death' (9) from the flow of the narration. Watching is no longer about signification, interpretation or about making *sense*. It is about making *sensation* and about being affected by the images of a pure cinema. Like Pangborn, the man is literally suspended in the space of Hitchcock's pure cinema, in the sense that suspense comes from the Latin *suspendere*. When two visitors enter the room, whom the man imagines to be two professors, he notes that an academic, hermeneutical – and, I would add, a psychoanalytical – approach must inevitably miss the affective dimension of the movie: 'their vocabulary of film [...] could not be adapted to curtain rods and curtain rings and eyelets' (10).

For the nameless spectator, the film becomes, in its deceleration, 'pure film, pure time' (6). The images slow down into arrangements of purely optical affect. In their separation from the narrative movement, they become pure crystal-images:

She is running into darkness, a beautiful thing to see, decelerated, the woman running, shedding background light as she comes, face and shoulders slightly shaped, total dark falling in around her. This is what they ought to talk about here, if they talk, when they talk, light and shadow, the image on the screen. (110)

For the spectator, it is ultimately a question of how to literally move into the projective plane of the screen: 'He wanted the film to move even more slowly, requiring deeper involvement of eye and mind, always that, the thing he sees tunneling into the blood, into dense sensation, sharing consciousness with him' (115). How to literally seep into the screen, or let the images seep into him: 'Or was the film thinking into him, spilling through him like some kind of runaway brain fluid?' (109). How to occupy the projective space between fiction and life? When another visitor of the installation goes to stand behind the screen and acts out Bates's movements, the man wonders 'what made this side of the screen any less truthful than the other side?' (4).

The middle section of *Point Omega* is a first-person narrative by Jim Finley, a filmmaker who plans to make a documentary starring Richard Elster, an academic who was involved in the American government's organisation of the war in Iraq. The two men, who are now identified as the two men who had walked into the installation in the 'Anonymity' section, are staying in a house in the desert, where Finley tries to convince Elster to participate in the documentary. At some point, Elster's daughter Jessie joins them. When she vanishes, the two men and the police search for her, but all they find is a knife. After a time, the two men return to New York.

In the middle of this story, Finley voyeuristically watches Jessie first in the bathroom and later on in her bedroom. After this, she vanishes. Has he killed her? Has he been re-enacting Bates? The story does not tell. In the final section, 'Anonymity 2', the male spectator's dream of meeting a woman in the installation becomes true. The woman is reminiscent of Jessie. The two talk for a while, they leave the installation together, but the meeting does not lead anywhere. The man goes back to the installation and 'returns his attention to the screen, where everything is so intensely what it is' (116). He thinks about his mother: 'pure literature'.

IX. To recapitulate

The poetics and politics one might develop from the above readings is one of affects: of the attribution of bodily affects and mental affectations

that are, in Hitchcock, realised optically as crystal-images. Hitchcock's movies are not so much adequate equations of an Oedipal logic. Rather, they are adequate optical equations of the infinitely complex diagram of the world, and of the human and non-human stressors and tensors that make up this diagram. They are adequate optical equations of the world's circumstances and its enigmatic dynamics that cut across an Oedipal logic. In this shift, the psychoanalytic stain becomes a smear that dissolves in the fluid dynamics of this world. Invariably, Hitchcock's optical arrangements are figures that form complex affective landscapes shot through with enigmatic, anonymous affects that wash over bodies and minds equally.

Let me close with a final rhetorical question, a stylistic device I have hijacked for this essay from Žižek, who likes to use it for his more outrageous claims. Here, then, is my outrageous claim: Is not psychoanalysis the ultimate MacGuffin in Hitchcock's work? Is not it merely a random object that exists only in order to get the schizoanalytics of Hitchcock's optical, cinematographic machine running?

Notes

1. For such deprogrammings see Ishii-Gonzáles 2004; Buchanan 2002, 2006; Conley 2009.
2. See also Conley's (2009) discussion of Deleuze's differentiation between the archive and the diagram as the fields of form and force, respectively: 'actual form' and 'virtual force'.
3. As Truffaut notes, Hitchcock 'hinge[s] the plot around a striking coincidence' (Truffaut 1968: 15).
4. '[T]he state of nature is always already more than a simple state of nature' (Deleuze 1991: 39).
5. Cf. Thomson 2009.
6. 'He was not interested in characters or motivation at all. That was the writer's job' (Rebello 1990: 41). See also Hitchcock's disinterest in the real-life story: 'It was the story of a man who kept his mother's body in his home, somewhere in Wisconsin' (Truffaut 1968: 338).
7. '[T]he thing that appealed to me and made me decide to do the picture was the suddenness of the murder in the shower, coming, as it were, out of the blue. That was about all' (Truffaut 1968: 338). Wood also maintains that Hitchcock's films 'derive their value from the intensity of the images – an intensity created and controlled very largely by context, by the total organisation – rather than from the creation of "rounded" characters' (Wood 1989: 164).
8. http://hitchcock.tv/quotes/quotes.html (accessed 10 October 2010).
9. Edelman deflects the psychoanalytic machine into the field of queer studies, reading the birds as embodiments of 'the arbitrary, future-negating force of a brutal and mindless drive' (Edelman 2004: 127). For a critique of psychoanalytic readings of Hitchcock, see Cohen, who maintains that 'it is insufficient to declare Hitchcock, or *Psycho*, simply anti-Oedipal [...] any more than one can hustle

to the Lacanian prop box to retrieve "maternal superego" to plaster over birds that have, as clearly as possible, deflected anthropomorphisms or family plots' (Cohen 2005b: 83). Against Žižek's 'painfully conventional' (Cohen 2005a: 47) mapping of 'the psychoanalytic facade' (Cohen 2005b: 78) and Deleuze's presumed 'relapse [...] into a logic of symbolization' (Cohen 2005a: 45) and 'figuration' (48), Cohen sets the grammatological play of the signifier.

10. In *Spellbound* (1945), the treatment is equally loose, although *The House of Dr. Edwardes* (Beeding 1928) contains deeply Oedipal moments. As Hitchcock notes, '*Spellbound* is based on complete psychiatric truth' (Hitchcock 1995d: 114). In the movie, the plot of the novel is significantly altered, and the staging of the dreamwork famously 'outsourced' to Salvador Dalí.

11. Thomson notes that the scene is 'the equivalent of the shower murder in *Psycho* – shot as lovingly as a romantic scene' (Thomson 2009: 109). See also Wood 1989: 153.

12. For a discussion of the optical technology see Wood (1989: 157, 159) and Žižek (1992b: 200, 236–7).

13. http://www.youtube.com/watch?v=MZjaVdJt59U (accessed 20 September 2010).

14. On the soundtrack of *The Birds*, see also Restivo 2004.

15. Cohen also considers the birds as 'causeless' (Cohen 2005b: 151), 'antiapocalyptic' (151) and ultimately as 'teletechnic agents' (155).

References

'Alfred Hitchcock: Wit & Wisdom', *Alfred Hitchcock: The Master of Suspense*, The Alfred Hitchcock Trust, available at http://hitchcock.tv/quotes/quotes.html (accessed 10 October 2010).

Ballard, J. G. (1982) 'Motel Architecture', in: *Myths of the Near Future*, London: Cape, pp. 178–94.

Beeding, Francis (1928) *The House of Dr. Edwardes*, New York: Little, Brown.

Bellour, Raymond (1986) 'Psychosis, Neurosis, Perversion', trans. Nancy Huston, in Marshall Deutelbaum and Leland Poague (eds), *A Hitchcock Reader*, Ames, IA: Iowa State University Press, pp. 311–31.

Bloch, Robert (1959) *Psycho*, Greenwich: Fawcett Publications.

Boileau, Pierre and Thomas Narcejac (1954) *D'Entre les morts*, Paris: Denoël.

Buchanan, Ian (2002) 'Deleuze and Hitchcock: Schizoanalysis and *The Birds*', *Strategies: Journal of Theory, Culture and Politics*, 15:1, pp. 105–18.

Buchanan, Ian (2006) 'Žižek and Deleuze', in Geoff Boucher, Jason Glynos and Matthew Sharpe (eds), *Traversing the Fantasy: Critical Responses to Slavoj Žižek*, Farnham: Ashgate Publishing, pp. 69–88.

Cameron, Ian and Richard Jeffery (1986) 'The Universal Hitchcock', in Marshall Deutelbaum and Leland Poague (eds), *A Hitchcock Reader*, Ames, IA: Iowa State University Press, pp. 265–78.

Cohen, Tom (2005a) *Hitchcock's Cryptonymies: Volume 1. Secret Agents*, Minneapolis: University of Minnesota Press.

Cohen, Tom (2005b) *Hitchcock's Cryptonymies: Volume 2. War Machines*, Minneapolis: University of Minnesota Press.

Conley, Tom (2009) '*The 39 Steps* and the Mental Map of Classical Cinema', in Martin Dodge, Rob Kitchin and Chris Perkins (eds), *Rethinking Maps: New Frontiers in Cartographic Theory*, New York: Routledge, pp. 131–48.

Deleuze, Gilles (1986) *Cinema 1: The Movement-Image*, trans. Hugh Tomlinson and Barbara Habberjam, Minneapolis: University of Minnesota Press.

Deleuze, Gilles (1989) *Cinema 2: The Time-Image*, trans. Hugh Tomlinson and Barbara Habberjam, Minneapolis: University of Minnesota Press.

Deleuze, Gilles (1991) *Empiricism and Subjectivity*, trans. Constantin Boundas, New York: Columbia University Press.

Deleuze, Gilles (1994) *Difference and Repetition*, trans. Paul Patton, New York: Columbia University Press.

Deleuze, Gilles and Félix Guattari (1983) *Anti-Oedipus: Capitalism and Schizophrenia*, trans. Robert Hurley, Mark Seem and Helen R. Lane, Minneapolis: University of Minnesota Press.

Deleuze, Gilles and Félix Guattari (1987) *A Thousand Plateaus: Capitalism and Schizophrenia*, trans. Brian Massumi, Minneapolis: University of Minnesota Press.

Deleuze, Gilles and Félix Guattari (1994) *What is Philosophy?*, trans. Hugh Tomlinson and Graham Burchell, New York: Columbia University Press.

DeLillo, Don (2010) *Point Omega*, New York: Simon and Schuster.

du Maurier, Daphne (1952) 'The Birds', in *The Apple Tree*, London: Gollancz, pp. 85–123.

Edelman, Lee (2004) *No Future: Queer Theory and the Death Drive*, Durham: Duke University Press.

Freud, Sigmund ([1925] 1953–74) 'Negation', in *The Standard Edition of the Complete Psychological Works of Sigmund Freud*, ed. and trans. James Strachey, 24 vols, London: Hogarth Press and the Institute of Psychoanalysis, vol. 19, pp. 235–9.

Hitchcock, Alfred (1995a) 'It's a Bird, It's a Plane, It's... *The Birds*', in Sidney Gottlieb (ed.), *Hitchcock on Hitchcock: Selected Writings and Interviews*, London: Faber and Faber, pp. 315–17.

Hitchcock, Alfred (1995b) 'On Film Production', in: Sidney Gottlieb (ed.), *Hitchcock on Hitchcock: Selected Writings and Interviews*, London: Faber and Faber, pp. 210–26.

Hitchcock, Alfred (1995c) 'On Style', in: Sidney Gottlieb (ed.), *Hitchcock on Hitchcock: Selected Writings and Interviews*, London: Faber and Faber, pp. 285–302.

Hitchcock, Alfred (1995d) 'Let 'Em Play God', in: Sidney Gottlieb (ed.), *Hitchcock on Hitchcock: Selected Writings and Interviews*, London: Faber and Faber, pp. 113–15.

Horwitz, Margaret M. (1986) '*The Birds*: A Mother's Love', in Marshall Deutelbaum and Leland Poague (eds), *A Hitchcock Reader*, Ames, IA: Iowa State University Press, pp. 279–87.

Ishii-Gonzáles, Sam (2004) 'Hitchcock with Deleuze', in Richard Allen and Sam Ishii-Gonzáles (eds), *Hitchcock: Past and Future*, New York: Routledge, pp. 128–45.

North by Northwest, directed by Alfred Hitchcock. USA: Metro-Goldwyn-Mayer, 1959.

Psycho, directed by Alfred Hitchcock. USA: Shamley Productions, 1960.

Rebello, Stephen (1990) *Alfred Hitchcock and the Making of Psycho*, London: Reed International Books.

Restivo, Angelo (2004) 'The Silence of *The Birds*: Sound aesthetics and public space in later Hitchcock', in: Richard Allen and Sam Ishii-Gonzáles (eds), *Hitchcock: Past and Future*, New York: Routledge, pp. 164–78.

Rope, directed by Alfred Hitchcock. USA: Warner Bros Pictures, 1948.

Serres, Michel (1995) *Genesis*, trans. G. James and J. Nielson, Ann Arbor: University of Michigan Press.

Spellbound, directed by Alfred Hitchcock. USA: Vanguard Films, 1945.

Spinoza, Baruch (2006) *Ethics, The Essential Spinoza: Ethics and Related Works*, Indianapolis: Hackett Publishing Company.

The Birds, directed by Alfred Hitchcock. USA: Universal Pictures, 1963.

The Man Who Knew Too Much, directed by Alfred Hitchcock. USA: Paramount Pictures, 1956.

The Pervert's Guide to Cinema, directed by Sophie Fiennes. Slavoj Žižek (writer and presenter). UK: Amoeba Film, 2006.

The Trouble with Harry, directed by Alfred Hitchcock. USA: Paramount Pictures, 1955.

Thomson, David (2009) *The Moment of Psycho: How Alfred Hitchcock Taught America to Love Murder*, New York: Basic Books.

'Trailer for *The Birds*', available at http://www.youtube.com/watch?v= MZjaVdJt59U (accessed 20 September 2010).

Truffaut, François (1968) *Hitchcock*, London: Martin Secker and Warburg.

Vertigo, directed by Alfred Hitchcock. USA: Paramount Pictures, 1958.

Wood, Robin (1989) *Hitchcock's Films Revisited*, London: Faber and Faber.

Žižek, Slavoj (1992a) *Looking Awry: An Introduction to Jacques Lacan through Popular Culture*, London: MIT Press.

Žižek, Slavoj (1992b) 'The Individual: Hitchcock's Universe', in Slavoj Žižek (ed.), *Everything You Always Wanted to Know about Lacan (But Were Afraid to Ask Hitchcock)*, London: Verso, pp. 211–72.

Signs Without Name[1]

Nadine Boljkovac Independent Researcher

Abstract

This paper argues that Chris Marker's 1982 film *Sans Soleil* derives its affective force from doublings and 'faces' of horror and beauty that reveal a twofold synthesis of actual and virtual. While a focus upon the material, ever in relation to transient yet lingering sensations, cannot discharge the power and force of the film, this paper endeavours nevertheless to assess and evoke Marker and Deleuze's own interrogative methods that thoroughly explore, in the manner of a revelatory 'schizoanalysis' or empiricism, molecular and variable operations beneath our 'molar' structures and organisations. As *Sans Soleil*'s voiceover states, 'If they don't see happiness in the picture, at least they'll see the black', a provocative remark that invokes indefinable singularities and the darkness of a wound, cracking of time and splitting of self in film, life and death. Considerations of death, consciousness and subjectivity extend this paper's examinations.

Keywords: Marker, affect, sensation, becoming, force, counter-actualisation, subjectivity

'Poetry is born of insecurity: wandering Jews, quaking Japanese; [...] moving about in a world of appearances: fragile, fleeting, revocable, of trains that fly from planet to planet [...]. That's called "the impermanence of things".'

Sans Soleil 1982; hereafter *SS*

The artist tells him- or herself that this world has had different aspects, will have still others, and that there are already others on other planets; finally, the artist opens up to the Cosmos in order to harness forces in a 'work'.

(Deleuze and Guattari 1987: 337)

Deleuze Studies 5.2 (2011): 209–240
DOI: 10.3366/dls.2011.0018
© Edinburgh University Press
www.eupjournals.com/dls

Lawrence [...] writes: 'To be alone, mindless and memoryless beside the
sea... [...].

Far off, far off, as if he had landed on another planet, as a man might after
death.'

(Deleuze and Guattari 1987: 189)

'I'm writing you all this from another world.'

(*SS*)

A seemingly otherworldly, fleeting yet haunting series of visual, voice
and sound assemblages amassed with the 'relentlessness of a bounty
hunter' constitute the opening moments of Chris Marker's *Sans Soleil*
(1982) during which the narration announces: 'He wrote: I've been
round the world several times and now only banality still interests
me.' At once specific, explicit and cryptic, the film's narration and
images of time deftly manifest doublings and paradoxes of life, creation
and experience: death and survival, memory and forgetting, horror
and beauty, fragility and indestructibility, joy and loss, layers of
life that simultaneously, collectively comprise, as *Sans Soleil* suggests,
familiar *and* indecipherable aspects of existence that the film seeks
to momentarily glimpse and distinguish. Via its embrace of spiritual
cosmic 'worlds' within our own whose language of 'electronic graffiti'
delineates 'the contours of what is not, or is no longer, or is not yet' (*SS*),
Marker's film sensorily evokes a melancholy whose disembodied wounds
bespeak the loss of actual limits and survival of virtual remains. By such
affecting embodiment, *Sans Soleil* effectively unearths the untranslatable
and impermanent, that invisible *between* or 'poignancy of things', the
'Japanese secret' that implies 'the faculty of communion with things, of
entering into them, of being them for a moment' so that, 'in their turn[,]
they should be like us: perishable and immortal' (*SS*).[2]

Persistently, *Sans Soleil* attempts to convey paradoxically enduring
yet evanescent sensations and melancholies, those poignant 'immobile
shadows' (*SS*) begot by disembodied wounds. At the margins of our
world between all things past and future, visible and invisible, the film
then encounters that ceaselessly double process, coincidence or *between*
of forces as it glares at the 'partition that separates life from death' and
that 'last state – before their [actual] disappearance – of the poignancy of
things' (*SS*). This pursuit, that is, of *Sans Soleil* and all Marker works
through their respectively innovative and new means is, as insists *Sans
Soleil*'s narration, 'not a search for contrasts' but a 'journey to the two
extreme poles of survival'. Yet whilst *Sans Soleil* purportedly examines
the two 'extremes' of Japan and Africa, it more profoundly contemplates

the dynamic movements of actual-virtual relations with their doublings and faces of horror and beauty that reveal the two sides of all things, that twofold synthesis of actual and virtual split continually into two like time's past-future divide itself.

Microscopically and intensely, the film pursues the 'virtual counterpart' (*SS*) and poignancy of all things corporeal and incorporeal, seen and unseen; through the unexpected and ever-transitive, *Sans Soleil* discerns virtual extensions, *thisnesses* that defy name, and *signs* that forever impinge upon the soul that line the actual mundane quotidian. 'He wrote me: coming back through the Chiba coast I thought of Shonagon's list, of all those signs one has only to name to quicken the heart, just name' (*SS*). A sign, as Deleuze through Spinoza proposes, 'can have several meanings' but is always 'an *effect*', 'the trace of one body upon another' (Deleuze 1997: 138). With regard to the impossibility of naming or affixing affective experience, *Sans Soleil* respectively remarks: 'To us, a sun is not quite a sun unless it's radiant.' In quest then of the ineffable, of signs without name or dynamic unfoldings and revelations of the routinely imperceptible, of *thisnesses*, haecceities and piercing moments 'held [...] at arm's length, [...] zoom's length, until [... their] last twenty-fourth of a second' (*SS*), *Sans Soleil* perseveres. 'If they don't see happiness in the picture, at least they'll see the black' (*SS*).

'The *white or black screen*, finally', writes Ronald Bogue à propos modern cinema, 'is the interstice made visible' (Bogue 2003: 179). 'The first image he told me about', begins *Sans Soleil*, 'was of three children on a road in Iceland, in 1965. He said that for him it was the image of happiness and also that he had tried several times to link it to other images, but it never worked' (*SS*). *Sans Soleil*'s first series of unlinked images, that of three Icelandic children, a US war plane and finally 'a long piece of black leader' (*SS*), indeed overtly exposes, in direct relation to Marker's 1962 *La Jetée*, the screen and the filmic cut, that *between* of images that potentially becomes, as Deleuze explains, the screen itself.

In relation to the means through which *Sans Soleil* foregrounds the cuts between its images, as through its long piece of black leader in these opening moments of the film, it is vital to return to Deleuze's writing on modern cinema and the postwar time-image. For, once more, Deleuze identifies

[a] reversal where the image is unlinked and the cut begins to have an importance in itself. [...] there is no longer linkage of associated images, but only relinkages of independent images. [...] one image *plus* another [...]. The cut may now be extended and appear in its own right, as the black screen, the white screen and their derivatives and combinations. (Deleuze 1989: 213–14)

Through this method of between or AND – what Deleuze terms a 'whole new system of rhythm' or 'serial or atonal cinema' – modern cinema, moreover *Sans Soleil* itself, gives rise to not only the emergence of a direct presentation of time but also the time-image's direct encounter with the limits of thought itself (Deleuze 1989: 214).

For this encounter between thought and image, as staged throughout many of Marker's films, also discovers particular significance via *Sans Soleil*. Unlike Marker's *La Jetée* as well as the early films of frequent collaborator and friend Alain Resnais that each emerge from a certain definitive horror – the Holocaust, Hiroshima, an atomic apocalypse – *Sans Soleil* shifts towards a more comprehensive, layered interrogation of both strangely familiar *and* indecipherable aspects of life that exist ever in relation to sufferings past and yet to come. *Sans Soleil*'s acute scrutinisation of the banal does indeed reveal unexpected horrors and excesses that bespeak not a single monumental historic event but countless unique injustices and sorrows and their everlasting reverberations.

To reiterate a primary contention of this paper and Deleuze's cine-philosophy, the time-image in effect 'puts thought into contact with an unthought, the unsummonable, the inexplicable, the undecidable, the incommensurable' (Deleuze 1989: 214), that breakdown or crack we confront as our corporeal *and* incorporeal reality, which death's virtual/impersonal, actual/personal aspects most profoundly embody. Engendered in response to the actual horrors of our world, their lingering affective effects and our complicity, complacency and banality, the modern cinema's expression of an 'impotence' or powerlessness precipitated the breakdown of the cinema's sensory-motor organisation, the method of linear, rational or 'sutured' continuity championed in classic cinema. What modern cinema of the time-image 'advances', claims Deleuze, 'is not the power of thought but its "impower"' (Deleuze 1989: 166).

Modern cinema in effect encounters what Deleuze by way of Artaud recognises as the 'powerlessness at the heart of thought', that which Deleuze through Artaud believes cinema 'essentially suited to reveal' (Deleuze 1989: 166). For the cracks or cuts of the image in modern cinema expose, as Deleuze maintains, time's fissure of an actual present into both future and virtual past, that domain of all past events that doubles or mirrors the present, as well as the self's own confrontation with the very limits of rational thought that fracture the limits of the self and effect its personal-impersonal split. 'What the modern cinema forces

thought to think is the outside, that dispersive, spacing force that passes into the interstice', Bogue writes (2003: 176).

At the 'two sides of the limit' of the self and of thought demarcated by the irrational cut, 'thought outside itself and this un-thought within thought' (Deleuze 1989: 278), *Sans Soleil*'s long piece of black leader and the disjointed images of its sequences correspond then to the fundamental importance of the 'interstice between two images' and the irrational, autonomous cuts that mark neither beginning nor end (200). The 'object of cinema', declares Deleuze,

> is not to reconstitute a presence of bodies, in perception and action, but to carry out a primordial genesis of bodies in terms of a white, or a black or a grey (or even in terms of colours), in terms of a 'beginning of visible which is not yet a figure, which is not yet an action'. (201)

This making perceptible of the imperceptible is a reversible process of becoming or movement through which novel actualisations and virtual differentiations surface. My larger project devoted to Marker and Resnais's films newly interrogates the multiple forces and interpenetrating bodies, *thisnesses* and things that comprise our world (see Boljkovac 2009b); its analyses reveal what Deleuze acknowledges as the cinema's 'essence', or at least 'one of its essences: a proceeding, a process of constitution of bodies from the neutral image, white or black, snowy or flashed' that ultimately, vitally, restores 'our belief in the world' (Deleuze 1989: 201), *this* world.

For despite Deleuze and Marker's seeming invocations of worlds beyond our own, their poetic cine-philosophy crucially examines creative means of becoming and living in *this* world through revelations of the virtual, untimely affects, forces and singularities of our incorporeal sensations and events and their corporeal effects. 'The problem', Deleuze asserts, 'is *not* that of a presence of bodies, but that of a belief which is capable of restoring the world and the body to us on the basis of what signifies their absence' (202). The problem, that is, is not one of appearances but of 'inconspicuous perceptions' (Deleuze 1993: 89) that make visible the invisible, the interstice, the *between* two images. To repeat Deleuze's words through Godard, 'make the indiscernible, that is the frontier, visible' (Deleuze 1989: 180), and so stare directly, once more, into the 'partition that separates life from death' whilst surveying that 'last state', before their disappearance, 'of the poignancy of things' (*SS*).

What we alternatively recognise as whole – continuous "'images in a chain... an uninterrupted chain of images each one the slave of the next", and whose slave we are' – merges again with that which Blanchot calls 'the force of "dispersal of the Outside"'' (Deleuze 1989: 180). This fissure, crack or '"dissociative force"', a '"hole in appearances"' (Deleuze 1989: 167), forever fractures that which *Sans Soleil* terms our own 'world of appearances', which parallels imperceptible worlds of disappearances. As it perceives this doubling of 'worlds' through its 'constant comings and goings' about the globe (*SS*), and through which we encounter the self's impossibility or impotence at the limits of habitual thought, chronological time and assured subjectivity, the film's epistolary narration remarks: 'In a way the two worlds [of appearances and disappearances] communicate with each other. Memory is to one what history is to the other: an impossibility.'

'The first image he told me about was of three children on a road in Iceland, in 1965.

He said that for him it was the image of happiness.' (*SS*)

Sans Soleil's title screens, in vivid red, purple and yellow, Russian, English and French, respectively, silently follow the film's opening sequence with its fleeting glimpses of a T. S. Eliot quotation, 'Because I know that time is always time / And place is always and only place',[3] three Icelandic children, US war-plane base and black leader that concludes the sequence. The pervasive blackness of both the leader and lengthy interstices between the disparate images underscores, as aforementioned, the film's explicit confrontation with the ineffable limits of cinema and thought that pushes, as Bogue contends through Deleuze with regard to the limits of cinema, 'the visible "to a limit which is at once invisible and yet can only be seen"' as it discloses a speech that '"is at once, as it were, the unspeakable and yet what can only be spoken"' (Bogue 2004: 23; see also Deleuze 1989: 260). If 'thought, in cinema', that is, may be 'brought face to face with its own impossibility', as Deleuze states through Jean-Louis Schefer, thought draws from this powerlessness 'a higher power of birth' through a '*suspension of the world*' and '*disturbance*, which, far from making thought visible [...] are on the contrary directed to what does not let itself be thought in thought, and equally to what does not let itself be seen in vision' (Deleuze 1989: 168).

How then can cinema make visible the invisible through images of time and movement? How does *Sans Soleil* pierce, rupture, reverberate and sensuously affect *beyond* any categorisation, recognition or 'image

of happiness' through its haunting pursuits of life's doublings and paradoxes, and what does this portend for film, life and its intercessions with 'the web of time' (*SS*) and death? 'What becomes essential in modern art', Daniel Smith maintains, 'is no longer the matter-form relation, but the *material-force* relation' (Smith 1996: 43), that which makes us sense unsensible forces, those forces of the Outside beyond apprehension and reproduction that compromise reason and effect the pre-individual.

Such a violent encounter with the intolerable and unthought that, once again, precipitates the cinema's sensory-motor break gives rise to that 'confrontation of an outside and an inside' through thought itself, that which, once more, is 'born from an outside more distant than any external world' and which 'confronts an inside, an unthinkable or unthought, deeper than any internal world' (Deleuze 1989: 278). At the frontier of the self's crack or disintegration and the cinema's own break with indirect representation, empirical and chronological succession (see Deleuze 1989: 155) via its irrational cut that foregrounds the 'two sides of the limit' (278), new kinds of subjectivity emerge which open to a freedom and 'joy' of life.

Through collision with the outside or limit from which they derive, these subjectivities or 'folds' of outside and inside, world and self, engender nonhuman becomings. Despite conventional readings of the film, *Sans Soleil*'s myriad disjunctive connections, or 'relinkages of independent images', do not then, again, convey a contrast between certain homogenised peoples and lands by way of a multi-level narrative or protagonist frequently regarded as a 'fictional stand-in for Marker' (Alter 2006: 103).[4] Rather, *Sans Soleil*'s deterritorialisations of once-historicised images expose the singularities, forces and relations that unfold through actualisations at various levels, before and beyond human consciousness and experience, and that comprise individualities. This break from a phenomenology as grounded in subjectified, clichéd perception (see Deleuze and Guattari 1994: 150) seeks to expose the effects of the virtual relations underlying our states of affairs and bodies that we commonly fail to perceive.

In other words, Marker and Deleuze, with Resnais and Guattari, advance thinking beyond the subject and consciousness as they realise a force of becoming through pure optical and sound descriptions in cinema and concepts in philosophy. These cinematic affects and percepts, and philosophical concepts, evoke both the before and after via the enduring prominence of the interstice or frontier itself through which a direct presentation of time surfaces, a continuum that senses pure duration

and directly captures invisible force, *thisness* and sensation – *red*ness, not blood (see Smith 1996: 46). How then does the artist's material, as Smith persists, 'become capable of "bearing" the sensation?' (42).

With specific regard to the cinema, we must again then also consider what Deleuze claims as 'the essence of cinema – which is not the majority of films' (Deleuze 1989: 168). For the essence of cinema, Deleuze contends, 'has thought as its higher purpose, nothing but thought and its functioning' (168) which operates by way of affect and sensation. '[A]s soon as it takes on its aberration of movement', Deleuze continues, the cinematic time-image

> carries out a *suspension of the world* or affects the visible with a *disturbance*, which, far from making thought visible [...] are on the contrary directed to what does not let itself be thought in thought, and equally to what does not let itself be seen in vision. [...] thought, in cinema, is brought face to face with its own impossibility, and yet draws from this a higher power of birth. (ibid.)

Once more, this 'experience of thought', which 'essentially (but not exclusively) concerns modern cinema' and which is 'a result of the change [or break from sensory-motor organisation] which affects the image' (169), requires 'not imaginary participation' (168). Rather, as my exploration of *La Jetée* also reveals through *thisnesses* and 'things that quicken the heart' (*SS*; see Boljkovac 2009a), this experience of thought corresponds to 'the rain when you leave the auditorium'; it is 'not dream, but the blackness' (Deleuze 1989: 168). This 'encounter with the unthinkable' (171) through sensation pertains to the capture of *thought outside itself*, a self-less seeing and becoming from which *pure* visual situations and a *free indirect discourse* emerge to disclose a new relation between film and thought. The artist's task is always sensation itself, not the sensational, not 'Happiness' but 'the black' that may bear the sensation, should it 'not let itself be seen' (*SS*).

The cinema's interaction of two *unlinked* images then that trace 'a frontier which belongs to neither one nor the other', as Deleuze writes with regard to a modern cinema such as Godard's (181), again distinguishes dimensions of *thisnesses* that can only be sensed, that something in the world 'not of recognition but of a fundamental *encounter*' that forces thought (Deleuze 1994: 139) and 'reach[es] the body before discourses, before words, before things are named: the "first name", and even before the first name' (Deleuze 1989: 172–3). Might we name the unnameable, 'those signs one has only to name to quicken the heart, just name' (*SS*)?

'What then', persists *Sans Soleil*, 'shall we call this diffuse belief, according to which every fragment of creation has its invisible counterpart?' (*SS*). In pursuit of these 'things' or *thisnesses* that quicken the heart, *Sans Soleil*'s experimental foray across intersecting virtual-actual lines of dynamic movements and relations encounters not forms and subjects but what Deleuze and Guattari may term 'a mode of individuation' that is 'very different from that of a person, subject, thing, or substance', and for which they reserve the name *haecceity* (see Deleuze and Guattari 1987: 261–3).

And so, from the rhythms, masks, chants and crowds of an African festival to outer space, an ocean's depths and the performativity of a Japanese parade, *Sans Soleil* traces the frontiers of our globe with an eye seemingly attuned to the exuberant yet more evocative of the minute. For, with 'a sort of melancholy comfort [derived] from the contemplation of the tiniest things', the film locates its heartbeat in these 'neighbourhood celebrations' (*SS*), between the liberated elements – speeds and affects – of forms, subjects and things that flash across the interstices of the film and its audio-visual forces, and through which the oft-indiscernible yet persistent pulsation of a heart, as resonant even through the sounds of a ferry, train or festive parade, may be heard and even felt. 'It might suffice', *Sans Soleil*'s world traveller adds, 'to pick up any one of the telephones that are lying around to hear a familiar voice, or the beating of a heart' (*SS*). Yet, how to name this ubiquitous throbbing of a 'chaotic universe',[5] the uprooted materials and affects of events and becomings, the assemblages, 'climates, winds, seasons, hours' 'we' and all things and animals populate (Deleuze and Guattari 1987: 263), the 'unthinkable which cannot even be spoken' (Deleuze 1989: 171)?

If the limit or ineffable itself as a force of becoming, again what Deleuze terms the 'power of the outside', passes into the interstice to directly realise time in the image (181), each interstice is then, as Bogue concludes, 'an expression or unfolding of the outside' (Bogue 2003: 176). Once more at the limit of personal and impersonal, this force of thought and becoming effects a becoming-imperceptible, a becoming-molecular, becoming-animal, becoming-child, before self-apprehension, memory, language – a '*becoming everybody*': 'For everybody / everything is the molar aggregate, but *becoming everybody / everything* is another affair', maintain Deleuze and Guattari,

> one that brings into play the cosmos with its molecular components. Becoming everybody / everything (*tout le monde*) is to world (*faire monde*), to make a world (*faire un monde*). [...] To be present at the dawn of the world.

[...] To reduce oneself to an abstract line, a trait, in order to find one's zone of indiscernibility with other traits, and in this way enter the haecceity and impersonality of the creator. (Deleuze and Guattari 1987: 279–80)

In relations of speed and slowness, *Sans Soleil*'s traveller-becoming-world skirts from one end of the globe to another across planes and spaces of territorialisation, deterritorialisation and reterritorialisation, those destructive yet also productive movements of social change that the film assesses and towards which it imparts positive force. 'Here', *Sans Soleil* interjects, 'to place adjectives would be so rude as leaving price tags on purchases' (*SS*). 'Japanese poetry never modifies', the narration continues; '[t]here is a way of saying boat, rock, mist, frog, crow, hail, heron, chrysanthemum that includes them all.' Hence, the story of a man from Nagoya who lost his love and killed himself; inasmuch as 'Happiness' exceeds and resists articulation, 'They say he could not stand hearing the word "Spring" ' (*SS*).

As *Sans Soleil* continues to trace and 'map out' the limits of actual-virtual frontiers, the doublings or foldings of life through which one lives 'in two times, at two moments at once' (Deleuze 1990: 158), the film gives rise to liberative dissolutions as truths of memory and history falter and life-affirming 'powers of the false' (see Deleuze 1989: ch. 6) and foreignness emerge within the familiar.

> He wrote me that the pictures of Guinea-Bissau ought to be accompanied by music from the Cape Verde islands. That would be our contribution to the unity dreamed of by Amílcar Cabral. Why should so small a country – and one so poor – interest the world? [...] They traumatized the Portuguese army to such an extent that it gave rise to a movement that overthrew the dictatorship, and led one for a moment to believe in a new revolution in Europe. Who remembers all that? History throws its empty bottles out the window. (*SS*)

If the truthful man wants 'nothing other than to judge life', as Deleuze argues through Nietzsche (Deleuze 1989: 137), to impose morality as a truth and right to self-appointed justice and repressive sovereignty, *Sans Soleil*'s making strange or 'world' via images that disclose a coalescence between virtual and real (see Deleuze 1989: 68) shatters any ideal of truth, and with it our world of appearances whose essential message is 'the code'. '[I]t's a coded hypocrisy', claims *Sans Soleil*; '[t]he code is the message. It points to the absolute by hiding it. That's what religions have always done' (*SS*). The following pages rather find that the 'essential point', as Deleuze sees it, is 'how the new regime of the image (the direct time-image)' shatters such censoring 'truths' in our actual world

and states of affairs as it forges a metamorphosing power of the false (Deleuze 1989: 134–5).

By way of an inclusive method of between through exhaustion (see Boljkovac 2009b: ch. IV; Deleuze 1997: 157–8), and to repeat Deleuze's words once more, what remains are bodies, forces, as Deleuze insists, 'nothing but forces' and their relations, 'the power to affect and be affected', 'the shock of forces, in the image or of the images between themselves' (Deleuze 1989: 139). As these forces of relations, visions of the unseen, or pure affects and percepts, once again encounter an outside, '*the outside* of language, but [...] not outside it' (Deleuze 1997: 112), they forge a foreign language in the interstices, cracks and breaks of the film that gives rise to a vital space of creative becoming and productive reinvention within the actual pre-existent world.

For *Sans Soleil*'s travels about the globe effectively happen *between* or *outside*; they encounter effects and affects, *thisnesses*, that pass or happen 'between two as though under a potential difference', not one term or thing becoming the other but each encountering the other, 'a single becoming which is not common to the two' but again *between* the two, something between or 'outside the two, and which flows in another direction' (Deleuze and Parnet 2002: 6–7). This 'double capture' of the conjunction AND is once more 'neither a union, nor a juxtaposition, but the birth of a stammering, the outline of a broken line' (9–10) and the creative emergence of an *anomalous*, minor people of geography, of 'orientations, directions, entries and exits' (2) and 'very varied lines' (10), an unpeopled people of desert islands,[6] of waves that fold into each other, of people 'populated by tribes' yet deserted and alone in a continual process of self-perceiving perception that forever repeats defining identity whilst defining movements of difference. 'The desert, experimentation on oneself', to repeat Deleuze's declaration, 'is our only identity, our single chance for all the combinations which inhabit us' (11).

As the following sections will discover, *Sans Soleil* effects its own becoming through a dynamic image of itself that engenders a perpetual movement and 'pure consciousness' (Deleuze 2004: 10) through an immanent, connective process of bringing together differentiating and identifying relations. This process of transforming identity through difference lies through an *auto*-perceptibility, of perceiving and being perceived, and affectivity, of affecting and being affected, across, through and over lines of remembering and forgetting, separation and creation.

The nomads of *Sans Soleil*, and the film's nomadic correspondent 'himself', occasion a 'movement [that] does not go from one point to another' but that rather 'happens between two levels as in a difference of potential' (Deleuze and Parnet 2002: 31), in a space of 'involution' or of being 'between' (29), a space of becoming, a deserted space of neither evolution nor regression, past nor future, nor even present, a space in the middle created and reached 'by losing, by abandoning, by reducing, by simplifying', by purifying oneself of one's self through a consciousness that precedes one's self and through which one becomes, a personal-impersonal process of actual contact and potential separation, a vital line, *a* life. Written in the interval before his own death, Deleuze's final essay, 'Immanence: A Life', a piece that resurfaces throughout my explorations of Marker and Resnais's cinemas, gives life to Deleuze's life's doctrine as it renews *Sans Soleil*'s own open-ended becoming.

> A life is everywhere, in all the moments that a given living subject goes through and that are measured by given lived objects: an immanent life carrying with it the events or singularities that are merely actualized in subjects and objects. This indefinite life does not itself have moments, close as they may be to another, but only between-times, between-moments; it doesn't just come about or come after but offers the immensity of an empty time where one sees the event yet to come and already happened, in the absolute of an immediate consciousness. (Deleuze 2001: 29)

Across and through the islands of deserted peoples it discovers, through nomads who have only geography and so have 'neither past nor future' as they exist 'always in the middle' without history (Deleuze and Parnet 2002: 31), *Sans Soleil* probes the *inverse* or *underside* of the actual as it inevitably identifies and yet sees newly while stuttering and pushing the terms of its cinematic means and 'language' 'to its limit, to its outside, to its silence' (Deleuze 1997: 113). As *Sans Soleil*'s journey 'to world' becomes a quest to chart and attain *pure sensation* in terms of remembering and forgetting, repetition and re-creation, Tom Conley's remarks regarding Deleuze's own 'multi-faceted or multi-layered ground plan of the relation of sensation and imagination to location' (Conley 2005: 209) resonate remarkably. For *Sans Soleil*'s rhizomatic, experimental mapping expresses virtual potential–those qualities of possible sensations that defy name: Happiness, unhappiness, emptiness, thirst, Spring, war, the 'great orchestral masses and accumulation of details', 'overcrowded, megalomaniac, inhuman', 'rhythms, clusters of faces', horror and beauty, both of which have 'a name and a face' (*SS*).

If *Sans Soleil* may be conceived as a series of performative encounters, an intensive map via its living screen of intensities and affects, its mapping is 'entirely oriented toward an experimentation in contact with the real' as opposed to any 'tracing'; for a map, as Deleuze and Guattari propose, is that which remains 'open and connectible in all of its dimensions' (see Deleuze and Guattari 1987: 12–15). While the cinema can re-present and re-fortify identity through redundancy, a practice that transforms a map into image, or 'rhizome into roots', *Sans Soleil* alternatively looks to the microscopic events, 'hallucinatory perceptions' and synaesthetic sensations that 'extricate themselves from the "tracing"' and 'balance of power' (Deleuze and Guattari 1987: 15) as it endlessly finds itself in an interval between geography and history, the seeing and non-seen.

Of those unseen, *San Soleil* demands: 'How can one claim to show a category of Japanese who do not exist? [...] their real name – eta – is a taboo word, not to be pronounced. They are non-persons. How can they be shown, except as non-images?' (*SS*). In ways parallel to Deleuze's creative lines of thought, *Sans Soleil* pushes repeatedly towards limits, towards the '*sentiendum*', '*memorandum*', '*cogitandum*' (Deleuze 1994: 141) or, as Bogue writes, 'the insensible that the senses alone can experience', 'the immemorial that memory alone can remember', 'the inconceivable that understanding alone can conceptualize' (Bogue 2004: 23). To render these paradoxes, to again push cinema, to repeat Deleuze's description, 'to a limit which is at once invisible and yet can only be seen' (Deleuze 1989: 260), should one speak then, as Deleuze suggests, of 'a nonstyle' or the ' "elements of a style to come which do not yet exist" ' (Deleuze 1997: 113), of new foreign means of reaching limits of language and cinema through a people and microscopic events yet to come, of rhizomatic maps, networks and fissure-veins in worlds beyond our sight and sun? 'He wrote: Tokyo is a city crisscrossed by trains, tied together with electric wire she shows her veins' (*SS*).

> [I]t is because this world is intolerable that [... thought] can no longer think a world or think itself. The intolerable is no longer a serious injustice, but the permanent state of a daily banality.
>
> (Deleuze 1989: 170)

> 'I've been round the world several times and now only banality still interests me. On this trip I've tracked it with the relentlessness of a bounty hunter'.
>
> (*SS*)

> [A]nd if the writer is in the margins or completely outside his or her fragile community, this situation allows the writer all the more possibility to express

another possible community and to forge the means for another consciousness
and another sensibility.

(Deleuze and Guattari 1986: 17)

'Art, and especially cinematic art', declares Deleuze, 'must take part in
this task: not that of addressing a people, which is presupposed already
there, but of contributing to the invention of a people' (Deleuze 1989:
217). On the margins of the communities he observes, *Sans Soleil*'s
nomadic correspondent witnesses 'a people of wanderers, of navigators,
of world travellers' whose fragile indestructibility ceaselessly fascinates
him (*SS*). 'He didn't like to dwell on poverty', admits the film's narration,
'but in everything he wanted to show there were also the 4-Fs of the
Japanese model. A world full of bums, of lumpens, of outcasts, of
Koreans.' More specifically, he speculates: 'how to film the ladies of
Bissau?' (*SS*).

Whilst he negotiates the two poles of survival, again, no more Japan
and Africa than the intolerable in the everyday and unthinkable in
thought, *Sans Soleil*'s global journeyman gives life to a 'being of thought
which is always to come' (Deleuze 1989: 167) as he envisions the
world and our becomings through it in ever-new ways. 'We are not in
the world, we become with the world', suggest Deleuze and Guattari;
'we become by contemplating it. Everything is vision, becoming. We
become universes. Becoming animal, plant, molecular, becoming zero'
(Deleuze and Guattari 1994: 169; see also Zourabichvili 1996). As an
'alien thinker within the thinker' (Bogue 2003: 177)[7] in the process
of becoming-other, a *spiritual automaton* with dismantled, paralysed
speech and sight torn from any individualised perspective, *Sans Soleil*'s
unseen protagonist perceives, reports and facilitates new kinds of selfless
subjectivity, life and worlds that fold into themselves inasmuch as
'memory lines forgetting' (*SS*).

For as the protagonist encounters the film's worlds they fold into
this wandering traveller so that 'he' and 'we' are enveloped in an
affective, nonhuman becoming-other, a zone of 'indetermination, of
indiscernibility' (Deleuze and Guattari 1994: 173) from which emerge
pure affects, intensities and sensory becomings – 'otherness caught in
a matter of expression' (177). Which is to say, while the film's
actualisations of virtual events participate in, incorporate and embody
the virtual giving it a body, a life, a universe (Deleuze and Guattari
1994: 177), the actualisation yet emanates a virtual excess and force
of the new which gives rise to new ever-differing worlds; such is, as
Sans Soleil reveals, 'the impermanence of things' (*SS*). 'It is the edge of

virtual, where it leaks into actual, that counts. For that seeping edge', claims Brian Massumi, 'is where potential, actually, is found' (Massumi 1996: 236). In this respect, *Sans Soleil*'s voyaging seer peers into the realm of the imperceptible and incommunicable as he interrogates the 'partitions', 'thresholds', 'poles', 'rifts', limits, frontiers and borders, the *folds* and 'coexistences' of our world with its 'subterranean tunnels that [...] run parallel to the city' and youth, the 'baby Martians', who 'live in a parallel time sphere' (*SS*).

These doubles and other dimensions of time forever newly repeat or refold to produce new becomings, interactions and transformations within our world, foldings, unfoldings and refoldings that *Sans Soleil* strives to assess and express. And so, as the virtual escapes the permanent, its immanent potential is in fact its impermanence and endless vitality, escape and excess in that *between*, zone or passing – again, that 'something passing from one to the other' – through which 'living beings whirl around', write Deleuze and Guattari, 'and [that] only art can reach and penetrate [...] in its enterprise of co-creation' (Deleuze and Guattari 1994: 173).

The 'walls between the realms are so thin', *Sans Soleil* reflects, 'that one can in the same breadth contemplate a statue, buy an inflatable doll, and give the goddess of fertility the small offering that always accompanies her displays' (*SS*), perhaps while also beginning to perceive the virtual-actual realms and dimensions of the imperceptible, that zone of doublings and indiscernibility that *Sans Soleil* constructs with 'blocs' of affects and percepts. To perceive the imperceptible while becoming-imperceptible, to perceive one's own self-perception while becoming-other and self-less, is to enter into relation with the 'undeterminable, the unreferable [...] "the reverse side of thoughts"', which itself is what dreams come up against and rebound, break' (Deleuze 1989: 167). Such is to confront the 'two poles of survival' (*SS*) and, by so doing, free and bear witness to *a* life 'in this world as it is' (Deleuze 1989: 173).

This encounter with the limits of self and thought at once invokes a painful actualisation and virtual potential whereby the '*intolerable*', as Smith indicates, is 'a lived actuality that at the same time testifies to the impossibility of living in such conditions' (Smith 1997: xliii). In *Sans Soleil*, such lived actuality or 'everyday banality' (*SS*) attests to the importance of the banal in its continuous form. As with the ultimate event of death, so too may *affect* be experienced punctually as 'localized in an event', as writes Massumi; yet, to repeat Massumi's observation, 'it is also continuous, like a background perception that accompanies every event, however quotidian' (Massumi 1996: 229). The

virtual-actual two-sidedness to which Massumi refers, the 'simultaneous participation of the virtual in the actual and the actual in the virtual, as one arises from and returns to the other' (228), is nothing other than *Sans Soleil*'s affective, self-perceptive and continuous contemplation of these two poles of survival, the two sides of all things that manifest a synaesthetic participation of the senses in each other.

And so, as the film cuts abruptly from its title screens to an image of a loudspeaker affixed to a boat, we suddenly experience the film's roaming eye whose nonhuman perception, as split from any subjective positioning, releases a *percept*, an impersonal seeing. Water visible below comprises much of the shot, an image punctuated by the noise of the soundtrack with its intense rhythm redolent of *La Jetée*'s own quickening heartbeat and audible pulsations. 'He wrote: I'm just back from Hokkaido, the Northern Island. Rich and hurried Japanese take the plane, others take the ferry. Waiting, immobility, snatches of sleep. Curiously all of that makes me think of a past or future war' (*SS*).

The world traveller, whose letters the film's narrator reads, writes of the 'small fragments of war enshrined in everyday life' that he perceives (*SS*). The 'fragility of those moments suspended in time' embody thresholds of reality, sleep, dream and fantasy that bespeak reality's twofold oscillation and exchange between actual-virtual dynamic relations, the two poles or sides of all things that fundamentally speak to potentials and dangers of existence, and *Sans Soleil*'s own revelatory becoming and movement between a 'world of appearances' and its incorporeal transformations (*SS*).

As *Sans Soleil*'s unearthing eye discharges affect from a world of appearances, the earthly and commonplace, it interrogates such reversible relations between actual-real and virtual-real – the ephemeral excesses of experience, the extraordinary beyond ordinary, beauty through horror, life through death – as the film takes on an ethereal, otherworldly sensory quality that exceeds any individualised perspective or place. For through the film, affect becomes an imperceptible yet deeply penetrating force[8] that manifests itself in *Sans Soleil*'s moments of greatest resonance and poignancy that are at once profoundly banal and surreal, intimate and unearthly. Despite all disjunctions, violences between and within the image, the film exudes a grace as it stares, and stares often, in an 'invisible' style evocative of Mr Yamada's 'action cooking', whose way of 'mixing the ingredients' in a restaurant in Nishi-nippori could usefully apply, *Sans Soleil*'s voyager conjectures, to 'certain fundamental concepts common to painting, philosophy, and karate' (*SS*).

If 'Mr Yamada possessed in his humble way the essence of style' through use of his 'invisible brush' (*SS*), *Sans Soleil*'s own style, or *nonstyle*, again exposes the foreign within the familiar as it endlessly pushes towards the invisible, that invisible counterpart of all things on the other side of actual. At the margins of the fragile communities he observes, the frontiers between a world of appearances and 'swarm of appearances', *Sans Soleil*'s disembodied visionary indeed expresses new potential worlds 'before the fall' through worlds 'inaccessible to the complications of a Puritanism whose phoney shadow has been imposed on it by American occupation' (*SS*); through worlds beyond our 'castrating censorship' and televised, 'portable and compact [...] already inaccessible reality' (*SS*); through worlds wherein participants within and without the film – viewer, Marker and those yet to come – enact and construct new truths and consciousnesses via transformative *becoming-others* in that passage between translatable and untranslatable, truth and 'Happiness'.

> 'I paid for a round in a bar in Namidabashi. It's the kind of place that allows people to stare at each other with equality; the threshold below which every man is as good as any other – and knows it.'
>
> (*SS*)

> All consciousness is a matter of threshold. [...] If life has a soul, it is because it perceives, distinguishes, or discriminates, and because a whole world of animal psychology is first of all a psychology of perception.
>
> (Deleuze 1993: 88; 92)

> 'It was in the marketplaces of Bissau and Cape Verde that I could stare at them again with equality.'
>
> (*SS*)

> In fact, the self is only a threshold, a door, a becoming between two multiplicities.
>
> (Deleuze and Guattari 1987: 249)

Like the drunken man the film observes directing traffic at a crossroads, *Sans Soleil* materialises at a crossroads between 'roads' or ways of common perception. For through its encounters with the thresholds of actual-virtual processes and borders between thought and non-thought, the film's expression of the people, animals and worlds it experiences exposes the minute, particular and imperceptible perceptions we fail to commonly perceive through our molar or macro apprehensions. We hear, for instance, as Deleuze writes, a sea's sound, those 'conscious,

clear, and distinct apperceptions' and 'macroperceptions' to which we are 'overly accustomed', yet not the 'murmurs of each wave' (Deleuze 1993: 86–7).

As *Sans Soleil* then strives to discern the 'pricklings', 'murmurings' and 'little foldings' of molecular perceptions to effect its own *becoming-animal* and so extract affects and percepts from conventional limited perception, the film cuts from a close-up of an emu to a graphic close-up match of a young African woman, a 'match' or becoming that at once evokes a new transformation via a 'becoming-emu' or animal of woman that suggests a 'phenomenon of bordering' and 'affectability [...] no longer that of subjects' (Deleuze and Guattari 1987: 245, 258). For the graphic match moves beyond a representation of resemblance or analogy, beyond what may be seen, interpreted and faithfully reproduced, towards the liberation and extraction of the virtual sense or pure affects and sensations of an *anomalous* animal, an 'animal' at the edge, fringes, borderline or *between*.

This is not to say that the woman becomes animal. 'Becomings-animal are basically of another power', explain Deleuze and Guattari, 'since their reality resides not in an animal one imitates or to which one corresponds but in themselves, in that which suddenly sweeps us up and makes us become – a *proximity, an indiscernibility* that extracts a shared element from the animal' (Deleuze and Guattari 1987: 279). The relations between animal and human throughout the film, in other words, and as foreshadowed by this early graphic match, express *Sans Soleil*'s becoming, its intensive production of ever-new virtual potentials and multiplicities of affects that exceed the thresholds and borders of our rigidly defined perceptible existence with its visible-invisible controls that perpetuate our illusory truths and freedoms.

'[L]et us at least say that there is counterinformation', to repeat Deleuze's intervention, if people may move ' "freely" without being at all confined yet while still being perfectly controlled' through communication and information 'we are told [...] we are supposed to be ready or able to [...] believe' (Deleuze 1998: 18). Alternatively, the *anomaly*, non-individuality, singularity or becoming of the animal and woman that manifests neither an individual nor a species is 'affect in itself' (Deleuze and Guattari 1987: 259), a becoming-animal 'which arrives and passes at the edge' (244) to forge means for new ways of thinking and seeing, for 'another consciousness and another sensibility' (Deleuze and Guattari 1986: 17).

To see and think ever-newly through such revolutionary means, as presented by *Sans Soleil*, Deleuze and Guattari, is not to look,

gaze or stare and concede to power-relations and terms of equality as hierarchically, historically constructed and articulated, but to free life's flow of images and perceptions from our reductive apprehensions of their actualised forms. Perception, by this impersonal, living, non-representational and non-interpretational sense, is always a new mode of becoming – a *becoming-animal* – that senses virtual elements before and beyond recognisable distinction, designation and actualisation. The release of such virtual potential through perception creates new worlds and releases inconspicuous perceptions at the road, threshold or crack between perceptible and imperceptible, communicable and incommunicable.

How then to communicate 'the simplicity' and 'lack of affectation' of the couple who came to perform the rite that would 'repair the web of time' so that their runaway cat Tora would be protected (*SS*); how to film a 'people of nothing' and 'emptiness' (*SS*); how to convey the 'built-in grain of indestructibility' of the women who choose their fiancées and deny 'the magical function of the eye' at the centre of all things (*SS*); how to conceive of survival, unity and equality alongside happiness, beauty and an ever-proliferating population of cats and animals?

'He wrote me that in the Bijagós Islands it's the young girls who choose their fiancées. He wrote me that in the suburbs of Tokyo there is a temple consecrated to cats' (*SS*). The film cuts from the close-up side profile of an emu in France gazing off screen right to a woman in Guinea-Bissau gazing off screen left to a cats' temple in Japan with its Maneki Neko cats aligned in rows beckoning off screen right. The assemblage of audio-visual images at once takes 'the temporal form of an instantaneous counteractualization' (Deleuze 1995: 170) as the images counteract and deterritorialise a notion of difference as entrenched in nationalistic and colonialist discourses.

By *Sans Soleil*'s global 'mapping', the film again, that is, as 'open and connectible in all of its dimensions', does not so much contrast 'African time to European time and also to Asian time' as it newly reconfigures these 'extreme poles of survival' through evocations of their singularities, affects and virtual possibilities (*SS*). Africa, Europe and Asia become undefined landscapes of a 'deterritorialised world', a world again wherein '[a]ll faces envelop an unknown, unexplored landscape' (Deleuze and Guattari 1987: 172) and exist within a time of the Aion, a 'floating', 'nonpulsed' time 'against pulsed time or tempo, experimentation against any kind of interpretation', a 'state where forms dissolve, and all that subsists are tiny variations of speed between movements in composition' (267).

Upon this virtual imperceptible plane or surface of consistency or immanence, a field or space of possibilities, becomings and productive interactions on the other side of the plane of organisation, development or transcendence, liberated 'particles of an anonymous matter' communicate

> through the 'envelope' of forms and subjects, retaining between them only relations of movement and rest, speed and slowness, floating affects, so that the plane itself is perceived at the same time as it allows us to perceive the imperceptible (the microplane, the molecular plane). (Deleuze and Guattari 1987: 267)

Here too the face is an open surface and series of layers, a white or blank 'map' that may become a deterritorialised space and intensive map of progressive new becomings and potentials through which may emerge a people of nomadic thinkers and survivors. '[T]he face is a map', exclaim Deleuze and Guattari (1987: 170), and while the film's traveller acknowledges 'the unbearable vanity of the West, that has never ceased to privilege being over non-being, what is spoken to what is left unsaid' (SS), Sans Soleil never ceases to ascertain revolutionary becomings through the faces of the lands, peoples and animals it encounters, the 'face-landscapes' that perceive and are perceived.

> 'The entire city is a comic strip; it's Planet Manga. How can one fail to recognize the statuary that goes from plasticized baroque to Stalin central? And the giant faces with eyes that weigh down on the comic book readers, pictures bigger than people, voyeurizing the voyeurs'.
>
> (SS)
>
> I see that behind the sockets of the eyes there is a region unexplored, the world of futurity.
>
> (Deleuze and Guattari 1987: 171)
>
> '[T]he more you watch Japanese television... the more you feel it's watching you.'
>
> (SS)
>
> Now the face has a correlate of great importance: the landscape, which is not just a milieu but a deterritorialized world.
>
> (Deleuze and Guattari 1987: 172)

The film cuts to a shot of a volcano whose conical mountain seems an island itself above the clouds. On the islands of Cape Verde, Sans Soleil's faceless explorer confronts the faces of other wanderers, navigators, world travellers, a 'people of nothing' and 'of emptiness' (SS), and as we stare openly with the film's vagabond, the faces compellingly return our glares. Immediately preceding this early sequence in the film, a series

of 'frozen' still shots exemplifying such perceiver-perceived relations are presented, each image 'stilled' upon a staring face: that of a young African woman upon a boat who glances ever briefly towards the camera before lowering her gaze ('How can one remember thirst?'); an elderly man who stares for a moment at the camera in the bar in Namidabashi ('the kind of place that allows people to stare at each other with equality; the threshold below which every man is as good as any other – and knows it'); and the two women at the jetty on Fogo in the Cape Verde Islands who forthrightly glare at the lens. Each 'frozen' still shot punctuates its sequence's end as it ironically reiterates the 'great concrete freeing of nonpulsed time' that Deleuze and Guattari suggest (Deleuze and Guattari 1987: 269) through a seeming pause or halting of time in the image.[9]

Prior to the third of the frozen still shots, *Sans Soleil*'s narrator remarks: 'Frankly, have you ever heard of anything stupider than to say to people as they teach in film schools, not to look at the camera?' This act of looking and being looked at repeatedly surfaces throughout *Sans Soleil* and Marker's entire oeuvre yet these relations between perceiver-perceived emerge perhaps with greatest force and intensity in *Sans Soleil*. For through the auto-perceptive doubling or folding of gazes whereby the perception of an other becomes also a perception of one's self and self-dissolution, we once again experience a perceptual perpetual process of identity and separation.

There is potential for reinvention of one's self *or* the reclamation of a self's identity that occurs, that is, whenever 'Marker's camera', the nomadic traveller's gaze, chances to rest upon a gaze that explicitly returns 'his' own, be it human, animal or otherwise. While a mirroring gaze may repeat organising determinations and our great redundancies of human segregation and classification, those a face most outwardly announces at its most blank, male/female, black/white, it potentially also realises and facilitates a self's separation and becoming-other, becoming-animal, becoming-imperceptible.

> I see her; she saw me; she knows that I see her; she drops me her glance, but just at an angle where it is still possible to act as though it was not addressed to me and, at the end, the real glance, straightforward, that lasted a twenty-fourth of a second, the length of a film frame. (*SS*)

If this is the stare of equality to which *Sans Soleil* ultimately refers, the glance and look of a face exacted from a woman of Bissau, the market lady of Praia, such 'equality' may then be the reflexive, transitive equivalence relation between perceiver-perceived – film, screen, camera,

viewer, filmmaker – as all bodies become-other through each other in an a-parallel or non-parallel evolution not of imitation or assimilation but of a differing doubling, a 'double capture' through which ' "what" each becomes changes no less than "that which" becomes' (Deleuze and Parnet 2002: 2–3). 'One might say', as does Deleuze, 'that something happens between them, at different speeds and with different intensities, which is not in one or other, but truly in an ideal place', such as the 'zone' of *Sans Soleil*,

> which is no longer a part of history, still less a dialogue among the dead, but an interstellar conversation, between very irregular stars, whose different becomings form a mobile bloc which it would be a case of capturing, an inter-flight, light-years. (Deleuze and Parnet 2002: 15–16)

On the 'landscape of another planet' *Sans Soleil*'s seeing nonhuman, unseen eye sees in fact the face of 'our future', a world wherein 'to call forth a vision, to be moved by a portrait, to tremble at the sound of music, can only be signs of a long and painful pre-history' (*SS*). Such a world, the film's narration suggests, could be told through 'one who has lost forgetting', such as the protagonist of 'the film to come' *Sans Soleil* describes who, at each moment through his impossible memory, might seem able to 'comprehend' (*SS*), as Deleuze proposes, 'all violence in a single act of violence, and every mortal event *in a single Event*' (Deleuze 1990: 152). Yet, as such is the ultimate task, to will, embrace and become worthy of all that happens to us, to remember yet always also to forget, '[n]aturally', as *Sans Soleil* concedes, this protagonist of 'the film to come' will fail. 'The unhappiness he discovers is as inaccessible to him as the poverty of a poor country is unimaginable to the children of a rich one' (*SS*).

To survive, to live, one must always, to repeat Deleuze's own repetitions, achieve a productive balance *between*, between the 'incorporeal crack at the surface' and the 'thickness' of a body, or risk self-destruction (Deleuze 1990: 156).

> If there is a crack at the surface, how can we prevent deep life from becoming a demolition job and prevent it from becoming it as a matter 'of course'? [...] [I]s it possible to limit ourselves to the counter-actualization of an event [...] while taking care to prevent the full actualization which characterizes the victim or the true patient? (Deleuze 1990: 157)

Is this then the 'secret' to which *Sans Soleil* repeatedly refers, 'the poignancy of things [that] implied the faculty of communion with things, of entering into them, of being them for a moment' (*SS*), the

poignancy, the *between*, the balance, the survival and proliferation of life which demands always a remembering and a forgetting, and an always becoming-other through a double becoming of the virtual-actual aspects of our bodies that are forever 'perishable and immortal' (*SS*)?

Sans Soleil relates the only recourse remaining for this would-be protagonist of the film to come,

> that which threw him into this absurd quest: a song cycle by Mussorgsky. [...] [I]t was then that for the first time he perceived the presence of that thing he didn't understand which had something to do with unhappiness and memory, and towards which slowly, heavily, he began to walk. (*SS*)

While the imperceptible presence of *Sans Soleil* admits, '[o]f course I'll never make that film', he has nonetheless given it a title, 'indeed the title of those Mussorgsky songs: *Sunless*'.[10] How far must we go between life and death to shed light on the 'sunless' whilst preserving the 'secret' of the *between*, of survival and 'happiness'? 'How long will it take to forget the secret?' (*SS*).

> Like the pyramid, the desert island exists before and after the advent of human or their incursions in the world. The island is a '[c]onscience of the earth and the ocean (...), ready to commence the world' [Deleuze 2004: 11].
>
> (Conley 2005: 214).
>
> 'Is it a property of islands to make their women into the guardians of their memory?'
>
> (*SS*)
>
> There remains the possibility of the author providing himself with 'intercessors' [...] of taking real and not fictional characters, [...] putting these very characters in the condition of 'making up fiction', of 'making legends', of 'story-telling'. The author takes a step towards his characters, but the characters take a step towards the author: double becoming.
>
> (Deleuze 1989: 222)
>
> 'I think of a world where each memory could create its own legend.'
>
> (*SS*)

On the desert island of Sal, 'a salt rock in the middle of the Atlantic' bestowed with seemingly countless days of unrelenting sun (*SS*), *Sans Soleil*'s voyager writes again to the film's female, faceless, nameless voice. Like the travelling 'he' of the film, 'she' is often also referred to as a 'me', a self, never individualised, always other, who exists between viewer and the nomad wanderer. As a 'character' himself, seeing but unseen, the

travelling, letter-writing nomadic 'man' and our correspondent through the film's excursions is 'continually becoming other, and is no longer separable from this becoming which merges with a people' (Deleuze 1989: 152), a becoming or folding that imbricates the filmmaker Marker himself. For inasmuch as 'each film-maker is a movement in himself', in this sense Marker 'too becomes another' (221) 'as he takes real characters as intercessors and replaces his fictions by their own story-telling, but, conversely, gives these story-tellings the shape of legends, carrying out their "making into legend" ' (152).

Through their becomings, fabulations or makings into legend, the people of *Sans Soleil* strive to intercede in the intermission or interstice between life and death as they acknowledge that 'moment that is only that of *a* life playing with death' (Deleuze 2001: 28), when quotidian life takes on an impersonal, singular life. 'Tokyo is full of these tiny legends, and of mediating animals' (*SS*), and as the people's rituals and legends take flight to reveal something more to do with happiness and forgetting than unhappiness and memory, their spiritual becomings temporarily free the film from its melancholy contemplations. If '[l]egends are born out of the need to decipher the indecipherable' and '[m]emories must make do with their delirium, with their drift' (*SS*), *Sans Soleil* derives a certain joy and anarchic madness through the signs of memory and sacred signs it senses and encounters that break through the 'wall' of a hierarchically signified stratified face.

And so, while we become implicated and other through these foldings, layers and reinventions of filmmaker, narrator, wanderer and character, a *free indirect discourse* arises, as through *La Jetée* (see Boljkovac 2009a). Through this pure act of speech torn from visual association and self, we hear *Sans Soleil*'s narrator obtain an 'original irreducible dimension' that resists the first person, even as she speaks in first person (Deleuze 1989: 242). This female voice of a becoming-other, becoming-woman, becoming-animal beyond the dominant authoritative male voice of ethnographic documentary film and majoritarian univocality[11] is *Sans Soleil*'s voice of the 'fourth person singular' (Deleuze 2004: 143; see also Deleuze 1990, Deleuze and Parnet 2002). The voice assumes Deleuze's general description of such a voice in modern cinema that, again, 'speaks as if he [she] were listening to his own words reported by someone else, hence achieving a *literalness* of the voice, cutting it off from any direct resonance, and making it produce a free indirect speech' (Deleuze 1989: 242).

The visual and sound images of *Sans Soleil* then become pure, 'autonomous components of a single, truly audio-visual image' that

'depends on a more complex link between the visual image *and* the sound image' (Deleuze 1989: 252). To once again reiterate Deleuze's thought, becoming is always a matter of *AND*, the making of a line between two bodies, an encounter between two, not of the two, in the two or common to the two, for in fact the two relations have nothing to do with each other (Deleuze and Parnet 2002: 7); rather, a joyful, wondrous encounter and becoming is an encounter with the animals, affects, intensities, movements, sensations and vibrations that move, touch, pierce and wound us; we are never the same. We are islands, Japan-becoming Africa, Africa-becoming Japan.... 'We are deserts', writes Deleuze, 'but populated by tribes, flora and fauna' (Deleuze 2004: 11). Back on the desert island of Sal, 'He wrote me: I've understood the visions. Suddenly you're in the desert the way you are in the night; whatever is not desert no longer exists' (*SS*).

In Bissau, 'where the magical function of the eye was working against [him]' (*SS*), *Sans Soleil*'s wanderer again contemplates the African women whose faces escape that magical eye, the 'faciality machine', as Deleuze and Guattari conceive it, whose 'social production of the face', as based upon '[o]ur semiotic of modern White Men, the semiotic of capitalism', would assimilate the women's faces to dominant signification and subjectification (Deleuze and Guattari 1987: 181, 182). 'All women have a built-in grain of indestructibility. And men's task', *Sans Soleil* observes, 'has always been to make them realise it as late as possible. African men are just as good at this task as others' (*SS*). As the women throughout the film glare at the camera, their collective corporeal polyvocality, vitality and force shatters any pretence of face, exotic mystery, ethnic othering or fetishisation as the intensities and affects of their faces and bodies resist capture. '[A]fter a close look at African women', the unseen or faceless female voice continues, 'I wouldn't necessarily bet on the men' (*SS*).

If the women, children, animals and islands of *Sans Soleil* that see and are seen then embody virtual worlds or potentials, 'desert islands' as populated with actual bodies and virtual anomalous survivors, these bodies form asubjective, 'collective assemblages of enunciation' that still evince the fragilities and insecurities of actual bodies. 'Such a creature on a deserted island would be the deserted island itself, insofar as it imagines and reflects itself in its first movement', Deleuze writes (Deleuze 2004: 11). As the peoples and lands of *Sans Soleil* constitute such double becomings of self-consciousness and renewal, reinvention and *fabulation* as *a people yet to come*, a singular people of more than 'twelve million anonymous inhabitants' (*SS*), their vital becoming-imperceptible and

immanence perhaps lies through the spiritual, sacred worlds of the islands the film discovers. We might proclaim with Deleuze that this is the 'constitution or reconstitution of a people, where the film-maker and his characters become others together and the one through the other, a collectivity which gradually wins from place to place, from person to person, from intercessor to intercessor' (Deleuze 1989: 153).

Islands, their cities and people in *Sans Soleil* become then sites of the double, retrospective, auto-perceptive becomings of filmmaker, narrator, wanderer and character whose folds envelope us. 'The *élan* that draws humans toward islands extends the double movement that produces islands in themselves', Deleuze notes (Deleuze 2004: 10). This double movement of separating and creating extends again and as well to a remembering and forgetting, repetition and difference, a 'dreaming of islands [... that] is dreaming of pulling away, of being already separate [...], of being lost and alone' whilst 'dreaming of starting from scratch, recreating, beginning anew' (Deleuze 2004: 10); as James Williams elsewhere writes, '[t]o connect and to discard are joint actions – we cannot do well at one without doing well in the other' (Williams 2003: 5).

Once more then, the doubling process is always one of a repeating difference that produces the effect of a counter-actualisation, a doubling of actual self and virtual impersonal other as doubled by a memory-image's doubling of each perception-image, a virtual doubling of present launched simultaneously towards future and past, that whole virtual past of our memories, experiences and 'images already affected by the moss of time' (*SS*) that *Sans Soleil* strives to perceive. 'I've spent the day in front of my TV set, that memory box', 'he' writes, whose commercials seem 'a kind of haiku to the eye' with their gazes that forever return his own (*SS*).

Like the whole of time itself, memory, as Bogue writes through Bergson and Deleuze, 'is not inside the individual mind, but each mind is inside memory, like a fish in the ocean. The ocean of memory is the virtual past, which gushes forth at each present moment in a perpetual foundation of time' (Bogue 2003: 119). As *Sans Soleil*'s traveller journeys across ocean from island to island listening to 'all the prayers to time' issued throughout his trip whilst 'collecting' materials for the film to come he will 'never make', he increasingly perceives his self's existence within time, within the 'zone' or 'web' (*SS*) of perpetual time, within which all life moves, lives and changes.

Through these travels across lands and lines of time, the film encounters layers and strata of landscapes and faces that expose the paradoxes and strange doublings of this stratigraphic, archaeological time as well, the junkyards with inoperative vehicles in a city of incessant transport; the imposed names and other faces of 'horror' that flicker and flash in incessant waves upon Japanese television; the anachronistic faces of a megalopolis that, at nightfall, 'breaks down into villages, with its country cemeteries in the shadow of banks, with its stations and temples', each district 'once again a tidy ingenuous little town, nestling amongst the skyscrapers' (SS).

Against his increasing perception of his self within time, and as the face-landscapes he discerns forever stare back, the film's correspondent visits a small bar in Shinjuku that reminds him 'of that Indian flute whose sound can only be heard by whomever is playing it. He might have cried out if it was in a Godard film or a Shakespeare play, "Where should this music be?"' (SS). This again is 'the impermanence of things', a release and perception of affect through a singular body's encounter with the world. What remains imperceptible to representation and recognition becomes sensate through a self's othering and openness to worlds and sensations beyond its own, the worlds of an other. Although always between two, the process of becoming, creation or life itself is always also a solitary affair 'because, when it comes down to it, you are always alone, and yet you are like a conspiracy of animals. [...] you have never been more populated'; such solitude is once more 'a means of encounter' with the self and its always becoming-other that arises *between*, between one AND an-other (Deleuze and Parnet 2002: 9).

We then are oceans around islands, deserted bodies and waves of encounters encountering other deserted bodies, either deserted islands of 'collective imagination, [which is] what is most profound in it, i.e. rites and mythology' (Deleuze 2004: 11), or islands of deserts whose deserts offer no means for possible life. We encounter other bodies whose affects either affirm our power and make us become, that is, or that reduce us to a powerlessness and incapacity for new life. Once again, '[w]e know nothing about a body until we know what it can do', to restate Deleuze and Guattari's declaration,

what its affects are, how they can or cannot enter into composition with other affects, with the affects of another body, either to destroy that body or to be destroyed by it, either to exchange actions and passions with it or join with it in composing a more powerful body. (Deleuze and Guattari 1987: 257)

The uncommon in *Sans Soleil*, the mystical, cosmic, spiritual and sacred worlds and rites of the people-islands it discovers, reveal the solitary collectivity of becoming Deleuze identifies. The 'people' and consciousnesses of the film's various reflective screens and surfaces, the faces of the television sets, billboards, the eyes of all the worlds the traveller confronts, engender a movement, not of human transport but the 'very moment of things' (Deleuze 2004: 10), a consciousness of pure duration itself, an *élan* that produces the desert and our 'beings' as deserted for, as Deleuze discerns, 'humans do not put an end to desertedness, they make it sacred' (10). 'Those people who come to the island indeed occupy and populate it', he continues,

> but in reality, were they sufficiently separate, sufficiently creative, they would give the island only a dynamic image of itself, a consciousness of the movement which produced the island, such that through them the island would in the end become conscious of itself as deserted and unpeopled. The island would be only the dream of humans, and humans, the pure consciousness of the island. (Deleuze 2004: 10)

The 'uncommon humans' of *Sans Soleil* with whom the Noro, or Japanese priestess, communicates – the spectres, monsters, spirits, 'gods of the sea, of rain, of the earth, of fire' (*SS*) – are resonances and reverberations of the virtual, again that invisible counterpart of every fragment of creation that may only be accessed through the uncommon 'beings' that outwardly bare their singularities – the women, children and animals of *Sans Soleil* who effect our own becoming-woman, becoming-animal, *becoming everybody, becoming world.*

> I learned that, as in the Bijagós, it is through the women that magic knowledge is transmitted.[...] Everyone bows down before the sister deity who is the reflection, in the absolute, of a privileged relationship between brother and sister. Even after her death, the sister retains her spiritual predominance. (*SS*)

> To that question so dear to the old explorers – 'which creatures live on deserted islands?' – one could only answer: human beings live there already, but uncommon humans, they are absolutely separate, absolute creators, in short, an Idea of humanity, a prototype, a man who would almost be a god, a woman who would be a goddess, a great Amnesiac, a pure Artist, a consciousness of Earth and Ocean, an enormous hurricane, a beautiful witch, a statue from the Easter Islands. There you have a human being who precedes itself. (Deleuze 2004: 11)

'And then in its turn the journey entered the 'zone', and Hayao showed me my images already affected by the moss of time, freed of the lie that had prolonged the existence of those moments swallowed by the spiral.'

(SS)

In Iceland, a volcanic island in the northeastern Atlantic bestowed with few days of unrelenting sun and where 'he' had 'laid the first stone of an imaginary film', *Sans Soleil*'s voyager writes again: 'And that's where my three children of Iceland came and grafted themselves in' (SS). The traveller becoming-filmmaker retrieves the shot, adding the footage he had cut, 'the somewhat hazy end, the frame trembling under the force of the wind beating us down on the cliff, everything I had cut in order to tidy up', only to discover that the remnants, the discarded shots and debris of the 'tidied' version 'said better than all the rest what I saw in that moment, why I held it at arm's length, at zoom's length, until its last twenty-fourth of a second' (SS).

The children observe the camera curiously as it ventures towards their blissful lack of self-apprehension and recognition; sensing the risk, the impermanence and fleetingness of the irrevocable, ephemeral moment with its affective aura of peacefulness that might at any moment vanish in time, the camera remains at a distance, an arm and zoom's length away from grasping the forgotten, the immanent unseen on the other side of seen. 'Small children', writes Deleuze, 'through all their sufferings and weaknesses, are infused with an immanent life that is pure power and even bliss' (Deleuze 2001: 30). Earlier on, again, as the age-weary traveller watches the youth dance in the park at Yogogi, he shares in their secret: 'The youth who get together every weekend at Shinjuku obviously know that they are not on a launching pad toward real life [...] they are life, to be eaten on the spot like fresh doughnuts' (SS).

Left to this world, a world also of sufferings and weaknesses whose profound difference from that of a child's lies through a self-consciousness cultivated as a means for narcissistic self-interest rather than reinvention, *Sans Soleil* then 'performs its own Dondo-yaki', its own fiery 'farewell to all that one has lost, broken, used' (SS) in pure Markeresque style. As the film's images enter Hayao's zone of 'electronic graffiti', the first transformed image a Maneki Neko cat from the shrine in Japan, the voyager remembers: 'Cat, wherever you are, peace be with you' (SS). The electronic ashes fill the film's final frames as the images assume new life. While the contours of their actual forms dance in flames or flashes of light, *Sans Soleil* at last honours the deserted islands of its journey, its virtual spirits and collective souls whose magic secret may simply be the name for happiness.

Notes

1. With grateful thanks to Charlie Blake, Ian Buchanan, Tom Conley, Ian James, James Williams and Emma Wilson for their inspiration and support.
2. As I have noted elsewhere (see Boljkovac 2009a and 2009b) Deleuze's filmic analyses face accusations of a partiality towards a canonical hierarchy of modernist 'art-house' cinema. Yet this seeming preference principally reflects Deleuze's fascination with the capacities of certain films to directly present not merely the flow of non-localised movement but also time itself through time-images or signs that liberate a human body from its self-imposed limits as it begins to perceive its world and self differently through select cinematic experiences. Interestingly however, despite evident admiration for the works of Marker's collaborators and friends, notably Alain Resnais, Deleuze's writings do not acknowledge Marker's cinema although Marker's films remarkably exemplify Deleuze and Guattari's considerations, as does Marker's persona itself.
3. Such newly repeats Deleuze's account of the time-image as that which 'always gives us access to that Proustian dimension where people and things occupy a place in time which is incommensurable with the one they have in space' (Deleuze 1989: 39). This Eliot *Ash Wednesday* quotation appears in the English version of the film; a Jean Racine quotation appears in the original French version. For both film versions and text of the complete quotations, see the 2007 Criterion Collection DVD collective release of *La Jetée* and *Sans Soleil*, under exclusive licence from Argos Films, and 'Racine/Eliot' in its accompanying booklet (DVD booklet 2007: 31).
4. Several assessments of *Sans Soleil*, by Nora Alter and Catherine Lupton, for instance, present such an argument. Whilst their extensive analyses of Marker's works are very thorough and useful, Lupton's position pertaining to what Jon Kear (1999: 15) terms a 'structure of reflective consciousness', and what Lupton regards as a 'process of sorting things out and linking them together' via 'a kind of global, disembodied consciousness', seems to propose a cohesive structure for the film through an *embodied subject* or *subjects* located in the film's albeit 'multivocal properties' (Lupton 2005: 149–57). Elsewhere in a nuanced analysis extending to animals and places, Sarah Cooper ventures beyond notions of the film's cohesion to problematise continuity *and* change within *Sans Soleil* (see Cooper 2008: 116–18). Conceptualisations of selfless consciousness, point of view and the author/creator/filmmaker/'Marker' himself will continue to be assessed throughout this paper.
5. Smith writes: 'Divergences, bifurcations, and incompossibles now belong to *one and the same universe*, a chaotic universe in which divergent series trace endlessly bifurcating paths: a "chaosmos" and no longer a world' (Smith 1997: xxvi). (See also Boljkovac 2009b, ch. II; Deleuze and Guattari 1994: 204.)
6. See Deleuze's 'Desert Islands' (Deleuze 2004: 9–14) and Tom Conley's 'The Desert Island' (2005).
7. See Deleuze 1989, ch. 7, also Bogue 2003, with regard to Deleuze's concept of the 'spiritual automaton'.
8. With regard to the 'autonomy of affect', or, once more, 'that which is imperceptible but whose escape from perception cannot but be perceived, as long as one is alive', Massumi's analyses again are valuable (1996: 229).
9. Such stillness recalls the stills of Resnais's *Nuit et Brouillard* (1995) and Marker's *La Jetée* (1962), and Marker and Bellon's *Le Souvenir d'un Avenir* (2001) (see Boljkovac 2009b, chs II, IV, VI).

10. Of Mussorgsky's *Sunless* Cycle, James Walker notes that 'Mussorgsky's remarkable talent for observing and truthfully conveying in music the innermost movements and moods of the soul' may be found in all the songs of *Sunless*, although Mussorgsky's 'inspiration understood best the moods of pain and unhappiness' (Walker 1981: 387).
11. For further discussion pertaining to minoritarian 'voices' and faces, see MacCormack 2000.

References

Alter, Nora M. (2006) *Chris Marker*, Urbana and Chicago: University of Illinois Press.
Bogue, Ronald (2003) *Deleuze on Cinema*, London and New York: Routledge.
Bogue, Ronald (2004) *Deleuze's Wake: Tributes and Tributaries*, Albany: State University of New York Press.
Boljkovac, Nadine (2009a) 'Mad Love', in Eugene W. Holland, Daniel W. Smith and Charles J. Stivale (eds), *Gilles Deleuze: Image and Text*, London: Continuum International, pp. 124–42.
Boljkovac, Nadine (2009b) *Untimely Affects: Violence and Sensation through Marker and Resnais*, dissertation, University of Cambridge, forthcoming as *Untimely Affects: Gilles Deleuze and The Ethics of Cinema* (Plateaus – New Directions in Deleuze Studies series), Edinburgh: Edinburgh University Press.
Conley, Tom (2005) 'The Desert Island', in Ian Buchanan and Gregg Lambert (eds), *Deleuze and Space*, Edinburgh: Edinburgh University Press, pp. 207–19.
Cooper, Sarah (2008) *Chris Marker*, Manchester: Manchester University Press.
Deleuze, Gilles (1989) *Cinema 2: The Time-Image*, trans. Hugh Tomlinson and Robert Galeta, Minneapolis: University of Minnesota Press.
Deleuze, Gilles (1990) *The Logic of Sense*, trans. Mark Lester with Charles Stivale, ed. Constantin V. Boundas, New York: Columbia University Press.
Deleuze, Gilles (1993) *The Fold: Leibniz and the Baroque*, trans. Tom Conley, Minneapolis: University of Minnesota Press.
Deleuze, Gilles (1994) *Difference and Repetition*, trans. Paul Patton, New York: Columbia University Press.
Deleuze, Gilles (1995) *Negotiations, 1972–1990*, trans. Martin Joughin, New York: Columbia University Press.
Deleuze, Gilles (1997) *Essays Critical and Clinical*, trans. Daniel W. Smith and Michael A. Greco, Minneapolis: University of Minnesota Press.
Deleuze, Gilles (1998) 'Having an Idea in Cinema (On the Cinema of Straub-Huillet)', trans. Eleanor Kaufman, in Eleanor Kaufman and Kevin Jon Heller (eds), *Deleuze and Guattari: New Mappings in Politics and Philosophy*, Minneapolis: University of Minnesota Press, pp. 14–19.
Deleuze, Gilles (2001) *Pure Immanence: Essays on a Life*, trans. Anne Boyman, New York: Zone Books.
Deleuze, Gilles (2004) *Desert Islands and Other Texts, 1953–1974*, trans. Michael Taormina, ed. David Lapoujade, New York: Semiotext(e).
Deleuze, Gilles and Félix Guattari (1986) *Kafka: Toward a Minor Literature*, trans. Dana Polan, Minneapolis: University of Minnesota Press.
Deleuze, Gilles and Félix Guattari (1987) *A Thousand Plateaus: Capitalism and Schizophrenia II*, trans. Brian Massumi, Minneapolis: University of Minnesota Press.
Deleuze, Gilles and Félix Guattari (1994) *What is Philosophy?*, trans. Hugh Tomlinson and Graham Burchell, New York: Columbia University Press.

Deleuze, Gilles and Claire Parnet (2002) *Dialogues II*, trans. Hugh Tomlinson and Barbara Habberjam, New York: Columbia University Press.

Kear, Jon (1999) *Sunless/Sans soleil*, Trowbridge: Flicks.

La Jetée, directed by Chris Marker. France: Argos Films, 1962. [The Criterion Collection (DVD) with Sans Soleil, 2007.]

Le Souvenir d'un Avenir, directed by Chris Marker with Yannick Bellon. France: Les Films de l'Équinoxe (France)/ARTE France, 2001. [Icarus Films (DVD), 2001.]

Lupton, Catherine (2005) *Chris Marker: Memories of the Future*, London: Reaktion Books.

MacCormack, Patricia (2000) 'Faciality: Stamping in Anti-Corporeality', conference paper, 4th European Feminist Research Conference in Bologna on 'Body, Gender, Subjectivity: Crossing Disciplinary and Institutional Borders', available at http://orlando.women.it/cyberarchive/files/mac-cormack.htm (accessed 17 November 2008).

Massumi, Brian (1996) 'The Autonomy of Affect', in Paul Patton (ed.), *Deleuze: A Critical Reader*, Oxford: Blackwell Publishers, pp. 217–39.

Nuit et Brouillard, directed by Alain Resnais. France: Argos Films/Como Films/Cocinor, 1955. [The Criterion Collection (DVD), 2003.]

Sans Soleil, directed by Chris Marker. France: Argos Films, 1982. [The Criterion Collection (DVD) with *La Jetée*, 2007.]

Smith, Daniel W. (1996) 'Deleuze's Theory of Sensation: Overcoming the Kantian Duality', in Paul Patton (ed.), *Deleuze: A Critical Reader*, Oxford: Blackwell Publishers, pp. 29–56.

Smith, Daniel W. (1997) 'Introduction: "A Life of Pure Immanence": Deleuze's "Critique et Clinique" Project', in Gilles Deleuze, *Essays Critical and Clinical* trans. Daniel W. Smith and Michael A. Greco, Minneapolis: University of Minnesota Press, pp. xi–liii.

Walker, James (1981) 'Mussorgsky's *Sunless* Cycle in Russian Criticism: Focus of Controversy', *The Musical Quarterly*, 67(3):382–91.

Williams, James (2003) *Gilles Deleuze's* Difference and Repetition, Edinburgh: Edinburgh University Press.

Zourabichvili, François (1996) 'Six notes on the Percept (On the Relation between the Critical and Clinical)', trans. Iain Hamilton Grant, in *Deleuze: A Critical Reader*, Paul Patton (ed.), Oxford: Blackwell Publishers, pp. 188–216.

A Deleuzian Imaginary: The Films of Jean Renoir

Richard Rushton Lancaster University

Abstract

This article contrasts the notion of a Deleuzian imaginary with that articulated by various film theorists during the 1970s and 1980s. Deleuze offers us, I argue, a way to conceive of the imaginary in the cinema in a positive way; that is, as something which opens up new expressions of the real. By contrast, for film theorists of the 1970s and 1980s, the imaginary was primarily conceived as a negative concept, as something which offered merely escapes or fraudulent distortions of the real. A Deleuzian imaginary for the cinema can be articulated, I argue, by way of the films of Jean Renoir.

Keywords: Imaginary, cinema, time-image, crystal-image, Jean Renoir

The 'imaginary' (or Imaginary with a capital 'I') emerged as one of the central terms of film analysis during the 1970s and 1980s. Especially under the influence of Lacanian psychoanalysis, film scholars like Christian Metz, Jean-Louis Baudry and Stephen Heath made the imaginary crucial for their analyses of cinema. For most of these scholars (although I count Metz as an exception in this regard), the imaginary was (and is) a bad thing indeed (see Metz 1982; Heath 1981, 1992; Baudry 1985). Louis Althusser's appropriation of the category of the imaginary was crucial here, for the delusions of the imaginary were held responsible for the ideological captivation of the subject (Althusser 1971). Althusser's political analyses were extended in brilliant ways in film studies by Baudry, Heath, Jean-Louis Comolli and others such that the political lesson of such analyses was that the spectators of popular

Deleuze Studies 5.2 (2011): 241–260
DOI: 10.3366/dls.2011.0019
© Edinburgh University Press
www.eupjournals.com/dls

cinema were – or are – constructed as ideological subjects while watching films (see Comolli 1985; Comolli and Narboni 1990). That is to say, the function of popular – especially Hollywood – cinema was (and is) to produce ideological subjects: bourgeois subjects of capitalist ideology. The cinema apparatus could achieve this operation of ideological fixity because it encouraged imaginary identifications in its spectators – in Metz's wonderful formulation, 'What is characteristic of the cinema is not the imaginary it may happen to represent, but the imaginary that it *is* from the start' (Metz 1982: 44).

The short version of this story might therefore be: the imaginary is bad and because popular cinema encourages identification at the level of the imaginary, then it too is bad, or it enforces 'badness', where badness ultimately means something like 'ideological manipulation'. The task of film theory, therefore, in response to the dominant ideological manipulations of the imaginary, was to support and advocate modes of filmmaking that worked to break down imaginary identifications, and it fell to overtly political or avant-garde filmmakers, from Straub and Huillet, to Jean-Luc Godard and theorist-filmmakers like Comolli and Laura Mulvey, to achieve this goal. Thus was a 'counter-cinema' posited against the popular cinema. (What I offer here in an extremely condensed manner is extended at some length in chapter 1 of my book on *The Reality of Film*; Rushton 2011: 20–41.)

It is within this environment that Deleuze wrote his *Cinema* books. And yet, if we look there, we will find no discussion of the imaginary nor of ideological manipulation. Indeed, in relation to cinema, Deleuze is fairly dismissive of such notions. '[I]s "the imaginary" a good concept?' he asks at one point, and he goes on to answer this question in the negative (Deleuze 1995: 66). Yet if he is dismissive of the imaginary as a concept appropriate for cinema (more on this later), then he might also sense that it is inappropriate for other reasons. The imaginary, certainly insofar as Lacan or Althusser conceive it, is predicated on a notion of doubled consciousness: the imaginary is a false or distorted replica of real things – as is made explicit by the notion of 'false consciousness'; a false consciousness is an imagined, untrue consciousness which hides or covers over a true or real consciousness beneath it. Therefore, the imaginary as a concept posits mental apparitions – such as ideologies – that offer false representations of real things (or, in Althusser's very precise formulation, 'ideology represents the imaginary relationship of individuals to their real conditions of existence'; Althusser 1971: 109). We can perhaps see how, for many scholars, such a schema was felt so easily applicable for the cinema: films

offer us only false representations of the real world, representations that become embedded inside or 'at the back of' our heads.

The relation to theories of consciousness is key, for the imaginary cannot merely be understood as an aesthetic category but must also be considered as part of a theory of consciousness. For Deleuze, we can link 'the imaginary' with some other terms he criticises forcefully in *Difference and Repetition*: recognition and representation. Deleuze criticises what is called 'thought' in the name of recognition: to merely recognise something, Deleuze argues, does not mean one is thinking. Recognition merely reprises things that one has already known and cannot bring consciousness or thought face-to-face with the new. For Deleuze, it is the encounter with the new that defines what thinking is. Furthermore, recognition does not *disturb* thought; in other words, recognitions do not *force us to think*. With recognition, and Deleuze's critique of it, we can discern an operation conceived in terms of an imaginary matching: does the thought I am now having – that I imagine in my mind's eye, insofar as that 'mind's eye' is separated from and distinct from the object of thought – match a thought I have had before or which I have encountered elsewhere? Does this object, for example, which I can represent to myself by way of my ability to imagine it in my mind's eye, which has a flat top and four legs, match other objects like it which I have seen and conceived in the past? Is it a 'table', and thus does it also match with that signifier which in English is called a 'table'? Such is the process of 'the imaginary' that leads to signification. What I am trying to describe here is the penchant for the imaginary, as an ability of the 'mind's eye', as a process of things (images) deposited in the mind, which belongs only to a logic of recognition or representation (I *recognise* these objects; I *represent* them . . .). For Deleuze, this is not what should be hoped for so far as thinking goes: *to think* should have greater aims than this:

> The 'I think' is the most general principle of representation – in other words, the source of these elements and of the unity of all these faculties: I conceive, I judge, I imagine, I remember, and I perceive – as though these were the four branches of the Cogito. On precisely these branches, difference is crucified. (Deleuze 1994: 138)

Recognition, representation and, along with these, 'the imaginary', insofar as they are posited as elements integral to thought and consciousness, can only lead to a repetition of the same, and never to the kinds of difference Deleuze wishes to discover in repetition. As a result,

for Deleuze, notions like recognition, representation and the imaginary cannot serve as markers of what he calls 'thought'.

For most readers, these must be very familiar Deleuzian themes, but what I want to pursue here is the relation between the imaginary conceived as an aesthetic category, on the one hand, and the imaginary as in some way constitutive of thought, on the other. Everywhere so far, we have only seen Deleuze's negative view of the imaginary. And yet, we must also bear in mind that for Althusser, for some Lacanians and definitely for film studies, the imaginary was (and is) also a negative category (for a contemporary Lacanian rendition of such arguments, see McGowan 2007). What, therefore, might Deleuze bring to a discussion of the imaginary which might allow us to conceive it in a different light? To add grist to the mill, film-studies scholars who mobilised the notion of the imaginary in the cinema did so with a view to criticising it as an aesthetic mode (there were, for these scholars, specific techniques which fostered the imaginary identifications of popular cinema [again see Baudry 1985, Comolli 1985]) at the same time as it enabled a critique of a specific kind of subjectivity – a masterful, fixed, bourgeois subject, 'captured' and fixed by the structure of representation so nonchalantly fostered by popular cinema (on this point see Heath 1992). Now, such a critique does not sound too far away from the kinds of criticisms we can get from Deleuze: the imaginary is a bad category because it does not enable a subjectivity true to thought and difference. Instead, the logic of the imaginary – fostered by recognition and representation – can only ever foster a return to sameness, a fixed consciousness impervious to thought. What, then, does Deleuze offer which might enable us to conceive of a different kind of imaginary, or at least an imaginary that need not be destined to negativity and a moribund subjectivity?

Of course, an additional question needs to be asked: Why would I want to flesh out a Deleuzian notion of the imaginary when it appears Deleuze is so hostile to such a conception? There are two immediate answers. First of all, Deleuze actually does invoke a notion of the imaginary, especially in *Cinema 2*, most importantly as a way of defining the difference between the movement-image and the time-image. So, on that score, there might be yet something useful to extract from a Deleuzian conception of the imaginary. A second reason is that, by coming into contact with a 'Deleuzian imaginary', we might more closely discern both the similarities and differences between Deleuze's approach to the study of film and that which is typically associated with the breakthrough film theories of the 1970s and 1980s. By comparing and

contrasting each position's approaches to 'the imaginary', a clearer sense of Deleuze's overall project can be uncovered.

As a first step, therefore, where and how does Deleuze refer to the imaginary in the *Cinema* volumes? In *Cinema 2* (1989), the 'imaginary' is invoked in contrast with the 'real'. However, what is distinctive about the time-image, and of the subset of the time-image known as the crystal-image, is that, according to Deleuze, for these images, the real and the imaginary become indiscernible. As is well known, a great many things become indiscernible in the time-image, not the least of which are the virtual and the actual, so might we immediately gain some ground by conjoining the real with the actual and the imaginary with the virtual? Such an equation is no doubt one of Deleuze's intentions, though we must also bear in mind that the virtual is no less real than the actual (one of its definitions is that it is 'real without being actual'). And so, this, too, is one of Deleuze's points: with the time-image, what is imaginary should be considered no less real than that which is supposedly real. Or, to put this another way, under the conditions of the time-image, the imaginary is as real as any other reality – such is the point of declaring their 'indiscernibility' as a fundamental factor of the time-image. What is important, therefore, for the time-image, is that there is no need to make distinctions between what is imaginary and what is real, for that is a distinction which ceases to make sense for the time-image. There, then, is a first point: for the time-image, the 'imaginary' need not be erased so that the 'real' can come to the fore. Instead, the very gesture of making a distinction between what is real and what is imaginary ceases to matter for the time-image. (Again, these are points I make at some length in chapter 5 of *The Reality of Film*; Rushton 2011: 126–47.)

By contrast, films of the movement-image are organised by their attempts to make clear distinctions between the real and the imaginary. In Sergei Eisenstein's *The Battleship Potemkin* (1925), an excellent example of the movement-image, the imaginary or 'unreal' elements of the film are several: the actions of the ship's doctor who insists the crew eat the maggot-infested meat; the priest whose duplicity Eisenstein famously emphasises; the ship's officers whose quarters and meals are far finer than those of the lower-ranked sailors and whose actions lead to the death of the sailor, Vakulinchuk; and the troops who massacre the crowds on the Odessa steps. These are all characters who have chosen false courses of action, according to the logic of the film, and who worship imaginary gods. By contrast, what is real for this film are the mutinous actions of the ship's crew, the mournful support of the townspeople, and the pleas for brotherhood ('Will they or won't they

shoot?') when another battleship threatens to attack the *Potemkin* and put down the mutiny. *The Battleship Potemkin* resolves itself on the side of reality (by contrast with a film like *Strike* [1925], whose conclusion is a triumph of the unreal, imaginary forces of oppression): the battleship does not attack the *Potemkin*, and the real forces of brotherhood and unity prevail over the imaginary ones of exploitation and oppression. For the movement-image, therefore, the real is asserted over the unreal, the real is clearly distinguished and contrasted with the imaginary that is declared unreal, bad, false or wrong.

On the other hand, an iconic time-image film, Welles's *Citizen Kane* (1941), refuses to make clear distinctions between the real and the imaginary. Where we might expect that the conflicts between the testimonies of those who remember Kane will, in some kind of final reckoning, be clarified in order that the 'true' stories of his life be clearly separated from the 'false' impressions – that is, that the 'real' be distinguished from the 'imaginary' – this is not at all what occurs. Rather, what we are left with at the end of the film is a series of possible truths, of possible imaginings about the life of Kane: nowhere is the line between what is real and what is imaginary clearly drawn. They remain 'indiscernible'.

This indiscernibility is not a problem for the time-image – it is not a shortcoming of the time-image that the real and the imaginary become indiscernible. For films of the time-image, it is instead merely something that is not at stake; or, at the very least, films of the time-image try to understand that the world or reality need not function by way of making clear distinctions between the real and the imaginary. Indeed, many of the world's problems, deficiencies and dead ends are a result of an all too disturbing quest to divide the real from the imaginary (to divide whites from blacks, rich from poor, Christians from heathens, men from women, bosses from workers ...).

I. Renoir

How does the time-image function for one of the cinema's great auteurs, Jean Renoir? Renoir introduces a very particular mode of the time-image, which image, as we shall see, Deleuze refers to as a 'cracked crystal'. Before we get to that, however, an initial outlining of the form or shape of the films can be drawn. Renoir's films concentrate on describing how a person or group of people are stuck in a reality which is in various ways inadequate, compromised, or downright nasty. The challenge the films set is therefore this: how can the characters get out of the real as

it is currently defined so as to discover a new real, a different reality composed in an entirely different way?

Generally considered Renoir's finest film, *La Règle du jeu* (1939) manages this composition in an exemplary way. Each of the characters is stuck in a reality that is unsatisfying and frustrating in various ways: they are all trapped in the 'rules of the game', and they seem fated to follow the rules of a game that each is reluctant to play for one reason or another. As a result, each character tries to find his or her way out of the game – that is, they imagine ways in which the rules of the game might be broken so that the real as it is might be smashed and a new real take its place. And that is the key: against the sterility of reality are posited various imaginary ways out: the imaginary affirms itself as a mode of escaping from the 'rules of the game'. Christine, for example, will dream of fleeing with the pilot, André Jurieu, or perhaps with Octave (as she momentarily decides late in the film); Lisette will dream of an affair with Marceau; Jackie falls in love with Jurieu; Marceau dreams of being a *domestique*; Schumacher imagines a life of self-sufficiency in Alsace, of living happily-ever-after with Lisette; Geneviève wants her love for Robert to continue Overall, there is a sense in which no one is quite sure what they want or how to get what they want. But one thing they all seem sure of is that *what is* is not what they want. It is here that the real and imaginary become indiscernible, for any attempt by the characters to define what they really want from what they imagine they want is futile. For the second half of the film – especially for the costume ball which is the climax of the group's stay at the château – the real and the imaginary become jumbled to the point of indiscernibility.

There are key moments in *La Règle du jeu* upon which we can focus. The first occurs when Christine spots Robert – her husband – passionately kissing Geneviève. This happens while the guests whom Robert has invited to his country house are engaged in a hunt, and Christine has borrowed a small spyglass or field glass in order to observe certain aspects of nature (a squirrel nestling in a tree, for example, over which ensues a discussion about whether they are beautiful animals or pests). Reframing her view, she observes Robert and Geneviève via the crystal clarity of the telescope. And this is indeed Renoir's version of the crystal-image: it is the all too clear vision of a reality that is flawed. Christine sees the reality of her husband's infidelity, and thus is inserted into reality a crack that will slowly and surely widen throughout the duration of the film. By way of this crack, questions arise for Christine: can she be reconciled with Robert and forgive him (as she indeed tries to make peace with Geneviève)? Or is a way out of this reality available

by fleeing with Jurieu (especially when Lisette assures her the affair between Robert and Geneviève has been going on since before Robert and Christine were married)? Or might she even escape with Octave? Christine's spying of her husband opens the crack in reality by which she begins to imagine various ways of getting out of that reality: she yearns for an escape into an imaginary which will give rise to a new real.

The other key moment I want to emphasise here is that of Schumacher's shooting dead of Jurieu in the mistaken belief that he, Jurieu, is about to make his escape with Lisette (Schumacher's wife). Again we are being shown a cracked crystal, the ways in which reality is flawed: Schumacher has been dismissed from the household by Robert for firing a gun inside the château, so he now seeks revenge for his misfortune, with the addition that he is still suspicious and resentful of his wife's motives and infidelities. His vengeful shooting of Jurieu is not, however, a way of opening up the cracks in the crystal. On the contrary, it is a way of sealing up the cracks: Schumacher shoots as a way of *preventing* escape, of barring Jurieu's and Christine's escape into the new real (for it is indeed Christine and not Lisette with whom Jurieu is attempting to escape). To then proclaim the incident an 'accident', as Robert does, is to reassert the rules of the game, to re-impose a real without the possibility of escape. The film's end entails a closure and repudiation of the crack – as one member of the party quips, 'a new definition of "accident"'.

Thus are evident Renoir's strategies: that of displaying a cracked crystal which can lead either to a new real – if one makes one's escape via the crack – or to a spiral of decay, corruption and death, if, on the contrary, the crack is sealed up and the inadequacies of the real re-established. Deleuze describes this process in the following way:

> In Renoir, the crystal is never pure and perfect: it has a failing, a point of flight, a 'flaw'. It is always cracked. And this is what depth of field reveals: there is not simply a rolling up of a round in the crystal; something is going to slip away in the background, in depth, through the third side or the third dimension, through the crack. (Deleuze 1989: 85)

My argument here is that we may equate the 'cracked crystal' with what I want to call a Deleuzian imaginary: if the real is flawed or cracked, then a way out of that crack can be found by invoking the imaginary. In short, the imaginary provides a way out of the real as it is currently structured – those are the stakes of a Deleuzian imaginary. This is a big contrast to the film theorists of the 1970s and 1980s who

criticised anything and everything that was imaginary because it took one away from everything that was real (the structures of reality, its contradictions): for those writers, one had to dismantle the structure, not get away from it.

Additionally, it should be noted that Deleuze is quite simply wrong to argue that it is Schumacher who shatters the crystal and opens up the crack (he has been too influenced by Bamberger's argument; see Deleuze 1989: 85). And he perhaps asks the wrong question, too (which is to say he is too influenced by Truffaut). The question should not be: 'who fails to play by the rules of the game?' but rather: 'how does one break the rules of the game?' All of the characters try, in one way or another, to break the rules, to find ways of getting out of the game they are in. However, and largely as a result of Schumacher's shooting of Jurieu, no one succeeds in breaking those rules and the rules are firmly re-established. In that regard, then, Deleuze is certainly correct to call *La Règle du jeu* 'pessimistic' (Deleuze 1989: 85).

Renoir constructs worlds or 'the real' in his films only in the hope that his characters might then find ways out of that real or those worlds. The crystal-image only shines or dazzles in order that a way out if it might be found. Ways out of them do happen in the films which have optimistic endings: the soldiers manage to escape into Switzerland in *Grand Illusion*; the revolution gains momentum in *La Marseillaise*; the criminal justifies his escape and continues on his way in *The Crime of Monsieur Lange*; Boudu continues on his merry way in *Boudu Saved from Drowning*

II. 'The Crack-Up'

As I have already mentioned, Deleuze, writing with Guattari, borrows the notion of the 'crack' from F. Scott Fitzgerald, especially from the formulations in his essay on 'The Crack-Up'. The most important small excerpt from that essay on which Deleuze and Guattari concentrate is this:

> The famous 'Escape' or 'run away from it all' is an excursion in a trap [. . .]. A clean break is something you cannot come back from; that is irretrievable because it makes the past cease to exist. (Fitzgerald, quoted in Deleuze and Guattari 1987: 199)

I have certainly referred to the notion of 'escape', especially with regard to *La Règle du jeu*, so we need to ask ourselves whether what was aspired to there were escapes or whether the attempts to get away from the rules

of the game were variants of the clean break; for example, we might wish to ask, were Christine and Jurieu making for an 'escape' or a 'clean break'? An escape, according to Deleuze and Guattari's formulations, is merely the denial of an encounter or confrontation: an escape will not lead to a new real but will be merely a 'getting away' within the same real. Or, to put it another way, the escape implies the eventual inevitability of a return: one may escape briefly or temporarily, but in the end the real will return; the real will re-impose itself and the emergence of the new will be thwarted. By contrast, the 'clean break' is something you cannot come back from. There, any return to the real *as it was* is impossible: the clean break establishes a genuine opening onto a new real.

And yet, the distinction between the escape and the clean break is only part of the story – at least so far as Deleuze and Guattari construe it. Deleuze and Guattari discover three lines of break in Fitzgerald: the break, the crack and the rupture. The former is 'a line of rigid segmentarity' (Deleuze and Guattari 1987: 198), and as such, is entirely predictable within the context of the social structure within which it occurs (we might note that someone like Lévi-Strauss was a master at charting these kinds of breaks within a society which designated their inner structures). The crack, on the other hand, begins to pull apart the structure, but it does so in a very specific way. The rupture, finally – what Fitzgerald referred to above as the 'clean break' – is a total disintegration of the structure, a complete breaking apart of the structuring coordinates.

The kinds of processes being referred to here are constants across Deleuze and Guattari's writings even where myriad different terms of designation are used (from the 'body-without-organs', to smooth and striated spaces, to disjunctive and conjunctive syntheses, positive absolute deterritorialisations – and so on), but the parameters of those processes remain fairly constant, it seems to me. At one end of the spectrum is a rigid social formation that is more or less unchanging, while at the other end of the spectrum is a complete disintegration of any sense of structure, a zero degree of absolute 'disformation' (of something *informe*). That is to say, on the one hand, we have formations which, at their most extreme, are fascistic, while on the other, we have a stateless lack of formation, chaos or anarchy, a revolution or a complete obliteration of the markers of meaning. If, therefore, one end of the spectrum is constituted by 'breaks' – that is, by social demarcations which rigidly structure a society – then the other end of the spectrum is constituted by 'ruptures', the disintegration of structures

from which there is no going back to the way things were. If the 'break' and the 'rupture' constitute the two extreme poles, then the 'crack' lies somewhere between these poles.

We do not need to look very far to see these kinds of formations occurring in Renoir's films: we find rigid social structures in *La Règle du jeu*, in the workplace and community of *La Bête humaine*, in the small village in *Toni*, in the colony of *The Golden Coach*, the small town of *Swamp Water*, the household of *The Diary of a Chambermaid*, in the neighbouring families of *The River*, in the bourgeois household of *Boudu*, in the empty displays of *Elena et les hommes*, in the European community of *Le Déjeuner sur l'herbe*, the monarchy of *La Marseillaise* (and in the small village courtroom at the film's beginning), and in the tormented community from which Lange escapes in *The Crime of Monsieur Lange*, in the horrific social divisions of *The Little Match Girl* Rigid, stultifying, crippling social formations are everywhere in Renoir. At the other pole, we have the moments where these social structures begin to shake apart – in various partial ways in *La Règle du jeu*, the attempts to rebel against outdated modes of life in *Toni* and *La Bête humaine*, in the Bastille Day celebrations and the flight of the chambermaid in *The Diary of a Chambermaid*, in Alexis's newly discovered lust for life in *Déjeuner*, in the acts of revolt and the swelling choruses of *La Marseillaise*, in Lange's getaway in *Lange*, the young girl's coming of age in *The River*, in the young man's revenge on the town in *Swamp Water*, in Boudu's continued reinvention of himself in *Boudu* – and even in the pitiful denouements of *The Little Match Girl* and *Elena*. But do any of these constitute a rupture? Or do they indicate, rather, the 'crack' to which we have already referred? How is it that we can characterise what occurs in these films?

Let us think about what happens to Christine in *La Règle du jeu* when she spies her husband's infidelity through the spy-glass. This moment, as I have already suggested, brings about the emergence of the 'crack': reality, at this point, begins to develop a 'chink', a fissure for which Christine had been unprepared and with which she does not immediately know how to deal. And this is certainly one of the key aspects of the 'crack' in Fitzgerald: that it 'happens almost without your knowing it' (as Ronald Bogue argues; see Bogue 2003: 159). 'Such fissures', continues Bogue, 'disintegrate old certainties and identities [. . .], leaving one without discernible coordinates for future action' (Bogue 2003: 159–60). Such is the crack Christine experiences, something that hits her unawares, leaving her with the sensation of not knowing quite what to do.

If the crack or rupture happens in this way, then the challenge is how to deal with it: what does one do now? For Christine, first of all, she tries to maintain her composure, to act as though the real has not been ruptured so that it can be repaired without any significant damage. Thus, she calls a truce with Robert in the hope that perhaps, after all, this crack will merely function as a break: the cuts and lines of reality *as it is* – the rules of the game – will remain undiminished and life will go on much the same as before. In terms that Deleuze and Guattari variously refer to as 'subjectification' in *A Thousand Plateaus* (1987) as an extension of the kinds of (transcendent) 'disjunctive synthesis' encountered in *Anti-Oedipus* (1977), what Christine engages in is a process of conforming subjectivity: she does not want to fall out of line with the rules of the game and thus maintains degrees of appropriateness – what Deleuze and Guattari call, at one point, a 'double turning away, betrayal, and existence under reprieve' (Deleuze and Guattari 1987: 129). These points are as close as Deleuze and Guattari get to declaring something akin to an Althusserian subject of ideology.

And yet, the crack widens, especially when Lisette tells Christine that Robert's affair with Geneviève has been continuing for a number of years – and that they had been lovers since before Christine and Robert were married. Here, something closer to a rupture becomes inevitable, so that during the costume ball, Christine decides she must get away at all costs: with Jurieu, with Octave, with whomever or however, for now is the time to make a clean break and enter a new real. We might note that, near the end of the film, Christine seems without the specific traits of subjectivity, but instead flitters from one suggestion to the next, as though determined now by the chaos which surrounds her rather than by a defined and anchored subjectivity. If we were to argue that Christine has made herself – or at the very least tries to make herself – something akin to a body-without-organs, then we can appreciate that she is looking for the kind of spark, a future, a possibility, a 'life', or an intensity or intensities that will set her free. Reading with Deleuze and Guattari:

> This is how it should be done [that is, this is how to make yourself a body-without-organs]: Lodge yourself on a stratum, experiment with the opportunities it offers, find an advantageous place on it, find potential movements of deterritorialization, possible lines of flight, produce flow conjunctions here and there, try out continuums of intensities segment by segment, have a small plot of new land at all times. (Deleuze and Guattari 1987: 161)

By virtue of the crack, then, Christine enters a mode of experimentation, becomes subject to a series of proposals or potential adventures of which she is willing to be a part, even if things do not turn out as she had planned. That the crack has the potential to open up or release these activities and potentialities is what is central both to Renoir's films and to Deleuze's theorisation of the 'cracked crystal' in those films.

And these cracks appear all over Renoir's films: right at the beginning of *Chambermaid*, when Celestine is abhorred by the butler's dismissal of the old maid: here, she throws herself into this job with a will to find a line of flight out of it, the 'small plot of land' she will cultivate. Or when the poacher-prisoner jumps through the window of the courtroom at the beginning of *La Marseillaise*: rejecting the rule of the petty landowners, he makes a 'clean break' and discovers the revolution. Or the arrival of the American in *The River*: as though out of nowhere, he opens up new possibilities and new worlds for the young girl. And the rescue of Boudu in *Boudu*: wanting to end it all, suddenly he gets another chance, and he rides that chance as far as he can, until he finds another plane to jump onto, another territory to explore. Or Alexis's happening upon the bathing Nénette in *Déjeuner*: in her he discovers a different world, a completely different way of conceiving of things (and of 'conception', as it were).

III. Renoir's Forms

We are in a position to map what occurs in Renoir's films, such as they can be conceived in terms of a three-stage pattern. First of all, reality *as it is* is mapped in a way that makes it intolerable: diseased, corrupted, unbearable. Strictly speaking, this is how Renoir forms his crystal-images: the dazzling display of his crystals is merely a show of decrepitude and social stagnation. Secondly, the crack or rupture in the crystal offers a way out of the real – and into an imaginary, as I have been trying to insist – by means of which the real can be reinvented. Reality is here broken apart, smashed to bits – call it a deterritorialisation or a body-without-organs (depending which Deleuzo-Guattarian schema one finds oneself in). Thirdly, once reality has been stripped bare and cracked up, then new 'shoots' of reality can emerge, reality can begin again, as something entirely new. This 'new real' which can (supposedly) emerge from the crack or rupture will not lead to the formation of 'subjects' (in, say, an Althusserian sense of interpellation – or in the sense Deleuze and Guattari give to 'transcendent disjunctive syntheses' in *Anti-Oedipus*). Rather, the hope – for Deleuze and Guattari, and for Renoir, too, we

must assume – is to produce a properly schizophrenic subjectivity. If we conceive of these processes in this way, then, following Deleuze and Guattari, the body-without-organs is envisaged as a surface, a blank surface which exists in something approaching a 'zero degree' state. For this state is something that occurs as a result of the crack or rupture: a blasting apart of all coordinates so all that remains is a nascent state of potentiality. There will be points on this surface, however, where 'breaches' occur; elements of one sort or another will intersect this surface (for example, Octave will make a suggestion to Christine; Robert will accept her wish to flee . . .). These intersections might be something we call *subjects*, but if this is a subject, then it is a subject (so claim Deleuze and Guattari) 'defined by the states through which it passes' (Deleuze and Guattari 1977: 20). Thus, this subject is being re-born with each new state, with each new intersection on the body-without-organs. Here, there is no ego, no 'I', no self, no 'subject' in the traditional sense. Rather, what we have are what Deleuze will later call 'pre-individual singularities' and 'non-personal individuations' (Deleuze 2006: 351).

Some of the finest formulations of these quasi-subjective states emerge in Deleuze's last published works. The notion of a 'transcendental field' replaces earlier formulations (though with different emphases) like the body-without-organs or deterritorialisation and, for me, it is a far more precise conception. A transcendental field refers neither to an object nor a subject but is instead 'a pure stream of a-subjective consciousness, a pre-reflective impersonal consciousness' (Deleuze 2001: 25). We might merely call this a set of a priori conditions (or preconditions) that comes before any subject or any state of things, the kind of notion Foucault took so brilliantly from Kant (see Foucault 1984), and which, for Deleuze, were extremely valuable in his later writings (beginning, it seems to me, with the *Cinema* books along with his book on Foucault [Deleuze 1988]). And yet, Deleuze still finds room to criticise traditional notions of subjectivity: if there is a transcendental field that defines the conditions of possibility for the emergence of a subject or object, then, necessarily, any subject will 'come out of' this field. As Deleuze puts it: 'Consciousness becomes a fact only when a subject is produced at the same time as its object, both being outside the field and appearing as "transcendents"' (Deleuze 2001: 26). A very Kantian formulation indeed (which is to say that Deleuze's criticisms of Kant continue to the end), for here the subject requires 'reflection': the subject must stop, reflect and be held in place in order to think in this way. And this is why reflecting is something that transcends the transcendental field (as Deleuze claims): '[Consciousness] is expressed, in fact, only when it is

reflected on a subject that refers it to objects' (ibid.). To put it simply, then, Deleuze's operations for subjectivity can be divided into those acts, aspects or events that occur *on* or *in* the transcendental field, where such events are only ever the processes of pre-individual subjectivities; or there will be operations which result in subjects as such: out of and beyond the transcendental field, the doubled consciousness of subjectivity exposes itself as a subject of reflection.

In this late essay (on 'pure immanence') Deleuze contrasts the doubled consciousness of subjectivity with what he calls '*a* life'. In doing so, he makes a virtue of the moments or incidents that occur outside our subjective consciousness, those aspects of '*a* life' which fall beyond the purview of 'subjective understanding' (using 'understanding' here very much in a Kantian sense). Why would Deleuze wish to do such a thing? Precisely because these are the moments which contain the seeds of change: they open up a space for change because they are not (or they are not yet) subject to the workings of the understanding; they are virtual moments, as distinct from actual ones. We can certainly conceive of these moments as ones in which subjectivity itself is shattered – cracked – so that non-subjective, pre-conscious impulses come to the fore. If a reflective subjective consciousness can be conceived in a crystalline way, then we can also conceive of such subjects as open to cracking and cracking up, and to crack the subject is precisely what Deleuze endeavours to do.

IV. *The Golden Coach*

The final part of the puzzle then is this: pre-individual singularities occur at the level of the virtual, while subjectivities are products of the actual. When writing of Renoir, Deleuze reserves his highest praise for the 1952 film, *The Golden Coach*. For Deleuze, it is in this film that Renoir's themes are taken to their 'highest point' (Deleuze 1989: 56). And it is true that in *The Golden Coach*, there are cracks all over the place: the Viceroy finds one in Camilla who awakens him from the court rituals he despises; Ramon, the bullfighter, also finds a crack in Camilla as he dreams of a celebrity marriage with her (they will be the celebrity couple of the colony); while Felipe is drawn to discover a new kind of life with the Indian tribe he encounters (a 'small plot of new land', to invoke the claims of *Anti-Oedipus*). Camilla herself discovers three cracks arising from her despondency with the theatre and her disillusionment at arriving in the colony to find it run down and shambolic (there are certainly no streets paved with gold to be found!).

For Camilla, the Viceroy offers an entry to another world of opulence, glamour and wealth, as symbolised by the glittering golden coach itself, the most glaring of Renoir's crystal figures. But Camilla also senses in Ramon, the bullfighter, the possibility of another kind of union, with a strong man, a 'real' man as she calls him at one point. Felipe she admires deeply, but she fails to share his dream; indeed, Felipe brings out her inability to decide, that characteristic of protagonists of the time-image who are destined to observe and contemplate, without quite knowing how to act.

Camilla's great sacrifice at the end of the film – her donation of the golden coach to the Church – is to have saved each of her suitors while at the same time being unable to save herself. Her only way out now is to return to the stage, the stage she had temporarily abandoned in the hope of discovering success in (the so-called) 'real life'. She returns, as it were, to the point of her original crack-up at the beginning of the film: upon the stage, she will continue to experiment, to discover and rediscover herself, to invent and reinvent herself. 'At the end of *The Golden Coach*', writes Deleuze, 'three characters will have found their living role, while Camilla will remain in the crystal, to try still other roles in it, one of which will perhaps make her discover the true Camilla' (Deleuze 1989: 87). If the three characters she has saved – the Viceroy, Ramon and Felipe – have discovered subjectivities which they can now comfortably inhabit, then Camilla herself has discovered no such subjectivity and remains destined to continue to try out roles, to be intersected by pre-individuated singularities, to inhabit the 'transcendental field' of the stage, in the quest to discover a new reality.

When writing on Renoir, Deleuze makes a number of key claims which, I would like to think, substantiate many of the claims I have been trying to make here:

> For Renoir, theatre is primary, but because life must emerge from it. Theatre is valuable only as a search for an art of living [. . .]. 'Where then, does theatre finish and life begin?' remains the question always asked by Renoir. We are born in a crystal, but the crystal retains only death, and life must come out of it, after trying itself out. (Deleuze 1989: 86)

> According to Renoir, theatre is inseparable – for both characters and actors – from the enterprise of experimenting with and selecting roles, until you find the one which goes beyond theatre and enters life. (Ibid.)

> Everything happens as if the circuit served to try out roles, as if roles were being tried until the right one were found, the one with which we escape to enter a clarified reality. (Ibid.)

[T]hrough the development of an experimentation, something will come out of the crystal, a new Real will come out beyond the actual and the virtual. (Ibid.)

[S]omething takes shape inside the crystal which will succeed in leaving through the crack and spreading freely. (Ibid.)

From the indiscernibility of the actual and the virtual, a new distinction must emerge, like a new reality that was not pre-existent. (Ibid: 87)

There are three points to consider here:

1. *Life must come out of the crystal.* The crystal dazzles and shimmers, but its forms are moribund: its glittering is merely an invitation to pass through so that one might find a new life. If we conceive of the crystal as virtual, as something located on or in the transcendental field, then it is life which intersects the transcendental field in much the same way as cracks will cut into the crystal and open up paths to new modes of life. It is thus only by 'jumping into' the virtual, by going through the crack in the crystal, that one might emerge into a new reality. At the end of *The Golden Coach* Camilla remains within the crystal, looking for new cracks and new ways out in order to discover a new life.

2. *The development of an experimentation.* Life, a new real, and thought, depend on experimentation. Camilla, for example, can only discover a new real if she is determined to try out roles, to experiment. Thus, by jumping into the virtual, by experimenting, one might indeed be doomed to failure (as occurs in *Toni*, *La Bête humaine*, *The Little Match Girl* and others...). Such are the risks of '*a* life': the new will only be encountered through the development of an experimentation.

3. *A new real emerges beyond the indiscernibility of the virtual and the actual.* Films of the time-image are characterised by an indiscernibility between the actual and virtual. It is only as a consequence of this indiscernibility that a new real can emerge. The time-image does not affirm the virtual over and above the actual, but rather celebrates their indiscernibility. By opening herself up to the virtual – to experimentation, to playing out roles, to entering the transcendental field – Camilla enters a zone where the distinction between the actual and virtual ceases to be relevant. Only by going through this zone of indistinction (the kind of zone which in other contexts Deleuze and Guattari will

call 'deterritorialisation') might Camilla then emerge into a newly defined zone of reality, a reality that has never existed before.

One must enter the transcendental field in order to then discover new realities, and the challenge for Deleuze, it seems, is to keep discovering new realities. The transcendental field is virtual, so that, if we transfer Deleuze's concepts into (Deleuze's own) cinematic terms, the crystal-image is riven by the virtual crack through which a new real can be discovered. Only by entering the crystal and trying to find ways of leaving the crystal through the crack, will a new real become available. In *The Golden Coach* Camilla makes a number of attempts to leave via the cracked crystal, only to find herself, in the end, back in the crystal, upon the stage, where she will try out new roles in the hope of finding new ways out of the crystal.

At the film's end, therefore, Camilla is left to experiment – it is no wonder Deleuze praises *The Golden Coach* so highly. This opportunity for experimentation, it seems to me, can be conceived as a Deleuzian imaginary (the consonance between the virtual and the imaginary is something I have already hinted at). By imaginary I mean: an openness to what happens to one, even beyond one's imagination, that one could not foresee. This, for Deleuze, as much as for Renoir or Fitzgerald, is the *crack*: that which forces one to change direction, to change coordinates – in short, for Deleuze, this is what it means to think.

Some readers might still believe it a stretch to call this a Deleuzian 'imaginary' when the Deleuzian 'virtual' is clearly appropriate. Nevertheless, calling upon a Deleuzian notion of the imaginary allows me to stress how different Deleuze's imaginary is from the imaginary typically posited by film studies. The latter always claims that the imaginary in cinema is bad because it fails to do justice to reality; it fails to properly convey the stakes of reality. Instead, it gives us only imaginary solutions. Deleuze endeavours to refute such conceptions. For him, films do not offer fraudulent realities. Rather, if the cinema offers anything that can be called 'imaginary', then it does so only as a way of closing down or getting away from the real: if the cinema has the capacity to show us the real, then it also has the ability to show us how we might get out of that real and enter a new real. For Deleuze, the way to do this is not by criticising the imaginary, but rather by embracing the imaginary and following it so as to enter a new real. Those who criticise the imaginary are all too keen to draw distinctions between what is real and what is imaginary; and this is the blind spot so characteristic of so much commentary on the cinema: that bad cinema is imaginary,

while good cinema lays bare the real in all its bitterness or glory (even where realism itself is criticised, it is only ever in the name of a higher reality, for realism is only reality dressed in the clothes of the imaginary [on this point, see MacCabe 1985]). That is what Deleuze can give to films studies: an imaginary that does not need to be banished to moral (or political) decrepitude. Instead, Deleuze gives us an imaginary to be celebrated and praised – and above all, an imaginary with which we can experiment, an imaginary by means of which the cinema itself allows us to discover new dimensions of reality. If the film theories of the 1970s and 1980s wanted to break down the imaginary so that the real would be exposed – and so that escapes from the real would be quashed – then Deleuze advocates the opposite: let the real as it is be cracked apart so that the imaginary might then have the opportunity to shape new realities. It is on this point that Deleuze definitively goes against the dominant arguments of film theory.

References

Althusser, Louis (1971) 'Ideology and Ideological State Apparatuses (notes towards an investigation)', in *Lenin and Philosophy and Other Essays*, trans. Ben Brewster, New York: Monthly Review Press, pp. 85–126.

Baudry, Jean-Louis (1985) 'Ideological Effects of the Basic Cinematographic Apparatus', trans. Alan Williams, in Bill Nichols (ed.), *Movies and Methods Volume II: An Anthology*, Berkeley, Los Angeles and London: University of California Press, pp. 531–42.

Bogue, Ronald (2003) *Deleuze on Literature*, London and New York: Routledge.

Boudu Saved from Drowning, directed by Jean Renoir. France: Les Établissements Jacques Haïk, 1932.

Citizen Kane, directed by Orson Welles. USA: RKO Pictures, 1941.

Comolli, Jean-Louis (1985) 'Technique and Ideology: Camera, Perspective, Depth of Field', in Bill Nichols (ed.), *Movies and Methods Volume II: An Anthology*, Berkeley, Los Angeles and London: University of California Press, pp. 40–57.

Comolli, Jean-Louis and Jean Narboni (1990) 'Cinema/Ideology/Criticism', in Nick Browne (ed.), *Cahiers du Cinéma Volume III: The Politics of Representation*, London: British Film Institute, pp. 58–67.

Deleuze, Gilles (1988) *Foucault*, trans. Sean Hand, London: Athlone Press.

Deleuze, Gilles (1989) *Cinema 2: The Time-Image*, trans. Hugh Tomlinson and Robert Galeta, London: Athlone Press.

Deleuze, Gilles (1994) *Difference and Repetition*, trans. Paul Patton, London: Athlone Press.

Deleuze, Gilles (1995) 'Doubts About the Imaginary', in *Negotiations: 1972–1990*, trans. Martin Joughin, New York: Columbia University Press, pp. 62–7.

Deleuze, Gilles (2001) 'Immanence: A Life', in *Pure Immanence: Essays on a Life*, trans. Anne Boyman, New York: Zone Books, pp. 25–34.

Deleuze, Gilles (2006) 'Response to a Question on the Subject', in *Two Regimes of Madness, Texts and Interviews, 1975–1995*, New York: Semiotext(e), pp. 349–51.

Deleuze, Gilles and Félix Guattari (1977) *Anti-Oedipus: Capitalism and Schizophrenia*, trans. Robert Hurley, Mark Seem and Helen R. Lane, New York: Viking.

Deleuze, Gilles and Félix Guattari (1987) *A Thousand Plateaus: Capitalism and Schizophrenia*, trans. Brian Massumi, Minneapolis: University of Minnesota Press.

Elena et les hommes, directed by Jean Renoir. Italy/France: France London Films, 1956.

Foucault, Michel (1984) 'What is enlightenment?', in Paul Rabinow (ed.), *The Foucault Reader*, New York: Pantheon Books, pp. 32–50.

Grand Illusion, directed by Jean Renoir. France: Réalisations d'Art Cinématographique (RAC), 1937.

Heath, Stephen (1981) *Questions of Cinema*, London: Macmillan.

Heath, Stephen (1992) 'Lessons from Brecht', in Francis Mulhern (ed.), *Contemporary Marxist Literary Criticism*, London and New York: Longman, pp. 230–57.

La Bête humaine, directed by Jean Renoir. France: Paris Film, 1938.

La Marseillaise, directed by Jean Renoir. France: Compagnie Jean Renoir, 1938.

La Règle du jeu, directed by Jean Renoir. France: Janus Films, 1939.

Le Déjeuner sur l'herbe, directed by Jean Renoir. France: Compagnie Jean Renoir, 1959.

MacCabe, Colin (1985) 'Realism and the Cinema: Notes on Some Brechtian Theses', in *Theoretical Essays: Film, Linguistics, Literature*, Manchester: Manchester University Press, pp. 33–57.

McGowan, Todd (2007) *The Real Gaze: Film Theory After Lacan*, New York: SUNY Press.

Metz, Christian (1982) *Psychoanalysis and Cinema: The Imaginary Signifier*, trans. Celia Britton, Annwyl Williams, Ben Brewster and Alfred Guzetti, London: Macmillan.

Rushton, Richard (2011) *The Reality of Film: Theories of Filmic Reality*, Manchester: Manchester University Press.

Strike, directed by Sergei Eisenstein. USSR: Goskino, 1925.

Swamp Water, directed by Jean Renoir. USA: Twentieth Century Fox, 1941.

The Battleship Potemkin, directed by Sergei Eisenstein. USSR: Goskino, 1925.

The Crime of Monsieur Lange, directed by Jean Renoir. France: Films Obéron, 1936.

The Diary of a Chambermaid, directed by Jean Renoir. USA: Benedict Bogeaus Production, 1946.

The Golden Coach, directed by Jean Renoir. France/Italy: Corona Films, 1952.

The Little Match Girl, directed by Jean Renoir. France: Jean Renoir/Jean Tedesco (Vieux Colombier), 1928.

The River, directed by Jean Renoir. France/India/USA: Oriental International Films, 1951.

Toni, directed by Jean Renoir. France: Les Films Marcel Pagnol, 1935.

Synaptic Signals: Time Travelling Through the Brain in the Neuro-Image

Patricia Pisters University of Amsterdam

Abstract

This essay presents some thoughts on schizoanalysis and visual culture around the proposition that cinema survives in the digital age as a type of image that, after the movement-image and the time-image, could be called the neuro-image. By considering clinical schizophrenia as 'degree zero' of schizoanalysis in a more critical sense, a reading of *The Butterfly Effect* unfolds the temporal dimensions of schizoanalysis as typical for a definition of 'the neuro-image'. The argument is that the neuro-image speaks from the (always speculative) future.

Keywords: schizophrenia, the neuro-image, *Difference and Repetition*, third synthesis of time, the future

I. Introduction

Schizophrenia is intimately connected to our times. As a neurological disease, schizophrenia differs from neurosis, as Deleuze and Guattari emphasise in *Anti-Oedipus* (Deleuze and Guattari 1984: 122). Neurosis is based on a repression complex related to a reality principle that remains intact. In schizophrenic psychosis, the reality principle no longer holds and is replaced by the internal reality of the brain. Deleuze argues that neurosis is not an adequate model for understanding the contemporary world. By contrast, the (schizophrenic) brain can provide us with a model for our contemporary existence, especially in relation to electronic and digital images:

Deleuze Studies 5.2 (2011): 261–274
DOI: 10.3366/dls.2011.0020
© Edinburgh University Press
www.eupjournals.com/dls

Neurosis is thus not the consequence of the modern world, but rather of our separation from this world, of our lack of adaptation to this world. The brain, in contrast, is adequate to the modern world, including its possibilities of the expansion of electronic or chemical brains: an encounter occurs between the brain and colour, not that it is enough to paint the world, but because the treatment of colour is an important element in the awareness of the 'new world' (the colour-corrector, the electronic image ...). (Deleuze 1989: 317, n. 20)

Deleuze explains his statement by referring to Antonioni's project 'Technically Soft', which shows an exhausted man who is on his back dying and looking at 'the sky which becomes ever bluer, this blue becoming pink' (Deleuze 1989: 317, n. 20). Deleuze's conjunction of the brain, image technology and an aesthetic effect is remarkable and demands to be unpacked. Could this awareness of a 'new world' by the treatment of colour relate to the reality of the brain-screen and to a schizoanalysis of cinema? To investigate this further I propose to look at *The Butterfly Effect* (2004) and propose productive connections with Deleuze's work on cinema, with the (schizophrenic) brain and with Deleuze's philosophy of time. This will allow me to see if, by way of a schizoanalysis of cinema, I can distinguish a new type of cinematic image. After the movement-image and the time-image, I suggest to call this new type of image the 'neuro-image' (see also Pisters 2008, 2011).[1]

The main character of *The Butterfly Effect*, Evan Treborn (Ashton Kutcher), suffers from a neurological disease that he inherited from his father and that was enhanced by a traumatic childhood experience.[2] Through this narrative, the film addresses the problem of time and the desire to change our destinies by travelling back and forth in time. The film's tagline is 'Change one thing, change everything'. This tagline refers to chaos theory and to how chaos relates to the natural state of being in the human brain. The film's emblematic title image is a brain scan that very subtly suggests the flapping wings of a butterfly, combining in this emblematic image the link between chaos theory and modern neuropsychology that the film plays with. On the DVD extras, scientists explain how chaos theory in physics has learned that a very tiny difference (such as a slightly different position in space) can create enormous differences in resulting movements and outcomes that are unpredictable. Psychologists explain how this insight from physics has also changed the practice of psychology, acknowledging the unpredictable effects of the smallest events on our brain-screens and mental life.[3] *The Butterfly Effect* takes these insights of modern science and grounds them with a knowledge of psychiatric disorders and the

real traumatic impacts that human beings can have upon each other. It then gives this experimental grounding a more fantastic spin, allowing its main character, who suffers from epileptic seizures and blackouts, to travel through time, change one little thing in the past, and thus change the future present.[4]

As Deleuze has shown with his cinema books, the problem of time is intrinsically related to the medium of film and has metaphysical dimensions.[5] In the second part of this article, I will return to the philosophical questions of time and the brain with respect to the neuro-image. In fact, a new relation to time will be a crucial argument in the conception of the neuro-image, which, as I will argue, has the future as its basic form of time; speculations about the future determine its present and past. First, however, I want to remain close to the film, its specific temporal experiments, and its clinical and scientific references to the brain, so as to consider it as just one possible experiment (among many possible others) in connecting a different conception of time to the delirious schizo-brain. In this sense, *The Butterfly Effect* offers not only an imaginative take on a contemporary neurological condition, but could also be read in a more allegorical way about our 'times'.[6]

II. The Temporal Architecture of the Schizoid Brain

The story of the film is told from three moments in Evan's life: Evan at the age of seven when he and his friends Lenny (Elden Henson), Tommy (William Lee Scott) and Kayleigh (Amy Smart) have a traumatic (incestuous) experience orchestrated by Mr Miller (Eric Stolz), who is Kayleigh and Tommy's father; Evan at the age of thirteen, when the four friends cause an accident; and Evan at the age of twenty, when he is in a mental institution in severe states of delusion, where the film starts. The plot moves back and forth between these different moments of time. But the time layers are interwoven with other possible pasts and their respective futures to which Evan wakes up in changed presents. In his blackouts Evan seems to be able to change the past. Wanting to save Kayleigh from a known future in which she is traumatised, depressed and lonely, working in a diner, he goes back to the moments of their childhood, makes different choices and returns to a present where Kayleigh has changed, differently, into: a sorority girl; then a heroin junky prostitute; and also an earthy type of hippy, depending on the impact of different changed pasts. But the destinies of all other characters, including his own, change in each temporal alteration as well, and in some cases very dramatically (in one version, Evan saves Kayleigh

but kills Tommy; in another, he causes Lenny's institutionalisation; in yet another, he prevents the accident when they are teenagers but is wounded himself, and he wakes up in a present where he has no arms and his mother dies of lung cancer because she starts chain smoking after Evan's accident).

Aesthetically, the images of the time travel and memory flashes also have different colour saturations and densities, which create patterns of recognition. Furthermore, a special shade of red, called 'Miller red' in the director's commentary, indicates the presence of danger. 'Institutional green' is connected to Evan's father's insanity and thus the hereditary legacy of his seizures and frightening abilities. We see here quite literally what Deleuze, as quoted earlier, has called 'an encounter occurring between the brain and colour' that is 'an important element in the awareness of a "new world" '. The brain and film aesthetics are interconnected, indicating that the combination creates new worlds. *The Butterfly Effect* suggests quite literally that the brain should be seen as a film: 'Think of your life as a film, rewind, go back, re-edit', the doctor in the mental hospital tells Evan when he tries to recover what happened during one of Evan's blackouts. The problem is that the complexity of the brain itself (and chaos) does not allow us to foresee all the consequences and implications of our choices, in spite of our desire for control. But the film strongly emphasises that all these different worlds have a mental reality on Evan's brain-screen and as such is pointing to the reality of our contemporary screen culture.

Throughout the film, Evan Treborn is put in an fMRI scanner several times and the unusually excessive plasticity of his brain is discovered mostly in the outer layers of the cerebral cortex where haemorrhaging and massive neural reconstruction can be noticed.[7] 'Forty years of memory in one year', Evan says of his own brain, 'it's an overloaded city, like a reprogrammed brain'. In these sequences, he is referring to neuroscientific insights about the abnormal plasticity and 'wild' synaptic connectivity of schizophrenic and epileptic brains (DeLisi 1997: 119–29). Epilepsy can be considered another modern affective brain disorder that is an important reference in elaborating schizoanalysis. Gary Genosko has demonstrated that Guattari was especially interested in Marco Bellocchio's film *Fists in the Pocket* (1965) because of its treatment of epilepsy. Genosko compares this film to Anton Corbijn's film *Control* (2007), about Joy Division's lead singer Ian Curtis who suffered from severe epileptic attacks and finally committed suicide. Genosko points out that the affective intensities of epileptic seizures have the potential to create new visions, new aesthetics (Genosko 2009: 167–73).

I would like to emphasise here this understanding of epilepsy as a form of schizophrenia in which neural connections are made much too quickly. In *The Aesthetics of Disappearance*, Virilio refers to 'pyknolepsy', a mild form of epilepsy in which a person is disconnected from reality and misses parts of the ongoing, over-saturated present. In pyknolepsy and even more in epilepsy, the brain operates too quickly, makes too many connections at the same time, causing literal overload resulting in seizure (see Virilio 1991).

The medical data in *The Butterfly Effect* thus correspond more or less to recent neurological findings about schizophrenia. Research has also shown that schizophrenia is generally more common in urban populations, which, considering the urbanisation of the contemporary world, makes it all the more a symptom of today's hyperstimulated culture (Sundquist et al. 2004; March and Susser 2006). By predicting at the end of *The Time-Image* new image-types as omni-directional brain cities that are overloaded with information, Deleuze's cinematographic brain-screens resonate as well quite literally with the scene described above from *The Butterfly Effect* (see Deleuze 1989: 265). Moreover, the wild time-travelling in Evan's seizured brain corresponds with neuroscientific perspectives according to which 'the temporal architecture of schizophrenia is characterised by bursts of complex, nonlinear phenomena alternating with truly random events' (Paulus and Braff 2003: 3). It is this temporal architecture of schizophrenia that I take as an important indication to explore the temporal dimensions of contemporary cinema. My point here is not to look for exact correspondence or proof in scientific discourse, but to make productive connections between different fields that all give important indications for the necessity of a schizoanalysis of contemporary screen culture. The temporal architecture of schizophrenia leads us back to the problem of time and Deleuze's philosophy of time as developed in the cinema books and in *Difference and Repetition*. A return to these books can give more clarity in the temporal dimensions of the schizoid brain-screen in *The Butterfly Effect*.

III. Difference and Repetition: The Third Synthesis of Time and the Neuro-Image

Time is an important aspect in Deleuze's film books and together *The Movement-Image* and *The Time-Image* can cover the whole range of the actual and the virtual (or matter and memory), the indivisible plane of immanence of Deleuzian philosophy. Movement-images and

time-images relate both to the actual and the virtual but they do so in different ways, as is clear from the difference between flashbacks (in the movement-image) and crystal-images (in the time-image). In this sense there seems to be no need for a third type of image, a neuro-image as I am proposing. There are, I believe, many instances that justify the neuro-image as simply an extension or intensification of the time-image. However, a return to *Difference and Repetition* can allow us to distinguish yet other metaphysical dimensions of time, and to make a distinct case for the conception of the neuro-image as a third type of image, or in any case a third dimension of the image.

Difference and Repetition is a book that poses the problem of the virtual and the actual in terms of difference and repetition, and addresses the complex problems of the conditions of appearances, things, life forms as they differ and are repeated. As James Williams has indicated, a consciousness of repetition is proposed by Deleuze in terms of certain variegated syntheses of time. Williams argues that Deleuze's syntheses offer a 'complex but deeply rewarding and important philosophy of time [that] will, no doubt, come to be viewed as one of the most important developments of [Deleuze's] philosophy' (Williams 2003: 85). In chapter 2 of *Difference and Repetition*, Deleuze develops the idea of the passive synthesis of time. As in the cinema books, Bergson is the main reference here, although the starting point of Deleuze's reflections is Hume's thesis that 'repetition changes nothing in the object repeated, but does change something in the mind which contemplates it' (Deleuze 1994: 70). Repetition has no in-itself, but it does change something in the mind of the observer of repetitions: on the basis of what we perceive repeatedly in the present, we recall, anticipate or adapt our expectations in a synthesis of time. This synthesis is a passive synthesis, since 'it is not carried out by the mind, but occurs in the mind' (Deleuze 1994: 71). The active (conscious) synthesis of understanding and memory are grounded upon this passive synthesis, which Deleuze, referring to Bergson, calls duration and which occurs on an unconscious level.[8] So although Bergson refers to the observation of our inner life in duration as consciousness, the temporal contractions that generate it are largely unconscious. Deleuze distinguishes different levels of passive syntheses that have to be seen in combinations with one another and in combination with active (conscious) syntheses:

> All of this forms a rich domain of signs which always envelop heterogeneous elements and animate behavior. Each contraction, each passive synthesis, constitutes a sign which is interpreted or deployed in active syntheses.

The signs by which an animal 'senses' the presence of water do not resemble the elements which the thirsty animal lacks. The manner in which sensation and perception – along with need and heredity, learning and instinct, intelligence and memory – participate in repetition is measured in each case by the combinations of forms of repetition, by the levels on which these combinations take place, by the relationships operating between these levels and by the interferences of active syntheses with passive syntheses. (Deleuze 1994: 73)

The first synthesis that Deleuze distinguishes is that of habit, the true foundation of time, occupied by the passing present. But this passing present is grounded by a second synthesis of memory: 'Habit is the originary synthesis of time, which constitutes the life of the passing present. Memory is the fundamental synthesis of time, which constitutes the being of the past (that which causes the present to pass)' (80). As Williams explains, the first synthesis of time occurs because habits (repetitions) form our anticipations based on what we have experienced before, 'as in the passive assumption that something will occur' (Williams 2003: 101). The second synthesis, Williams calls archiving, 'as in the passive sense of the present passing away into the past as a stock of passing presents' (ibid.). The second synthesis of time is equivalent to Proust's involuntary memory (Deleuze 1994: 85). In the description of these two syntheses of time, Deleuze refers explicitly to Bergson. The first and second syntheses rely on each other as in the alliance of the soil (foundation) and the sky (ground), but they also have their own characteristics.[9]

The conception of the syntheses of time is incredibly sophisticated and complicated and I cannot do justice to the richness of the arguments Williams and others have constructed around them so powerfully and convincingly. Nevertheless, I take that it is possible to argue that the first synthesis of time, habitual contraction, can be recognised as movement-images that Deleuze describes as the sensory-motor aspects of the brain-screen. Similarly, I consider that the second synthesis of time can be related to the dominant form of time in the time-image, where the past becomes more important and the ground of time manifests itself more directly. It has to be noted that each synthesis of time has its own relation to other times. The first synthesis of time as the living or passing present relates to the past and the future as dimensions of the present. In this way, the flashback (and flashforward) in cinema can be seen as the past and future of the movement-image that is based in the present. In the movement-image, we always return to the present. In the second synthesis of time, the past becomes the ground, the time within which

time operates, and thus the present and the future become dimensions of the past. So, instead of the synthesis of a particular stretch of duration, the present now becomes the most contracted degree of all of the past, the 'pure past'. In *The Time-Image* the different time-images that Deleuze distinguishes are grounded in Bergson's conception of the 'pure past'. As such, time-images become dimensions of the second synthesis of time; the present and the future become dimensions of the past as its crystallising points, and the virtual becomes more indistinguishable from the actual than in the movement-images that have the present as their founding dimension.[10]

However, in *Difference and Repetition*, Deleuze also distinguishes a third synthesis of time: the third synthesis of time is the future as such. 'The third repetition', he writes, 'this time by excess, [is] the repetition of the future as eternal return' (Deleuze 1994: 90). In this third synthesis, the foundation of habit and the ground of the past are 'superseded by a groundlessness, a universal ungrounding which turns upon itself and causes only the yet-to-come to return' (91). In this third synthesis, the present and the past are dimensions of the future. 'In the work of the third passive synthesis', Williams explains, 'there is the sense of the openness of the future with respect to expectancy and archiving' (Williams 2003: 101). This openness and its risks also imply the possibilities of change (making the future different from the past and the present). It is the condition for the new. The third synthesis is complicated since it does not simply repeat the past and the present, but instead cuts, assembles and orders from them, to select the eternal return of difference in a series of time: 'Identities, or the same, from the past and the present, pass away forever, transformed by the return of that which makes them differ – Deleuze's pure difference of difference in itself' (103).[11] The three syntheses of time together account for Deleuze's philosophy of time.

Addressing the third synthesis of time, Deleuze breaks off from Bergson as Nietzsche becomes the main point of reference. In *The Time-Image*, Bergson also seems to disappear in favour of Nietzsche's appearance, though in the cinema books, Nietzsche is not explicitly connected to the question of time. Chapter 6 of *The Time-Image*, for example, discusses Orson Welles and the powers of the false, and Nietzsche is the important reference for understanding the manipulation of such powers. These powers are discussed, however, as a consequence of the direct appearance of time, which is mainly elaborated in terms of the pure past of the second synthesis of time. At the end of the discussion of Welles's cinema, the powers of the false are connected to

the creative powers of the artist and the production of the new (though not explicitly to the eternal return and the future). Also, the series of time are mentioned in *The Time-Image*, especially in the chapter on bodies, brains and thoughts (ch. 8). Here the bodies in the cinema of Antonioni and Godard relate to time as series. In the conclusion of the book, Deleuze explains this chronosign of time as series:

> the before and after are no longer themselves a matter of external empirical succession, but of the intrinsic quality of that which becomes in time. Becoming can in fact be defined as that which transforms an empirical sequence into series: a burst of series. (Deleuze 1989: 275)

We can see that after all the insistence on the Bergsonian temporal dimensions of the movement-image and the time-image, this form of time (series of time) remains rather underdeveloped on a theoretical level in the cinema books. Referring back to *Difference and Repetition*, we can now consider that the powers of the false and the series of time that can be sensed in some time-images might belong to this third synthesis of time. Taking this logic one step further, what I suggest is that this third synthesis of time that already appears in the *Time-Image* (in a more or less 'disguised' form) is the dominant sign of time under which neuro-images are formed.[12] The neuro-image belongs to the third synthesis of time, the time of the future (though this certainly does not exclude the other times, as the past and the present now become dimensions of the future).[13] Moreover, it has to be noted that each synthesis also opens up to the other syntheses (each with their own respective dimensions of time). So we get here a complex architecture of time, that is played out with ever greater consciousness on our brain-screens in the neuro-image.

IV. The Schizoid Brain: Perspectives from the Future

So how does all this relate to *The Butterfly Effect*? Is it possible to see this film as based upon the 'third synthesis of time'? As was clear from the plot descriptions that I gave, the film is preoccupied with time. The various pasts could be seen as flashbacks dependent on a present where Evan is at high school, and thus considered as based on the first synthesis of time. However, this present is actually too unstable and does not form the foundational basis of the traditional flashback which investigates the past from a centre in the present (think of the famous flashbacks in Marcel Carné's *Daybreak* [1939], where all events

lead to the situation in the stable present where Jean Gabin has locked himself up in an apartment). Could the variations of the past then be explained as dimensions of the pure past and thus be based in the second synthesis of time? There are arguments to be made for that; after all, the present situation depends on what happened in the past (the children at age seven and at age fourteen). And so we could consider everything that happens as indistinguishable crystals between the virtual and the actual, never knowing exactly when we have left one domain and entered the other. But that does not explain the series of time that the film produces. Rather, I suggest, the past and the present are dimensions of the (always speculative) future imagined on Evan's schizoid brain-screen. Each moment Evan changes something in the past, the present changes (in unpredictable ways) accordingly. This is what happens when we are in the third synthesis of time: the past and present are 'recut' with different speeds, intensities and orders. The third synthesis of time is related to the creation of the new, to hope for the future, an eternal recurrence of 'difference', but also to death (death is the future for all of us, but also calls for rebeginnings). After Evan has revisited 'all of the past' and 'all of the present', like a database of options of 'new worlds' from a future perspective, we return to the beginning of the film where Evan is in the psychiatric hospital and is told that the diaries (that give him entrance into his pasts) are nothing but fantasies to cope with his guilt (of having killed Kayleigh in what is most likely to be the 'real' version of the past and the present). Here the director's cut of the film differs significantly from the theatrical version.

In the theatrical release of *The Butterfly Effect*, several scenes were deleted which were re-edited in to the director's cut ('Thank God for DVD,' the directors exclaim with relief). In the first deleted scene, Evan finds documents in an old shoebox that indicate he inherited his disease from the male side of his family. Not only his father but also his grandfather had been hospitalised for the same mental illness. In another scene, he learns from his mother that he was actually her third baby; two others were stillborn before him. This leads to the ending that the directors originally planned, where Evan, after so many variations of the past and its futures in the present all go wrong, decides to go back to the moment before his birth and strangle himself with the umbilical cord, preventing his own birth. His mother then, this cut suggests, will have a daughter from another husband (breaking the male insanity heritage) and Kayleigh will marry somebody else. The studio did not want this ending, considering it too dark.[14] It is a dark ending indeed. But apart from being dark, it is also a mysteriously powerful narrative option that

in fact can only be explained as an 'insane' solution to the question of (im)possible futures. But metaphysically it is the absolute zero degree of the third synthesis of time: to have died before birth, in order to create a new present – all from the point of view from the future. *The Butterfly Effect* is told from the perspective of the future and shows the pathological (deadly) dimensions of this Time of the Future that is Now.

But as I want to argue in the larger project, the neuro-image has also more creative and political aspects that relate to a productive form of schizoanalysis that acknowledges the affective and illusory realities of our contemporary brain-screens (Pisters 2011). One can think of the ways in which contemporary Hollywood cinema often quite literally speaks from a future perspective, *Minority Report* (2002) with its precogs characters and pre-emptive crime fight being the most obvious example. On a narrative level, many films start from a point in the future. Here *Inception* (2010) is the most notable case in point, where we enter the main character's brain architecture from a moment in the future where he is old and dying. One can also think of *Avatar* (2009) as a neuro-image that speaks from a speculated future of the planet. But one can also think of political cinema, such as the Palestinian film *The Time that Remains* (2010) that remixes political reality in order to 'gain time' for the future, to sustain in the creation of imaginative realities. Contemporary culture is full of neuro-images that are based in the third synthesis of time. But we need schizoanalysis to understand its many possible dangers and empowerments.

Notes

1. In the first volume on Deleuze and schizoanalysis of cinema (Pisters 2008), I make an explicit like between schizophrenia as disease and schizophrenia as (cultural and political) process or strategy. In this volume I will depart again from pathological schizophrenia but discuss its temporal and metaphysical dimensions. All this is more elaborated in *The Neuro-Image* (Pisters forthcoming).
2. When referring to schizophrenia, I will propose an inclusive definition of mental illnesses as 'delusional or affective illnesses' that are defined as brain disorders by contemporary neuroscience, including neurological diseases such as epilepsy, autism and (manic) depression.
3. I refer to the director's cut of the film as distributed on DVD, which is commented upon by the filmmakers and which contextualises the film with both scientific theories and insights and film historical backgrounds (*The Butterfly Effect: The Director's Cut* 2004). Besides the directors' commentary, the DVD contains notable extra material such as 'The Science and Psychology of Chaos Theory' and 'The History and Allure of Time Travel Films'.

4. In the DVD extra, *The Butterfly Effect* is framed within the genre of time-travel movies.
5. Freud defines the unconscious in terms of displacement, condensation, and repression, all related to sexuality. The Deleuzian unconscious is based on Bergson and related to the synthesis of memories and duration (see Kerslake 2007). In *Difference and Repetition*, Deleuze relates Eros specifically to the second synthesis of time (Deleuze 1994: 85).
6. Garrett Stewart discusses time and memory in *The Butterfly Effect*, as well as in *Donnie Darko* (2001), as a Hollywood Gothic science fiction, as opposed to the European uncanny humanism of films such as *The Double Life of Veronique* (1991) and *Swimming Pool* (2003) (Stewart 2002: 327–50).
7. fMRI stands for functional magnetic resonance imaging, which is a non-invasive brain scanning technique that measures changes in blood flows related to neural activity. It is one of the most recent and commonly used neuroimaging technologies.
8. Deleuze's argumentation is complex and extended. For insightful and very precise discussions of *Difference and Repetition*, James Williams (2003) and Joe Hughes (2009) are indispensible references.
9. Deleuze gives the ground of the past the characteristics of the sky: 'the foundation concerns the soil, it shows how something is established upon this soil [...] whereas the ground comes rather from the sky, it goes from the summit to the foundations [...]' (Deleuze 1994: 79).
10. Alia Al-Saji (2004) elaborates on the influence of Bergson in *Difference and Repetition*, referring mainly to the second synthesis of time.
11. Elsewhere, he clarifies this differently: 'When thinking of the future (F) as different from the past (P), we may be tempted to think that the difference lies between P and F. But Deleuze's point is that in a selection we move from an assembly P/F to a new assembly P'/F'. We select a new past and a new future. So any difference is between P/F and P'/F'' (Williams 2006: 112).
12. Alain Resnais's cinema, for instance, can be considered as 'neuro-images avant-la-lettre'. It is important on the one hand to acknowledge the fact that Deleuze has already mapped out the contours of the neuro-image in his cinema books. On the other hand, it also allows us to see how Resnais's cerebral screens anticipate the digital logic of our contemporary screens as a will to art (and thus indicate a resonating link between the neuro-image's brain-screen and the digital age in a non techno-deterministic way). See for an extended analysis of Resnais's cinema as early neuro-image, chapter 4 of *The Neuro-Image* (Pisters forthcoming) or the online lecture 'Signs of Time: Cerebral Metaphysics of the Neuro-Image' at http://vimeo.com/11779080.
13. Richard Rushton also refers to the syntheses of time in connection to cinema, indicating how the virtual and the actual can be read as the first and second synthesis of time in the movement-image in *Letter from an Unknown Woman* (1948). His focus (in a discussion with Mark Hansen) is on spectatorship, and he relates the time-image to the third synthesis of time and the dissolution of the subject (Rushton 2008). I propose a more meta-theoretical perspective by arguing that the movement-image, the time-image and the neuro-image are each based in a different synthesis of time, each has their own relations to past, present and future, and each opens up to the other syntheses.
14. In the theatrical version, Evan scares Kayleigh away the first moment they meet when they are seven so that they never cross paths again. The film ends eight years in the future where Evan recognises Kayleigh in a crowded city streets but after a moment of hesitation lets her pass by. All versions of alternative endings can be viewed on YouTube.

References

Al-Saji, Alia (2004) 'The Memory of Another Past: Bergson, Deleuze and a New Theory of Time', *Continental Philosophy Review*, 37, pp. 203–39.

Avatar, directed by James Cameron. USA: Twentieth Century Fox, 2009.

Control, directed by Anton Corbijn. UK/USA: 3 Dogs and a Pony, 2007.

Daybreak, directed by Marcel Carné. France: Les Films Vog, 1939.

Deleuze, Gilles (1986) *Cinema 1: The Movement-Image*, trans. Hugh Tomlinson and Barbara Habberjam, London: Athlone Press.

Deleuze, Gilles (1989) *Cinema 2: The Time-Image*, trans. Hugh Tomlinson and Robert Galeta, London: Athlone Press.

Deleuze, Gilles (1994) *Difference and Repetition*, trans. Paul Patton, London: Athlone Press.

Deleuze, Gilles and Félix Guattari (1984) *Anti-Oedipus: Capitalism and Schizophrenia*, trans. Robert Hurley, Mark Seem and Helen R. Lane, London: Athlone Press.

DeLisi, Lynn (1997) 'Is Schizophrenia a Lifetime Disorder of Brain Plasticity, Growth and Aging?', *Schizophrenia Research*, 23:2, 119–29.

Donnie Darko, directed by Richard Kelly. USA: Flower Films, 2001.

Fists in the Pocket, directed by Marco Bellocchio. Italy: Doria, 1965.

Genosko, Gary (2009) *Felix Guattari: A Critical Introduction*, London and New York: Pluto Press.

Hughes, Joe (2009) *Deleuze's Difference and Repetition*, London: Continuum.

Inception, directed by Christopher Nolan. USA: Legendary Pictures, 2010.

Kerslake, Christian (2007) *Deleuze and the Unconscious*, London: Continuum.

Letter from an Unknown Woman, directed by Max Ophüls. USA: Rampart Productions, 1948.

March, Dana and Susser, Ezra (2006) 'Invited Commentary: Taking the Search for Causes of Schizophrenia to a Different Level', *American Journal of Epidemiology*, 163:11, pp. 979–81.

Minority Report, directed by Steven Spielberg. USA: Amblin Entertainment, 2002.

Paulus, Martin and Braff, David (2003) 'Chaos and Schizophrenia: Does the Method Fit the Madness?', *Biological Psychiatry*, 53:1, pp. 3–11.

Pisters, Patricia (2008) 'Delirium Cinema or Machines of the Invisible?', in Ian Buchanan and Patricia MacCormack (eds), *Deleuze and the Schizoanalysis of Cinema*, London: Continuum, pp. 102–15.

Pisters, Patricia (forthcoming), *The Neuro-Image: A Deleuzian Film-Philosophy of Digital Screen Culture*, Stanford, CA: Stanford University Press.

Rushton, Richard (2008) 'Passions and Actions: Deleuze's Cinematographic Cogito', *Deleuze Studies Journal*, 2:2, pp. 121–39.

Stewart, Garrett (2002) 'Cimnemonics versus Digitime', in David Rodowick (ed.), *Afterimages of Gilles Deleuze's Film Philosophy*, Minneapolis and London: University of Minnesota Press, pp. 327–50.

Sundquist, Kristina, Gölin Frank, Jan Sundquist (2004) 'Urbanisation and Incidence of Psychosis and Depression', *British Journal of Psychiatry*, 184, pp. 293–8.

Swimming Pool, directed by François Ozon, France/UK: Fidélité Productions, 2003.

The Butterfly Effect: The Director's Cut, DVD, directed by Jason Mackye Gruber and Eric Bress. USA: New Line Cinema/Icon Home Entertainment, 2004.

The Double Life of Véronique, directed by Krzysztof Kieślowski. Poland: Sidéral Productions, 1991.

The Time that Remains, directed by Elia Suleiman. UK/Italy/Belgium/France: The Film, 2010.

Virilio, Paul (1991) *The Aesthetics of Disappearance*, trans. Philip Beitchman, New York: Semiotext(e).

Williams, James (2003) *Gilles Deleuze's Difference and Repetition: A Critical Introduction and Guide* (Edinburgh: Edinburgh University Press.

Williams, James (2006) 'Science and Dialectics in the Philosophies of Deleuze, Bachelard and Delanda', *Paragraph: A Journal of Modern Critical Theory*, 29:2, pp. 98–114.

Deterritorialisation and Schizoanalysis in David Fincher's *Fight Club*

William Brown and David H. Fleming
Roehampton University/University of Nottingham, Ningbo

Abstract

Taking a schizoanalytic approach to audio-visual images, this article explores some of the radical potentia for deterritorialisation found within David Fincher's *Fight Club* (1999). The film's potential for deterritorialisation is initially located in an exploration of the film's form and content, which appear designed to interrogate and transcend a series of false binaries between mind and body, inside and outside, male and female. Paying attention to the construction of photorealistic digital spaces and composited images, we examine the actual (and possible) ways viewers relate to the film, both during and after screenings. Recognising the film as an affective force performing within our world, we also investigate some of the real-world effects the film catalysed. Finally, we propose that schizoanalysis, when applied to a Hollywood film, suggests that Deleuze underestimated the deterritorialising potential of contemporary, special effects-driven cinema. If schizoanalysis has thus been reterritorialised by mainstream products, we argue that new, 'post-Deleuzian' lines of flight are required to disrupt this 'de-re-territorialisation'.

Keywords: schizoanalysis, *Fight Club*, mind–body, digital, de-/re-territorialisation

Deleuze Studies 5.2 (2011): 275–299
DOI: 10.3366/dls.2011.0021
© Edinburgh University Press
www.eupjournals.com/dls

I. Introduction

In *Anti-Oedipus* (1983), Gilles Deleuze and Félix Guattari advanced a radical conception of desire, no longer shackled to absence and lack, but based on a productive process of presence and becoming. Rather than the old 'Oedipalising' models of psychoanalysis, whereby the subject is constituted or gains an identity through identification with something that is always already lost (identity as having a fixed goal, *telos*, or, in another sense, a reified *essence*), Deleuze and Guattari proposed that identity constantly undergoes shifts and changes, in response to, or in accordance with, the situation in which it finds itself. The process of becoming (as opposed to the 'thing' of being) that Deleuze and Guattari describe, then, is one in which the conventional distinctions between inside and outside, actual and virtual, and even between self and other significantly blur. To comprehend and understand the world thus, as well as the works of art it contains, is known as *schizoanalysis*.

In this essay, we employ a schizoanalytic approach to expose the radical potential for deterritorialisation (that is, the upsetting of those conventional distinctions listed above – and perhaps even the upsetting of distinctions *per se*) to be found in David Fincher's *Fight Club* (1999). As we shall show, this potential for deterritorialisation is located at the level of form and content, and in the effects the film displays in the real world (that is, on spectators). In other words, we shall explore not only what happens in the narrative (its content), but also how the film itself is put together (its form) and functions in the world. Particular attention will be paid to the film's construction of photorealistic digital spaces and composited images, before examining the actual (and possible) ways in which audiences relate to the film, during and after screenings. Finally, we shall adventurously propose that schizoanalysis, when applied to a Hollywood film as here, suggests one or both of two things: that Deleuze underestimated the deterritorialising potential of contemporary, special effects-driven cinema, and/or that schizoanalysis has itself been reterritorialised if found in mainstream products. In this manner, we highlight how new, 'post-Deleuzian' lines of flight are required to disrupt this 'de-re-territorialisation'.

II. *Fight Club*

Fight Club has already garnered much academic attention, being schizophrenically read through a plethora of critical and discursive lenses/paradigms. Amongst others, it has been read as a film dealing

with, or invocative of: a/the contemporary 'crisis of masculinity' (Taubin 1999; Giroux 2001; Friday 2003), capitalism and consumerism (Giroux and Szeman 2001; Ta 2006; Lizardo 2007), violence and pain (Windrum 2004; Gormley 2005), fascism and anarchy (Dassanowsky 2007; Chandler and Tallon 2008), auteurism (Orgeron 2002; Swallow 2003) and the gaze (Church Gibson 2004). While some discussions of the film make mention of Deleuze's work – for example, Grønstad (2003), who concentrates on masochism – only Patricia Pisters (2003) has treated the film to an (albeit brief) Deleuzian analysis to date, illuminating an absent people's becoming, a political mobilisation of a *class of violence*, and an expressive interplay between time- and movement-image regimes. We should like to acknowledge the validity of all of these heterogeneous analyses, for the film is rich enough to allow for their co-existence, but we should also like to extend these much further, particularly Pisters's interpretation, to see what feedback the film offers to help us (better) understand Deleuze (and Guattari).

Based on Chuck Palahniuk's novel (1999), *Fight Club* tells the story of an unnamed narrator, often referred to as Jack (Edward Norton), who suffers from insomnia and convinces himself he is ill. Initially, a cynical doctor sardonically advises he attend therapy groups for disease sufferers, so he can see real suffering. Attending the sessions allows him to find a strong emotional release, and he is again able to sleep – that is, until a woman called Marla Singer (Helena Bonham Carter) begins attending the same groups and re-activates his sleeplessness.

The narrator's day job as an insurance recall co-ordinator finds him evaluating whether it will be cheaper for his car company to recall faulty products or settle lawsuits in or out of court. This involves extensive travel across the USA, and during one trip he encounters the enigmatic anarchist Tyler Durden (Brad Pitt). Thereafter, he returns home to find his apartment destroyed by an explosion seemingly ignited by a gas leak. He contacts Tyler, who invites him to stay at his dilapidated house, but not before asking the narrator to punch him. Reluctantly, the narrator hits Tyler, and they begin scrapping. By degrees Fight Club is born. The ennui of modern life and a/the crisis in masculinity mean that other disaffected males are drawn to the nocturnal fights. Since participants find these physical experiences immensely satisfying, the clubs begin to proliferate. For the narrator, actively fighting allows him to sleep again more than simply observing and sharing in others' suffering. In time, Tyler turns Fight Club into Project Mayhem, a covert organisation driven to overthrow late capitalism – initially through minor acts of

vandalism, which escalate into a terrorist plot to destroy financial corporations and blow up their headquarters.

Aware the narrator is no longer attending therapy sessions, Marla contacts him to find out why. She initially hams up an attention-grabbing suicide attempt, which the narrator ignores, but to which Tyler responds. As a result, Tyler commences an intensely sexual relationship with Marla, which the narrator finds distasteful, as he does Project Mayhem, from which Tyler likewise excludes him. As the narrator attempts to retard Project Mayhem, he increasingly discovers many of the men involved in it, impossibly, know him, even though he remains convinced he has never met them. As the terrorist plot inexorably heads towards its cataclysmic apogee, the narrator finally realises the members of Project Mayhem do know him, but not as the famous founder of Fight Club, but because he *is* Tyler Durden. As Tyler, the narrator *has* met them before.

Realising *he* has been the architect of Project Mayhem, the narrator tries to bring about its end by killing the part of himself that is Tyler – by shooting himself in the head. The bullet dislocates his jaw, but the gesture is seemingly enough to 'kill' Tyler. However, this action does not prevent the organisation from achieving its anarchic goals. The film ends, therefore, as several corporate towers collapse, and as the final credits begin to roll, a six-frame splice-in of a man's penis is inserted into the film – evidence, seemingly, that Tyler is in fact not dead, since we know from the narrative that he habitually inserted single frames of pornography into films whilst working as a projectionist.

III. Against Mind–Body Dualism

Below, we argue *Fight Club* features deterritorialisations that enable becomings through the body as well as deterritorialisations that enable becomings through the brain. By the latter, we mean the images we see might depict the thoughts of the narrator (thoughts that take bodily form are embodied in the cases of the other figures that we see onscreen), and by the former, we mean the film features moments in which the narrator's visible physical state can lead to new thoughts, as perhaps is most recognisable in the case of insomnia, where a physical state (prolonged waking) induces fantasy hallucinations. Both becomings imply that brain and body are not as easy to separate as we might believe, if we were to adopt a 'classical' Cartesian mode of thought. However, in order to commence our schizoanalytic reading of the film, and in order to break down the binary opposition between body and brain, we should like to spend some time elaborating what this means

at the level of content, before turning our attention to the corresponding themes built into the form/style of the film.

Gaining momentum in the 1990s, those involved in cognitive approaches to cinema attempted to put distance between psychoanalytic and Marxist readings of films, particularly those inspired by 'post-structuralist' thought (see Bordwell and Carroll 1996). In the crossfire between cognitive and 'post-structuralist' approaches, Deleuze came to be associated with the latter more than the former, perhaps due to his status as a 'continental' philosopher. As such, scholars like David Bordwell (1997: 116–17; 2010), while usefully identifying some limitations of Deleuze's film scholarship, go too far by dismissing it altogether. Although this is neither the time nor the place to rehearse in detail the reasons for and in particular against Deleuze's association with post-structuralist thought and his distantiation from cognitive approaches, we should like to say that recent developments in neuroscience and other disciplines that often form the theoretical basis for cognitive approaches seem to suggest that Deleuzian models of mind–body parallelism were not far off the mark. Neuroscientists such as Antonio Damasio (1994; 1999) and philosophers like George Lakoff and Mark Johnson (1999) have argued that not only is there no 'homunculus' directing thought, but the brain is embodied and 'basic' or 'lower-level' processes, from homeostasis to galvanic skin responses, are influential on emotions and feelings, which in turn are deeply influential on thoughts. Thus, the brain is not uniquely a rational disembodied tool that disregards 'irrational' phenomena like emotions and visceral responses (or affects). Rather, whatever rational thought the brain is capable of is dependent almost entirely upon what happens in the body and the fact that we have bodies at all.

Were cognitive film studies to look beyond its 'continental' and 'post-structuralist' thought prejudices, it might find Deleuze a useful ally precisely for his articulation of a body–mind parallelism, something symbolised in his overlap with Antonio Damasio via their shared Spinozian interest (see Deleuze 1988; Damasio 2003), as outlined by William E. Connolly (2006). In *Spinoza: Practical Philosophy*, Deleuze describes how parallelism disallows any primacy of the brain over the body, or of the body over the brain, which would be just as unintelligible (Deleuze 1988: 18). Mind and body are here freed of hierarchical relations, so that the brain becomes a partial machinic-component that sends efferent signals to the body, while the body simultaneously sends afferent orders to the brain, of which it is just a part and, correlatively, which is just a part of it. Spinoza's dictum 'Give me a body then'

comes to take on new meaning, as it can be through the body that new thought is achieved, with new physical states being matched by new neuron connections in the brain. In Deleuze's cinematic paradigm, to think becomes 'to learn what a non-thinking body is capable of, its capacity, its postures. It is through the body (and no longer through the intermediary of the body) that cinema forms its alliance with the spirit, with thought' (Deleuze 2005b: 182). The scene in *Fight Club* where Tyler inflicts a chemical lye burn on the narrator epitomises best this non-hierarchical relationship between the feeling body and the thinking mind – and visually actualises a direct relationship between bodily senses (feeling) and brain activity (thought).

The scene starts as an action-image. Tyler holds the narrator and administers powdered lye to a wet-kiss upon his hand. The excruciating bodily pain caused by the chemical burn immediately catalyses a visceral thought-image montage that vies for prominence amongst the action-images. The film here displays what we might call a motific re-folding of brain and body cinemas as the feelings and sensation of the physical burn directly stimulate thought. The narrator initially attempts to apply meditation to escape the intense pain, and viewers are presented with serene images of a green forest. After returning to a close-up of the hand, now bubbling as his flesh chemically dissolves, mental images (opsigns) of fire and intertitle-like images isolating words like 'searing' and 'flesh' intermix with sounds of intense burning and crackling (sonsigns). These compete with Zen-like images of trees, birdsong and the narrator's healing cave as he attempts to escape these overwhelming feelings and sensations. This begins to illuminate a powerful parallel-image sequence, wherein a brain-cinema montage overlaps performative action-images and affective bodily close-ups. The fact that Tyler is also coded as a mental manifestation serves to introduce another level of actual/virtual folding within the meniscus of the image. Thus, the images push and pull in two simultaneous directions that underscore a parallel relationship between mind and body, feeling and thought. As this relationship surfaces throughout the film, the model of parallelism increasingly becomes related to a process of immanent deterritorialisation.

IV. Deterritorialising the Body

When analysing films, it is often hard to separate form from content. As such, while we shall examine how *Fight Club*'s content (that is, its plot) involves the deterritorialisation of the narrator's body in such a way that schizoanalysis offers a suitable framework through which

to understand it, we shall also make explicit reference to the filmic form – although we reserve a prolonged analysis of form for a later section. To better understand how the body is deterritorialised within the film, we respectively analyse the roles insomnia, hunger, cancer and violence play, as well as considering the various ways in which these deterritorialising forces allow the narrator to enter a liminal state wherein the boundaries between fantasy and reality, inside and outside, thought and action, begin to blur.

In a Deleuzian-inflected engagement with insomnia narratives, Patricia Pisters argues that 'it is only when one is exhausted or "paralysed" that the sensory-motor action gives way to pure optical sound situations [and that] one enters into a dream world or visionary otherworldliness' (Pisters 2003: 136). After being sleepless for six months, the narrator laments: 'with insomnia nothing's real. Everything's far away. Everything's a copy of a copy of a copy'. These subjective experiences are aesthetically reflected by images drained of colour, depth and sound, as well as expressively and expressionistically distorted effects, such as crackling electrical charges that overlap edits, distended sounds that warp entire scenes, and 'single-frame' subliminal flashes of Tyler that flicker within the *mise-en-scène* prior to his 'real' introduction. Here, the exhaustion created by the narrator's insomnia provides the conditions for distorted formal images and sounds that viewers perceive. Although these are implied hallucinations, it is hard to tell these 'fantasy' elements apart from the narrator's 'real' perceptions.

The film often depicts the narrator performing mundane tasks like brushing his teeth or going to the toilet, but barely shows him eating. Significantly, when he opens his fridge, we see it is bare. While it is never explicitly stated he is hungry or deliberately fasting, the *mise-en-scène* becomes suggestive of an ascetic drive that becomes another condition aiding his entry into a warped, dreamlike world where bodily experiences become inseparable from those of the brain (thought, or fantasy, becomes indistinguishable from reality). In an essay on 'The "Fasting Body" and the Hunger for Pure Immanence', psychotherapist Jo Nash argues that fasting enables

> an altered state of consciousness [to arise] that permits a collapsing of the dualistic affective divisions between subject and object, within and beyond, to enable an experience of transversal, trans-Oedipal desire to enjoy both, at one and the same time [...]. Binary divisions of inner and outer, self and other, mind and body, thought and feeling, are overcome, through a conscious decision to resist the desire to consume. (Nash 2006: 325–6)

The narrator's lack of consumption on the physical level is eventually succeeded by his refusal to consume on what we might call a capitalist level later in the film. But while these initial conditions of insomnia and hunger set the scene for a primary deterritorialisation of the self through the body, the narrator finds himself reterritorialised by the physical and spiritual release he experiences by attending disease support groups in acts of 'misery tourism'.

The narrator's new-found ability to sleep and cry is in particular enabled by his physical interaction with a testicular cancer sufferer called Bob (Meat Loaf Aday) who has developed (what the narrator calls) 'bitch tits' as a result of his orchiectomy and subsequent chemical imbalance. While the narrator attends therapy groups for genuine victims of cancer, he is of course only a tourist among these sufferers. However, once Marla arrives and begins to infiltrate all the groups, not only can he no longer sleep again, but it is as if Marla becomes a kind of cancer that infects him: 'If I had a tumour, I'd call it Marla.' While this no doubt encourages a reading relating to the film's surface misogyny and exclusive treatment of masculinity, an issue to which we shall return, it is important to establish how Marla, in particular Marla-as-cancer, triggers a second level of deterritorialisation that will only be eased – temporarily – by the advent of Tyler.

Beyond toying with the notion of calling his tumour Marla, there are several other ways in which Marla can be understood to operate in a cancerous fashion. Her consistent smoking (even in cancer recovery sessions), for instance, along with her claims of actually having cancer during an attention-seeking 'suicide' attempt ('my tit is rotting off') thematically associate her with cancer and its causes. Furthermore, her gothic appearance – black eyeliner, black clothes – also grant her a form of necrotic presence that begins spreading everywhere. As a cancerous force, Marla becomes another active agent in the narrator's deterritorialising process. This notion is signalled during a support group scene where the narrator joins terminally ill sufferers in guided meditation, whereby they retreat into their 'healing caves'. Typically, the narrator finds his 'power animal' there, a computer generated imagery (CGI) penguin that encourages him to 'slide'. However, once Marla arrives, she replaces the penguin, and, exhaling smoke, implores him to 'slide', or, for the sake of this argument, deterritorialise. In other words, Marla begins to assert her presence in both the narrator's waking and dream life.

By degrees, the narrator quits the groups, meets Tyler and begins Fight Club. Mirroring the initial affect and effect of the support groups, the

physical experience of violence functions as a physical and psychological release that allows him to sleep. But, where the therapy sessions helped reterritorialise the narrator, in that he could sleep safe in his IKEA catalogue-like apartment, here the violence is part of a prolonged and temporarily more satisfactory deterritorialisation. Losing his home, the narrator joins Tyler in an abandoned house, and begins to lose teeth and turn up at work with a bruised face and body. Seduced by Tyler, he eventually rejects the consumerist lifestyle that characterised his earlier existence. The violence therefore serves as a deterritorialising force; as Pisters argues, it equals 'the shocks in the brain' and is 'connected to a strategy of deterritorialisation' (Pisters 2003: 97–8). We can locate another echo of a body and mind parallelism in Pisters's equation of cerebral and physical violence here, but we should presently like to spend some time sorting through the complexity of this deterritorialisation.

We have argued the narrator's flirtations with danger serve a deterritorialising end, and that this process is subsequently rounded off by a reterritorialisation signalled through his ability to sleep. However, if his misery tourism and initial forays into violence are undertaken with the goal of reterritorialisation, then what *real* deterritorialisation is going on? That the deterritorialisation is undertaken with a specific goal in mind suggests that this is only a reterritorialising deterritorialisation. But in fact this reterritorialisation that lies at the heart of the narrator's first and superficial attempts at deterritorialisation occult – at least at first – a more profound deterritorialisation. For it will ultimately turn out that the narrator has not been asleep (or 'reterritorialised') at all. As Tyler, the narrator has been escalating the violence of Fight Club to ever-greater levels, culminating in Project Mayhem. As this is only revealed at the climax of the film (when we watch it for the first time), the continued deterritorialisation that takes place in spite of the appearance of reterritorialisation (he seems happier/can sleep) must be manifested in different ways. How is this so?

The continued, 'deeper' deterritorialisation is manifested through the reappearance of Marla and the appearance of the Project Mayhem goons who move in with Tyler and the narrator. Here, the analogy between Marla and cancer can be extended: in the same way that she is a continued and persistent 'cancerous' presence in the film, so, too, does the increased presence of other black-clad and nameless figures in the *mise-en-scène* reinforce as much. Like a cancer growing, the Project Mayhem goons come to represent the continued but evolving deterritorialisation of the narrator's world. Their dilapidated home thus becomes the body in which these malignant, or terrorist, 'cells' take

their place; according to the narrator, the house becomes 'a living thing, wet inside with so many people sweating and breathing'. It is from this base that the terrorist organisation mounts its attack on the surrounding organs of the embedding culture. That is, Fight Clubs and terrorist cells begin to crop up everywhere across the US, and these are organised by Tyler, who takes advantage of the narrator's travels to coordinate Project Mayhem. It is important to stress, then, that even though we do not know as much until near the film's end, Tyler is also part of the deterritorialisation of the narrator, and utilises the rhizomatic web of national airline routes to spread Project Mayhem (cultural cancer) in a way similar to a disease travelling around the body's circulatory and cardiovascular system.

Finally, the increased, 'deeper' deterritorialisation of the narrator taking place without his (or the first-time viewer's) knowledge, is also marked in an affective scene depicting unhinged violence waged against an unconscious opponent, Angel Face (Jared Leto). While there are several scenes of ritualised violence in the film, which collectively witness the body become an affective threshold of intensity, in this scene both form and content synergistically interface to affectively frame a deranged attack, which transcends the (diegetically) established ritualised codes. Framed from the victim's position and scored with affective sounds of pounding flesh and crunching bone, the scene formulates a gruesome unflinching visceral experience, in which the narrator reveals that all is not well and that he, too, needs to go further and become more deterritorialised if he is to find peace or happiness again.

Between insomnia, hunger, cancer and violence, then, we get a sense of the central role that the body plays in *Fight Club* and particularly in the narrator's deterritorialising line of flight from bourgeois consumerist conformity to anarchistic terrorist. However, as we indicated above, the body is not alone in this process. If insomnia and hunger can help break down the boundaries between reality and illusion, between self and other, and if cancer can do the same, in that a cancer is both alien and within us, and if violence can also change our thoughts by making marks on and modifying our bodies, then the parallel brain, too, must equally be involved in this process.

V. Deterritorialising the Brain

We explained earlier that the narrator's insomniac experiences are conveyed expressively via a combination of sound and *mise-en-scène*:

warping distortions and washed-out lighting trouble our ability to tell what is real and what is not, and expressionistically reflect the narrator's experiences. While *Fight Club* does feature a now-famous twist ending whereby the narrator discovers he *is* Tyler and the mastermind behind Project Mayhem, we might initially suspect that the end sees the narrator reterritorialised as 'himself', in that Tyler is 'dead', despite the fact that Project Mayhem appears to have destroyed the banks. We have already mentioned, however, how the closing splice-in of a penis hints that Tyler is, in fact, still at large. While this is seemingly so, we should like to extend the argument somewhat further, by suggesting that there is very little in the film that we can truly claim to be 'real' or 'outside' of the narrator's brain. This is manifest in that final splice-in: Tyler, should he be the perpetrator, does not splice the penis into a film *within Fight Club* (as happens earlier). Rather the film into which the penis is spliced is *Fight Club* itself. In other words, not only might Tyler and other elements of the *mise-en-scène* be figments of the narrator's imagination, but so might the *whole film*. How can we mount such an argument?

We shall make this argument by looking specifically at the character of Marla, and posit that she, too, is as much a figment of the narrator's imagination as Tyler. 'And suddenly I realised that all of this, the guns, the bombs, the revolution had something to do with a girl named Marla Singer,' says the narrator after the film's opening shots. Although we may not take note of the importance of these words during an initial viewing, they become the first clue hinting at Marla not being a real person. Indeed, not only is it logically unlikely for a woman to attend therapy sessions for testicular cancer sufferers (or to smoke at an emphysema victims group), but, when the narrator addresses her on the issue, she walks away, crossing a road to pawn some stolen clothes. (Narrator: 'Let's not make a big thing of this.' Marla, walking away: 'How's this for not making a big thing?') Marla crosses the road, effortlessly missing speeding vehicles that intercut her path. The narrator, however, steps forward to encounter car horns, screeching brakes and skidding tyres. Is the fact that Marla ghosts across without a problem, whilst the narrator is nearly killed, also an indicative clue hinting that Marla does not exist? As a virtual image, Marla may well function as a fantasy manifestation and embodiment of the narrator's guilt and unease at being a tourist at the support groups. Viewing Marla as another virtual splitting of the narrator is also verbally hinted at, when the narrator informs us that 'her lie reflected my lie'.

The narrator lies awake in bed imagining approaching Marla to demand she stop attending the groups; when he 'actually' approaches her, however, Marla quickly announces she has seen him practising this, suggesting that she, like Tyler, might know everything he thinks and feels. Furthermore, when the two finally barter to divide up the groups, Marla tellingly says she wants the 'brain parasite' and 'organic brain dementia' meetings. This also prompts the narrator to respond: 'You can't have the whole brain!' This exchange not only reinforces the possibility that Marla is a brain-screen image (an embodied manifestation of a thought), but it also creates a circuit with another scene where Tyler discusses his desire to kill off *his* 'loser alter ego' (the narrator) in order to take over the whole brain.

Through a series of visual rhymes and thematic reflections, Marla is also linked to the virtual image of Tyler, serving to reinforce the sense that she is not 'real'. As Marla's introductory vignette ends, for instance, she is framed in silhouette walking into the depth of the frame. A subliminal flash of Tyler is momentarily introduced so their bodies occupy the same position onscreen. Both also wear dark sunglasses (whilst indoors) when we first see them, and both are in the habit of stealing things (Marla steals clothes and food, while Tyler steals human liposuction fat to make soap and bombs). Both characters also smoke and circle mysteriously around the crowds at group therapy sessions and Fight Club meetings, where couples come together to hug or fight respectively. While we have already mentioned how Marla manages to infiltrate the narrator's 'healing cave', it might also be worth mentioning that she literally seems to fuse with Tyler during a sex scene which is the product of the narrator's imagination: their coital bodies rendered in a blurry CGI sequence that Fincher discusses as a Francis Bacon version of Mount Rushmore (Swallow 2003: 130).

What might be the significance of identifying Marla as another (earlier) virtual image/character on a par with Tyler? Deleuze and Guattari may provide an illuminating answer, when they contend that it becomes 'the special situation of women in relation to the man-standard' that accounts for the fact that all becomings initially pass through a 'becoming-woman' (Deleuze and Guattari 2004: 321). Here, it would appear Marla formulates the first virtual threshold of the narrator's becoming process; somewhat ironically introduced during the 'Remaining Men Together' testicular cancer meeting, that is an event attended by castrated males. Marla enters as the narrator hugs Bob (a man in a physical process of becoming-woman with his aforementioned 'bitch tits'). If *Fight Club* can be accused of forwarding

a masculinist narrative, then, this becoming-woman process might conceivably highlight how the film does not respect boundaries between inside and out, and between self and other, in that not only is Tyler revealed to be the projected and embodied fantasy of the narrator, but so is Marla. What is more, rather than allow these figures to be re-centred around/reterritorialised within the male narrator, we would posit a further, deterritorialising ambiguity: these are not so much projections of the narrator as *also the narrator*. Marla is not some 'female' aspect of a 'male' narrator, then, but rather the narrator is both sexes, male and female, at once, and potentially a whole lot more (including Bob who is somehow both female – castrated and with breasts – and male, while not quite being either at the same time). Tyler, Marla, Bob: they are not 'part of' the narrator; they *are* the narrator, such that we cannot attribute sex or gender except as a means of simplifying for the sake of argument what he/she/it is. In this way, masculinist or misogynist readings of the film become hard to sustain: the boundary between genders is not one the film observes, then, but one it troubles, even if instinctively we feel tempted to 'reterritorialise' it within traditional gender(ed) interpretations.

VI. The Form of *Fight Club*

The above examples provide a good link into a discussion of *Fight Club*'s filmic form. That is, while the narrative content tells the story of a character whose bodily experiences are impossible to distinguish, or are cut in fluid fashion with, 'his' mental experiences, we can recognise these same themes reflected by the film's formal and aesthetic construction. We shall highlight this by investigating the film's expressive lighting scheme, its depiction of bodies, and the new forms of space generated by digital technologies.

Fight Club has a very stylised look, as was intimated by our discussion of the expressionistic use of colour to affectively convey the psychological effects of insomnia. Throughout, the film's aesthetic is further blocked using a dark, saturated Technicolor palette, with the underground Fight Club spaces having a chthonic appearance that contrasts with the electric blue over-world office spaces. In order to hold and capture the film's low light levels, Fincher and cinematographer Jeff Cronenweth used non-anamorphic spherical lenses and various development processes to render a style that visually echoes the film's key themes. As Fincher says:

We talked about making it a dirty-looking movie, kind of grainy. When we processed it, we stretched the contrast to make it kind of ugly, a little bit of underexposure, a little bit of re-silvering, and using new high-contrast print stocks and stepping all over it, so it has a dirty patina. (Swallow 2003: 143–4)

The dark spaces often feature the greatest amount of bodily action (the brawls), while the contrasting washed-out lighter spaces reflect the affected spiritual or cerebral dimensions of the film. In keeping with the above discussion of a mind and body parallelism, Amy Taubin argues the film's use of light provides 'such a perfect balance of aesthetics and adrenaline [... that it feels] like a solution to the mind–body split' (Taubin 1999: 18). Significantly, actors' bodies are depicted as lean, muscular and 'taut', especially Brad Pitt's as Tyler. Pamela Church Gibson (2004) argues that this clearly fetishises and commodifies the male bodies, highlighting a 'gaze' that becomes ambiguous, upsetting a normative (straight) viewing position without reinscribing an overtly 'oppositional' or 'gay' one.

We shall return to the spectator of *Fight Club* shortly, but first turn our attention to the film's editing and, in particular, how it uses digital technology to create spaces that can be navigated with a new (total) ease. The film opens with a virtuoso two-and-a-half minute tracking shot beginning in the fear centre of the narrator's brain (although we do not necessarily know this on first viewing), moving backwards past firing synapses and floating cells of bodily matter, before accelerating outwards via a pore, past a giant drop of sweat dribbling from his pate amidst giant, looming bristles of hair, down his face and along the barrel of a gun. As the 'camera' passes the gun's sights, it comes to a rest. The focus changes and what previously had been only an affective rush of colour is pulled into focus to become recognisable as the face of Edward Norton with gun in mouth.

Instants later, while the narrator is explaining the nature of Project Mayhem's plot, an illustrative camera rushes vertiginously down the outside of the skyscraper from the top floor, down through the pavement and ground into a basement car park which houses a bomb nestled alongside a concrete column. The camera then changes trajectory, heading sideways – again at breakneck speed – through areas of solid earth until it reaches another subterranean car park, in which the camera races towards a van, through a bullet hole in its rear window, performing a circling close-up of a bomb counting down to destroy the buildings we have just impossibly and rapidly travelled through. Both shots are in part constructed through the use of CGI and animation – since it

would be physically impossible to manipulate a material camera to pass from the inside of a human actor's brain to the outside, while changing its focal range so we see individual synapses at one moment and a face in focus the next. Similarly, one could not easily drop a material camera thirty-one storeys, through the ground, across an underground space, through a bullet hole and around a bomb in one continuous fluid movement.

That these examples are computer generated is formally important, as we shall see, but it is the continuity of the shots that we should like to emphasise at present. For while, as discussed above, the shots of the lye-burning are intercut with images of green woods and words from dictionaries, such that we switch perceptibly from an image of what is happening in the diegetic world to images of thoughts, here the distinction between the two is not so clear cut. While the montage sequence of the lye-burning happens rapidly – so quickly, that we cannot *count* the shots but must simply get caught up in the speed of the film itself – we can still tell that we are seeing a montage of shots cut together. When the 'camera' (which is not really a material camera) passes from the inside to the outside of the narrator's brain in the film's opening, we cannot so easily separate inside from outside by breaking the sequence into shots. Rather, the inside of the brain and the outside 'physical' world are rendered 'impossibly' as one single continuum. It is not that fantasy and reality are presented as binary opposites, then. Instead *Fight Club* shows that fantasy continues into reality and vice versa in such a way that we can no longer tell them apart.

The subsequent plunge taken by the CG 'camera' into the basement achieves a similar effect. Since we start with a shot of Tyler from outside the building while they wait for the bombs to detonate, we might believe that this is an 'objective' shot of the action. However, since the camera responds to the narrator's voice-over and takes us down to the bomb, it becomes clear the film is responding to his thought processes: we see what the narrator wants us to see – meaning that the film is not 'objective' at all, but rather highly subjective (if we can distinguish the two). However, where Fincher could easily have cut directly from Tyler to the bombs, he does not. The refusal to cut has an added effect: by showing the space between Tyler, the narrator and the bombs, Fincher shows us their connected nature. This similarly blurs the boundary between the objective and the subjective, in a way that is more troubling than using cuts, since we cannot but *falsely* impose a boundary between where the film becomes 'subjective' or 'objective', if the lack of a cut means that *there is no boundary*. In cinematic terms, this

is not necessarily new, since *Citizen Kane* (1941) features similar camera movements in the famous shot where the camera travels through the El Rancho nightclub's neon sign before descending through a skylight into the bar where a drunk Susan Alexander (Dorothy Comingore) slouches. The impression of continuity across two shots is here achieved through a dissolve, but the film fails to present a truly convincing continuous space, since the angles between the first and second shot do not exactly match. The continuous spaces in *Fight Club*, meanwhile, are free of such mismatches, in part because they are created using 3D digital spaces which negate the need for changing material camera positions, and because the movements can be so much faster than those of *Citizen Kane*. This speed of the movement is important, not just in terms of moving too fast for viewers to notice 'flaws' in continuity, but also in terms of the camera movement arguably appearing as 'fast' as a cut. Whereas film has perhaps long since had the ability to 'move' at the speed of thought via editing, here the 'camera' can achieve this effect *without* editing, meaning the boundary between thought-images and pro-filmic 'reality' becomes blurred.

In other words, *Fight Club* is shot in a style that makes form reinforce content: in a narrative in which we shall finally not be able to tell apart the narrator from Tyler from Marla, such that they all form a 'schizophrenic' continuum (in a similar manner to Deleuze and Guattari's thesis that 'at root *every name in history is I*' [Deleuze and Guattari 1983: 85–6]), so, too, is the space in the film shown as a schizophrenic continuum, that passes literally from inside to outside of the brain as if there were no division between the two, and from seemingly objective to subjective shots as well. As Fincher has said, in a way that is reminiscent of Deleuze's call for cinema as a depiction of thought:

> It's like, pfpp, take a look at it, pfpp, pull the next thing down [. . .]. It's gotta move as quick as you can think. We've gotta come up with a way that the camera can illustrate things at the speed of thought. (Quoted in Smith 1999: 58)

These sequences of intense continuity differ, slightly, from the 'intensified continuity' of contemporary cinema noted by Bordwell (2002). Bordwell describes the increased cutting rate of contemporary cinema, while here we are describing a cinema that does not (seem to) cut at all. However, it is not that these sequences, and others like it, including the narrator walking through an IKEA catalogue, and the camera becoming the gas spreading around the narrator's apartment

before it is destroyed, are 'better' than the lye-burning sequence that uses montage. Indeed, the use of montage during the lye-burning heightens the tension and invasive violence of that particular moment. Rather, in *Fight Club* the camera (and the film) seems capable of doing whatever it wants; it does not have to use *either* montage or continuity; it can use both as and when it desires and for expressive purposes. Again, the option of using montage and/or continuity has long been available to filmmakers, but the ability to pass through solid objects (skulls and walls), the ability to change scale (neurons and entire heads in the same shot), and the speed with which this is rendered onscreen intensifies the blurred boundary between the imaginary and the real, particularly when continuity is taken to these extremes.

Earlier we mentioned a moment wherein the narrator hugs Bob, significantly at the same moment Marla is introduced. We in fact encounter this sequence twice within the film. The first time formulates the initial jump backwards into a sheet of past which kick-starts the entire flashback – as if the narrator deliberately wanted to return to this moment (of becoming-woman) as the starting point for the story of his deterritorialisation. In the second occurrence, the now-familiar image is replayed, but we find Marla enter at the exact moment when the narrator forms a hugging assemblage with Bob's 'bitch tits'. This is the moment of forking time that orients and justifies the first flashback. Significantly, in the space of the 'Remaining Men Together' group, we can perceive how Marla, or the becoming-woman process in general, is related to and formulates an assemblage with the concept of organic sickness and disease, and thereafter continues to inform the nature of the immanent deterritorialisation process (becoming-cancer). These instances of repeated shots and recurring time loops, often with minor differences, also go to show that the film is edited in such a way as to be the thought of the (unreliable) narrator, and thus offer us a strange but original form of time-image that infests a narrative that might otherwise be considered an action-image.

The digital nature of many of the images can reinforce this sense. For, when the digital 'camera' can pass smoothly through walls and human heads, or change scale at will, then these continuous digital spaces call for new modes of thought and action because these kinds of continuities have been hard if not impossible to achieve (at least photorealistically) without the digital technology used to create them. As such, the digital nature of these shots is linked to new ways of thinking about time and space. In this film, both time and space are presented as a fluid continuum: space can be traversed in spite of the nature of

the supposedly material objects that fill it; time, likewise, can be crossed like a space – backwards and forwards, sideways, in whichever direction the narrator's brain takes us and without obstacles. In other words, these sequences present us with any-spaces-whatever, except that, unlike the 'traditional' any-spaces-whatever described by Deleuze, these are supermodern or, what William Brown (2009) might term 'posthuman' any-spaces-whatever. We propose this because of the continuity between inside and outside that is (digitally) presented: since the 'camera' can and does go anywhere, our sense of identifiable spatial coordinates is undermined – and, what is (retroactively) understood as the inside and then the outside of the narrator's head/brain becomes a vertiginous rush of changing colours.

Again, the form here matches the content, since much of the narrator's life is spent in airports and anonymous hotels, the kind of non-places described by Marc Augé (1995), and which have been linked by Réda Bensmaïa (1997) to Deleuze's concept of the any-space-whatever (even if, *contra* Bensmaïa, Deleuze does not himself refer to Marc Augé in his work, but to Pascal Auger, a former student [Deleuze 2005a: 112]).[1] Production designer Alex McDowell tried to ensure that locations like 'the airliner interior, the hotel rooms, the office and Jack's [*sic*] apartment all used the same palette of colours and fabrics, suggesting the "sameness of life outside the Fight Club" ' (Swallow 2003: 128). In other words, the film consciously tries to anonymise and homogenise the spaces in which much of the narrative takes place, making these non-places also become any-spaces-whatever, and demanding new modes of thought and movement.

VII. The *Fight Club* Spectator

While we have thus far often mentioned the viewer and the spectator (sometimes referring to these as 'we') in relation to *Fight Club*, we should now like to turn our attention more particularly to the film's viewer(s). For, while *Fight Club* might in content be a film about bodies which depicts not only thoughts (inserts of the narrator's brain patterns) but thought itself (the *process* of thinking, as demonstrated in the film's style/form), then what does this say of the spectator? Firstly, we should like to say that *Fight Club* affects its spectator in much the same way that the characters seem to be affected in the film. That is, *Fight Club* is for the spectator both a *physical* (visceral, or affective) experience, and an experience that can inspire new forms of thought.

Earlier, we mentioned the scene in which the narrator disfigures Angel Face in a fight ('because I wanted to destroy something beautiful'). We mentioned the way in which the sequence is shot from the victim's point of view and how the sound of the violence is affectively amplified: cartilage and bones crunch, skin slips and splits as the narrator mangles the young man's visage. As in the lye-burning scene in which we see images of skin searing, the shots of the narrator's face being torn apart when he shoots himself in the jaw, and the fights more generally, here, too, the filmmakers are interested not just in showing spectators what is happening, but in placing viewers 'within' the action such that they experience the film not just in a detached, visual manner, but *physically*, viscerally even. And if the film is designed to affect the spectator in a physical manner, one might say that *Fight Club* does to the viewer what it depicts happening to the characters. That is, the film enacts a physical form of violence that is deterritorialising and puts viewers' bodies through new experiences that call for new modes of thinking and movement, and allow us to become, as opposed to simply being: we experience insomnia with the narrator via the distorted sound, colour and flickers of Tyler across the screen; and we watch not just Tyler splicing pornographic frames into other movies, but also, pornographic frames being spliced into *this* movie. The narrative actively seeks to affect its viewers directly as opposed to merely telling a story about someone who terrorises film viewers.

Fight Club's narrator offers us technical explanations about 'cigarette burns' or 'changeover' marks, which we see in movies when a projection reel has nearly run its course and needs switching. As he explains this in voice-over, Tyler illustrates by pointing to an actual 'cigarette burn' that features in/on *Fight Club* itself. Furthermore, Tyler rhapsodises about the woes and taunts of contemporary consumerist lifestyle, addressing the camera directly and even managing to dislodge the film itself from its projector, revealing the celluloid image's sprockets. These examples suggest that *Fight Club* not only wants to affect us physically, but also mentally, assaulting any passive spectatorial engagement. That is, as it becomes harder to tell apart the diegetic from the non-diegetic, where the film world begins and ends, not least because we are directly spoken to and because we apparently – impossibly – see the very film that we are watching being ripped from its projector, *Fight Club* seeks to induce challenging new modes of thought. Schizoanalytically speaking, it seeks to induce schizoanalysis: not only can the viewer not tell apart the narrator from Tyler (from Marla) within the film, but the film also pays no attention to the supposed boundary between the fictional world and

our real world. *Fight Club* might be a fictional film, but its physical affects and the new modes of thought that it inspires are genuinely *real* experiences, and so perform modes of cinematic becoming.

In this manner, what 'shocks' the film achieves on our body, it perhaps also inflicts on our brain. In other words, while *Fight Club* is a film that moves at the 'speed of thought', darting from one moment in time to the next, across spaces at breakneck speed, it also sets up three intertwined and parallel time frames reminiscent of the time-image (the three-minute countdown to the towers exploding as the film commences, the dilated flashback memory embedded within this short period, and the viewing time of the film itself). Although ostensibly an action film, *Fight Club* does, as Pisters argues, involve movement-images that expressively toy with time-image regimes. Rather than a straightforward film that tells the story in chronological order, the 'cerebral' nature of the narration effectively unsettles our relationship with time and seeks to make us aware of the non-linear processes entailed in thought and memory.

Beyond its crystalline treatment of time, the film is also a 'twist' movie designed to be re-viewed and re-experienced after an initial, 'naïve' viewing. On account of this, a powerful cinematic consciousness surfaces that knows more than any of the characters embedded within the diegesis. The film's formal construction thus becomes responsible for introducing a virtual and actual circuit into the narrative, since upon subsequent viewings, each spectator retains a memory (a virtual 'past-that-is-preserved') of their initial viewing that overlaps and contrasts with the actual images perceived during a second or third encounter. *Fight Club* therefore plays with time on a meta-cinematic level, and illustrates how time can bring the 'truth' of an image into crisis. In other words, *Fight Club* is not a one-off phenomenon, but a film to be re-viewed and which makes its presence felt in the 'real world' such that fiction and reality become indiscernible.

Mark B. N. Hansen (2004) has argued Deleuze did not give enough weight to the spectator, and suggests that recent neuroscientific findings in fact go *against* some of his arguments concerning the cinema viewing experience. However, Richard Rushton (2009) has recently brought the 'Deleuzian spectator' to prominence: film viewers are not so much conscious of a film but conscious *with* a film. We 'fuse' with it when viewing in such a way that the film-viewer assemblage constitutes a new form of consciousness, a new form of thought. Viewing *Fight Club* not only involves such a process (since this process happens *de facto*, albeit with differing degrees of intensity), but it quite self-consciously involves such a process, as the über-rapid movement in any and all directions

and across time, together with the direct address to the audience, makes clear. To paraphrase the narrator, 'I am Jack's brain' might be a useful starting point for us to articulate what happens when watching the film. But we can go further than this: I become Jack's brain, such that Jack and the film and I (the viewer) cannot be distinguished anymore. We have become a new consciousness that fundamentally deterritorialises us from our 'normal' selves and allows us to *become*. Since the film involves people whose altered physical states (through fights, burns, etc.) lead to new modes of thought (that is, changes in the body lead to changes in the brain – as a result of mind–body parallelism), so is this true for the viewer with regard to the physical states in which the film puts *us*. Robert Sinnerbrink (2008) has called for something like a *rapprochement* between the 'affect' and the 'brain' Deleuzians, and a schizoanalysis of *Fight Club* allows us to put this into effect: not only within the film do physical experiences lead to new modes of thought for the characters, but the film itself is for the spectator a physical and mental experience that leads to new modes of thought, new becomings.

As such, Pitt describes the film as a 'virus' because it is not 'a film you can just *watch*; it's a contagious set of ideas [. . . that] will make you feel *something*' (Swallow 2003: 143–4). One might say, then, that the film involves a 'cancerous' becoming, but not necessarily with the negative connotations that this typically entails. 'Marla is like one of those sores on the top of your mouth that you wished would go away but can't help tonguing', says the narrator as he finds Marla in his 'healing cave'. In a manner akin to the becomings that Steven Shaviro (1993) has described in David Cronenberg's work, the disease-virus-cancer-sore that is *Fight Club* involves a becoming that may not be uniquely pleasurable, but is a becoming in which we are profoundly involved nonetheless – and it is up to us to use this becoming positively (in effect, to treat this 'cancer' as a part of our newly constituted selves, to nourish and not deny it). Palahniuk (2005) writes that both his novel and the film (more particularly the film) have spawned many real-life Fight Clubs: if he is to be believed (if reality is, as Palahniuk titles his memoir, *Stranger than Fiction*, then perhaps we can schizoanalytically believe nothing), then it would seem that not only does the film affect us in theory or during viewing, but it can also lead to new movements and thoughts in real life.

VIII. Conclusion: *Fight Club* as Hollywood Film

We have endeavoured to use schizoanalysis to interpret *Fight Club* not just as a film *about* a narrator undergoing deterritorialising experiences

that lead to new becomings (starting with the becoming-woman signified through the presence of Marla Singer), but as a film that *enacts* a form of schizoanalysis on or with the viewer. The potential for schizoanalysis is in any and every film (we become conscious with all films, perhaps with the world itself at each and every moment), but in *Fight Club* this potential is realised and brought to the fore with an intensity that is often unseen in mainstream Hollywood cinema.

While *Fight Club* is a narrative that critiques the unthinking nature of the consumerist lifestyle, the film is itself a commodity designed to make money, not just in the theatre, but through DVD sales and so on. Like Tyler himself, the film perhaps betrays megalomaniacal and fascistic leanings as much as it is a critique of these processes. The narrator may seek to prevent Tyler from destroying the corporate consumerist world, but he fails (Tyler is still at large come the film's closing; the banks *are* destroyed). But this failure is not necessarily matched by any change in the real world. Even if real Fight Clubs have been created as a result of the film, does the film-as-commodity in fact reinforce as much as it seeks to overthrow the consumerist lifestyle? If schizoanalysis as a process seeks to disrupt the 'unthinking' modes of thought consumerist modernity might impose upon us, has schizoanalysis ultimately failed when it has been co-opted into or become 'axiomatised' within mainstream Hollywood filmmaking?

While we might speculate that Deleuze would be unimpressed with *Fight Club* had he seen it, does the above analysis suggest that Deleuze overlooked the schizoanalytic potential of the mainstream? Or does it suggest that (a version of) Deleuzian thought has itself become mainstream, meaning that we must now seek to find even 'newer' ways of thinking and moving in the world – new experiences that will enable newer becomings? If *Fight Club* is a product of capitalism, which always seeks to produce new others precisely so as to consume them and to be able to grow, then is it really revolutionary at all? We suspect that the answer is both: *Fight Club* realises a potential that Deleuze may not have seen in mainstream, action-image cinema, while it also must to a degree undermine the power of that potential, perhaps by virtue of that potential being realised in and of itself. However, rather than being a negative thing, we can also read this as a new fold in Deleuzian thought: *Fight Club* may reterritorialise schizoanalysis, but this reterritorialisation of deterritorialisation is simultaneously a deterritorialisation of the modes of thought that reify and reterritorialise Deleuze. *Fight Club* is famous for its so-called rules, the first rule being that you do not talk about Fight Club. The law may condemn behaviour

that is deemed unethical (from the point of view of the law, Tyler Durden is a criminal), but 'the man who obeys the law does not thereby become righteous; on the contrary, he feels guilty and is guilty in advance, and the more strict his obedience, the greater his guilt' (Deleuze 1989: 84). In contrast to obeying the law, then, and beyond good and evil, we say that when it comes to finding out what a body can do, there are no rules. Let us schizoanalyse schizoanalysis, deterritorialise deterritorialisation, and unlock the potential for becoming that lies not just in *Fight Club*, but in each and every encounter we have.

Note

1. Pascal Auger's name is misspelt when Deleuze first mentions the concept of the any-space-whatever in *Cinema 1* (Deleuze 2005a: 112). Paris VIII has published online transcripts and recordings of Deleuze's seminars on cinema, and these include one in which Deleuze credits Pascal Auger with the concept of the any-space-whatever, and in which Auger himself also talks about the term in relation to Michael Snow's *Wavelength*. However ingenious (and still valid) the link between Marc Augé and Deleuze, it was not one intended by Deleuze himself. See Deleuze 1982 for more.

References

Augé, Marc (1995) *Non-places: Introduction to an Anthropology of Super-modernity*, trans. John Howe, London: Verso.

Bensmaïa, Réda (1997) 'L' "espace quelconque" comme "personnage conceptuel" ', in Oliver Fahle and Lorenz Engell (eds), *Der Film bei Deleuze/Le Cinéma Selon Deleuze*, Weimar: Verlag der Bauhaus-Universität Weimer/Presses de la Nouvelle Sorbonne, pp. 140–59.

Bordwell, David (1997) *On the History of Film Style*, Cambridge, MA: Harvard University Press.

Bordwell, David (2002) 'Intensified Continuity: Visual Style in Contemporary American Film', *Film Quarterly*, 55:3, pp. 16–28.

Bordwell, David (2010) 'Now You See it, Now You Can't', *Observations on Film Art: Kristin Thompson and David Bordwell*, available at http://www.davidbordwell.net/blog/?p=8509 (accessed 12 November 2010).

Bordwell, David and Noël Carroll (eds) (1996) *Post-Theory: Reconstructing Film Studies*, Madison: University of Wisconsin Press.

Brown, William (2009) 'Man Without a Movie Camera – Movies Without Men: Towards a Posthumanist Cinema?', in Warren Buckland (ed.), *Film Theory and Contemporary Hollywood Movies*, London: Routledge/AFI, pp. 66–85.

Chandler, Christopher N. and Philip Tallon (2008) 'Poverty and Anarchy in *Fight Club*', in Read Mercer Schuchardt (ed.), *You Do Not Talk About Fight Club: I am Jack's Completely Unauthorised Essay Collection*, Dallas: Benbella Books.

Church Gibson, Pamela (2004) 'Queer Looks, Male Gazes, Taut Torsos and Designer Labels: Contemporary Cinema, Consumption and Masculinity', in Phil Powrie, Ann Davies and Bruce Babington (eds), *The Trouble with Men: Masculinities in European and Hollywood Cinema*, London: Wallflower Press, pp. 176–86.

Citizen Kane, directed by Orson Welles. USA: RKO Pictures, 1941.

Connolly, William E. (2006) 'Experience & Experiment', *Daedalus*, 135:3, pp. 67–75.

Damasio, Antonio (1994) *Descartes' Error: Emotion, Reason, and the Human Brain*, London: Vintage.

Damasio, Antonio (1999) *The Feeling of What Happens: Body and Emotion in the Marking of Consciousness*, London: Vintage.

Damasio, Antonio (2003) *Looking for Spinoza: Joy, Sorrow and the Feeling Brain*, London: Vintage.

Dassanowsky, Robert (2007) 'Catch Hannibal at Mr Ripley's Fight Club If You Can: From Eurodecadent Cinema to American Nationalist Allegory', *Film International*, 5:3, pp. 14–27.

Deleuze, Gilles (1982) 'Cinéma cours 11 du 02/03/82', available at http://www.univ-paris8.fr/deleuze/article.php3?id_article=174 (accessed 16 February 2011).

Deleuze, Gilles (1988) *Spinoza: Practical Philosophy*, trans. Robert Hurley, San Francisco: City Lights Books.

Deleuze, Gilles (1989) 'Coldness and Cruelty', in Gilles Deleuze and Leopold von Sacher-Masoch, *Masochism: Coldness and Cruelty and Venus in Furs*, trans. Jean McNeil, New York: Zone Books.

Deleuze, Gilles (2005a) *Cinema 1: The Movement-Image*, trans. Hugh Tomlinson and Barbara Habberjam, London: Continuum.

Deleuze, Gilles (2005b) *Cinema 2: The Time-Image*, trans. Hugh Tomlinson and Robert Galeta, London: Continuum.

Deleuze, Gilles and Félix Guattari (1983) *Anti-Oedipus: Capitalism and Schizophrenia*, trans. Helen R. Lane, Robert Hurley and Mark Seem, Minneapolis: University of Minnesota Press.

Deleuze, Gilles and Félix Guattari (2004) *A Thousand Plateaus: Capitalism and Schizophrenia*, trans. Brian Massumi, Minneapolis: University of Minnesota Press.

Fight Club, directed by David Fincher. USA: Fox 2000 Pictures/Regency Enterprise, 1999.

Friday, Krister (2003) ' "A Generation of Men Without History": *Fight Club*, Masculinity and the Historical Symptom', *Postmodern Culture*, 13:3.

Giroux, Henry A. (2001) 'Private Satisfactions and Public Disorders: *Fight Club*, Patriarchy, and the Politics of Masculine Violence', *jac*, 21:1, pp. 1–31.

Giroux, Henry A. and Imre Szeman (2001) 'Ikea Boy Fights Back: *Fight Club*, Consumerism, and the Political Limit of Nineties Cinema', in Jon Lewis (ed.), *The End Of Cinema As We Know It: American Film in the Nineties*, London: Pluto Press, pp. 95–104.

Gormley, Paul (2005) *The New-Brutality Film: Race and Affect in Contemporary Hollywood Cinema*, Bristol: Intellect.

Grønstad, Asbjørn (2003) 'One-Dimensional Men: *Fight Club* and the Poetics of the Body', *Film Criticism*, 28:1, pp. 1–23.

Hansen, Mark B. N. (2004) *New Philosophy for New Media*, Cambridge, MA: MIT Press.

Lakoff, George and Mark Johnson (1999) *Philosophy in the Flesh: The Embodied Mind and Its Challenge to Western Thought*, New York: Basic Books.

Lizardo, Omar (2007) 'Fight Club, or the Cultural Contradictions of Late Capitalism', *Journal for Cultural Research*, 11:3, pp. 221–43.

Nash, Jo (2006) 'Mutant Spiritualities in a Secular Age: The "Fasting Body" and the Hunger for Pure Immanence', *Journal of Religion and Health*, 45:3, pp. 310–27.

Orgeron, Devin (2002) 'David Fincher', in Yvonne Tasker (ed.), *Fifty Contemporary Filmmakers*, London: Routledge, pp. 154–61.

Palahniuk, Chuck (1999) *Fight Club*, London: Vintage.

Palahniuk, Chuck (2005) *Stranger than Fiction: True Stories*, London: Anchor Books.

Pisters, Patricia (2003) *The Matrix of Visual Culture: Working with Deleuze in Film Theory*, Stanford, CA: Stanford University Press.

Rushton, Richard (2009) 'Deleuzian spectatorship', *Screen*, 50:1, pp. 45–53.

Shaviro, Steven (1993) *The Cinematic Body*, Minneapolis: University of Minnesota Press.

Sinnerbrink, Robert (2008) 'Time, Affect, and the Brain: Deleuze's Cinematic Aesthetics', *Film-Philosophy*, 12:1, pp. 85–96.

Smith, Gavin (1999) 'Inside Out: Gavin Smith goes One-on-One with David Fincher', *Film Comment*, 35:5, pp. 58–68.

Swallow, James (2003) *Dark Eye: The Films of David Fincher*, London: Reynolds and Hearn.

Ta, Lynn M. (2006) 'Hurt So Good: *Fight Club*, Masculine Violence and the Crisis of Capitalism', *The Journal of American Culture*, 29:3, pp. 265–77.

Taubin, Amy (1999) 'So Good It Hurts', *Sight and Sound*, November, pp. 16–18.

Wavelength, directed by Michael Snow. Canada/USA: 1967.

Windrum, Ken (2004) '*Fight Club* and the Political (Im)Potence of Consumer Era Revolt', in Steven Jay Schneider (ed.), *New Hollywood Violence*, Manchester: Manchester University Press, pp. 304–17.